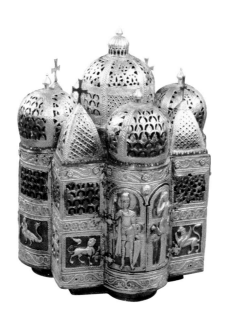

THE SECRET LANGUAGE OF
CHURCHES &
CATHEDRALS

Decoding the Sacred Symbolism of Christianity's Holy Buildings

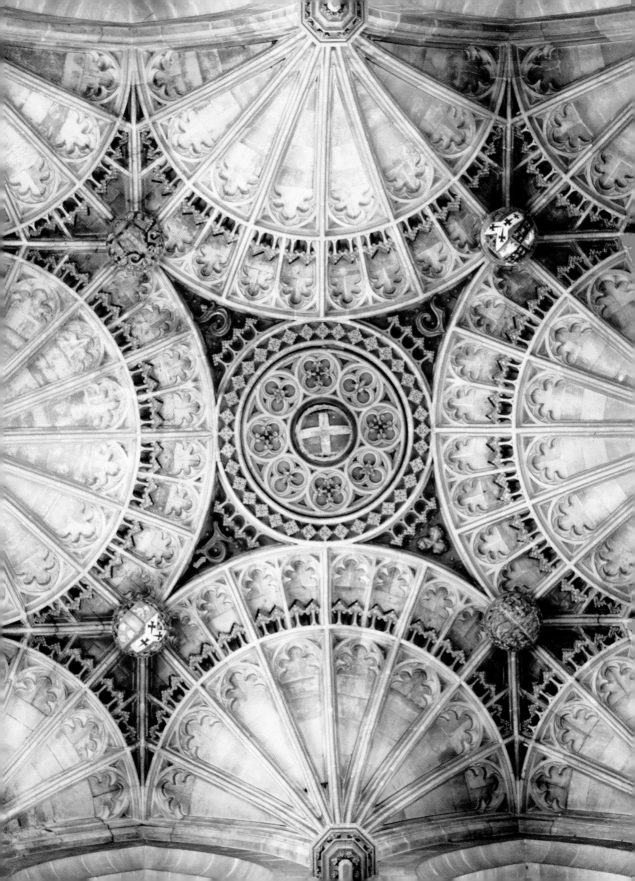

THE SECRET LANGUAGE OF
CHURCHES &
CATHEDRALS

Decoding the Sacred Symbolism of Christianity's Holy Buildings

Richard Stemp

dbp

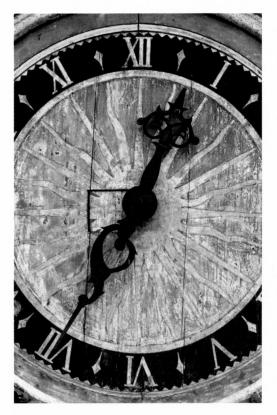

◖ CLOCK FACE

LATE 17TH CENTURY, CHURCH OF THE HOLY SPIRIT, TALLINN, ESTONIA

This is the oldest public clock in Tallinn, and reminds us how important the Church was for daily life: religious services, announced by a peal of bells, would have structured the day and the week. The central sunburst on the clock refers not only to the passage of the sun across the sky, but also to the light of God, which was often depicted like this in the 17th century. The Holy Spirit frequently appears at the centre of this light (see illustrations, pages 59 and 66) and His presence can be assumed here, from the name of the church itself.

PRELIM IMAGES:

ENDPAPERS: Left – *Ludovico Cigoli*, Brunelleschi's dome, c.1610; right – *Anonymous*, the construction of Brunelleschi's dome, 15th century (drawings, both in the Gabinetto dei Disegni, Florence, Italy).

PAGE 1: A perfume brazier from Constantinople or Italy, late 12th century, Basilica of San Marco, Venice, Italy.

PAGE 2: *John Wastell*, Bell Harry Tower, 1494–1497, Canterbury Cathedral, England.

The Secret Language of Churches & Cathedrals

Richard Stemp

This paperback edition first published in the UK and USA in 2016 by DBP, an imprint of Watkins Media Limited
19 Cecil Court
London WC2N 4EZ

enquiries@watkinspublishing.com

First published in 2010 by Duncan Baird Publishers Ltd

Managing Editor: Christopher Westhorp
Managing Designer: Luana Gobbo
Picture Editor: Julia Brown
Picture Assistant: Emma Copestake

British Library Cataloguing-in-Publication Data:
A CIP record for this book is available from the British Library

ISBN: 978-1-78028-961-8

10 9 8 7 6 5 4 3 2 1

Typeset in Adobe Garamond and AgfaRotis
Colour reproduction by Colourscan, Singapore
Printed in China

NOTES

The Scripture quotations contained herein are from the King James Version of the Bible. Reproduced by permission of the Crown's Patentee, Cambridge University Press. Citations are to chapters then verses.
Abbreviations used throughout are BC Before Christ (the equivalent of BCE Before the Common Era), AD Anno Domini (the equivalent of CE Common Era), c. circa.

DEDICATION

In Memory of my Mother, whose devotion to God meant that we went to church every week.
And for my Father, whose devotion to her meant that we got there.

CONTENTS

INTRODUCTION

"Here's the church and here's the steeple
Open the doors and see all the people."

According to this well-known nursery rhyme and its accompanying hand-actions, a church is a recognizable, more-or-less rectangular structure, with a steeple – something like James Gibbs' St Martin-in-the-Fields in Trafalgar Square, in central London. This may not be a coincidence: shortly after the church was completed in 1726, Gibbs published his *Book of Architecture*, which became one of the most important sources for the design of churches in America. Thus St Martin's is effectively the model for the numerous, similarly proportioned churches – built out of brick or clapboard, and combining a porch or portico with a tower or steeple – scattered across the United States.

However, as a church building, this structure is not inherently Christian. The portico is inspired by classical temples whose pagan forms of a triangular pediment supported by six Corinthian columns were embraced by the architects of the Italian Renaissance in the fifteenth and sixteenth centuries. The steeple, on the other hand, is an essentially Gothic structure with its origins in the north of Europe. Non-functional, the steeple points the way to God and marks the position of the church to viewers from afar. This combination of sources – classical and Christian, Renaissance and Gothic, northern and southern European – says much about the history of the Church, and this evolution of styles is the essence of Part Three of this book (see pages 130–213).

Even the word "church" needs some clarification. "*A* church" can refer to a building in which Christians practise their religion. "*The* Church" is the body of Christians who worship together, and it describes a group of people, a community, as much as it does the place of worship itself. After all, this worship can take place in many types of building, whether "church", cathedral, chapel or meeting house. And, even if the form of "church" that Gibbs created

– influenced by his training in Rome and by the work of Christopher Wren, the great British architect of the preceding generation – was sufficiently diffused to inspire a nursery rhyme, churches can take on a multitude of appearances.

For example, the simplicity of geometric forms and the purity of the white stone of St Martin-in-the-Fields (see illustration, right) could not be more different from the multicoloured onion domes of the Cathedral of the Resurrection in St Petersburg, also known as the Cathedral of the Resurrection of Jesus Christ or the Church on Spilt Blood (see illustration, page 8).

The Cathedral of the Resurrection was inspired by Russian churches of the sixteenth and seventeenth centuries, notably St Basil's in Moscow and the Vladimir Cathedral in Kiev. In fact, the St Petersburg cathedral was not started until 1883, and so it is a deliberate evocation of past times. This reflects the cathedral's function as a memorial church built by Tsar Alexander III on the site where his father was fatally wounded. The style looks back to what was seen as a happier past, and its dedication (to the Resurrection) looks forward to a happier future. The domes in the St Petersburg cathedral are merely decorative, whereas at St Basil's each of its eight domes sits above a separate chapel arranged around a central ninth: the structure is an eight-pointed star, or two overlapping squares – the number eight being symbolic of the end of time, and our future in heaven (see pages 104–107).

◐ ST MARTIN-IN-THE-FIELDS
James Gibbs, 1721–1726, LONDON, ENGLAND

The first mention of a church on this site was in 1222. Located in between Westminster and the City of London, the church was then quite literally "in the fields". St Martin-in-the-Fields (its patron is Martin of Tours) was rebuilt in 1542 for King Henry VIII and then in 1721 under King George I, whose coat of arms is displayed boldly in the pediment.

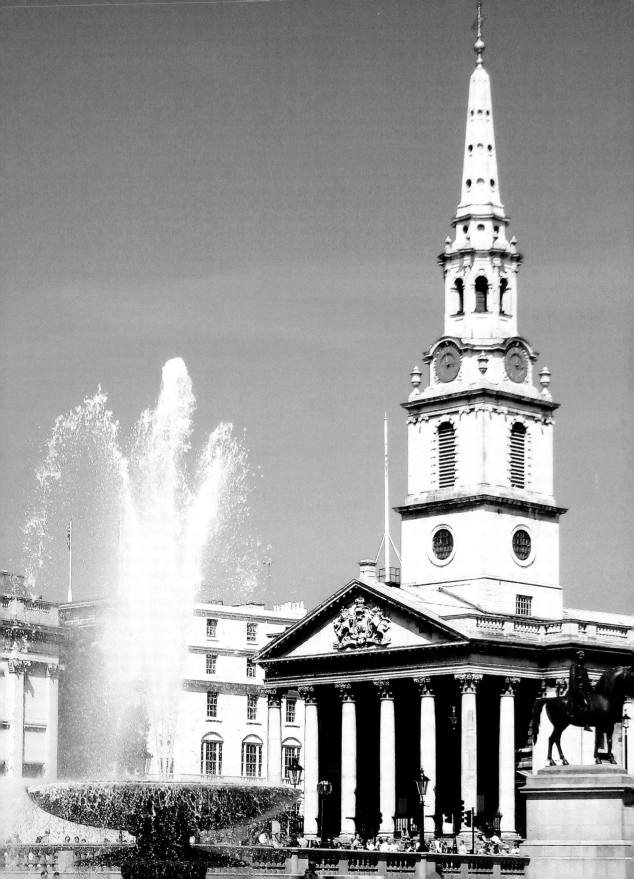

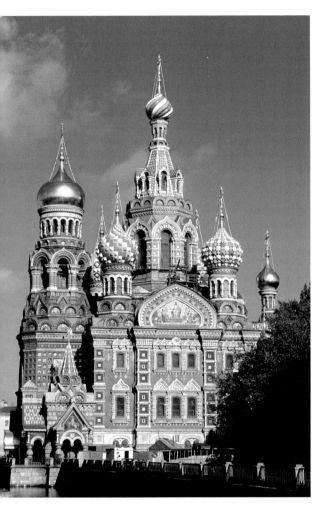

CATHEDRAL OF THE RESURRECTION
Alfred Alexandrovich Parland, 1883, St Petersburg, Russia

Built on the site of the assassination of Tsar Alexander II, this building
is frequently called "the Church on Spilt Blood" and deliberately
employs the Russian Revival style as an evocation of past times
(see pages 202–205). The building was looted after the revolution,
"upgraded" from church to cathedral in 1923 and closed in 1932.
Damaged during the Second World War, the cathedral was used first as
a warehouse and then as a museum, only reopening for worship in 1997.

St Martin-in-the-Fields is part of the Church of England,
the mother Church of the worldwide Anglican Communion,
one of the major traditions within Christianity. The Church
of England is a branch of the "Western" or "Catholic"
Church, whose final separation from the Eastern Orthodox
Church (to which the Cathedral of the Resurrection
belongs) is generally dated to the Great Schism of 1054. The
Western Church has also fragmented, most notably during
the Reformation in the sixteenth century when Protestants
(loosely defined, because there are many denominations)
broke away from the Roman Catholic Church, repudiating
the authority of the pope. Although the definitions, and
names, of the three main branches of Christianity are open
to debate, for simplicity's sake the terms used in this book are
"Orthodox", "Protestant" and "Roman Catholic".

The House of God

For all three Christian traditions, the church building is
important in different ways. This is expressed succinctly
in a relief built into the wall of Florence Cathedral
(see illustration, right). The sculpture represents the
Annunciation, the point in the biblical narrative when
Gabriel announces to the Virgin Mary that she is to become
the Mother of God. Between the two there is a canopy, or
tabernacle, which contains the words of Gabriel's greeting,
"Ave Gratia Plena" ("Hail, full of Grace"), referring to Mary
and her state of perfection. On the roof of the tabernacle
is carved the hand of God, represented thus in accordance
with several biblical references. For example, the Book of
Psalms (48.10) includes the statement "Thy right hand is full
of righteousness". Below this, a dove flies into the tabernacle.
When told of the forthcoming birth Mary enquires how it
is possible, because she is a virgin, and Gabriel explains it
will occur through the agency of the Holy Spirit, represented
most frequently in Christian art as a dove – so in the sculpture
the Holy Spirit has entered the tabernacle in the same way
that it will enter Mary. The tabernacle contains the words
"full of grace" and thus is figuratively "full of grace" itself, as

◯ THE ANNUNCIATION
12TH CENTURY, FLORENCE CATHEDRAL, ITALY

This relief is considerably older than the south wall in which it is embedded, having been removed from the earlier cathedral and reused: the rounded forms of the drapery identify it stylistically as Romanesque, whereas the building itself is Gothic, and was not started until 1296. Between Archangel Gabriel and Mary is a prominently displayed canopied structure, or tabernacle, that contains Gabriel's words in Latin, which translate as "Hail, full of Grace". The hand of God, appearing on the cupola of the central structure, and the dove of the Holy Spirit entering into it, represent the incarnation of Christ in architectural terms (and equates the building with Mary).

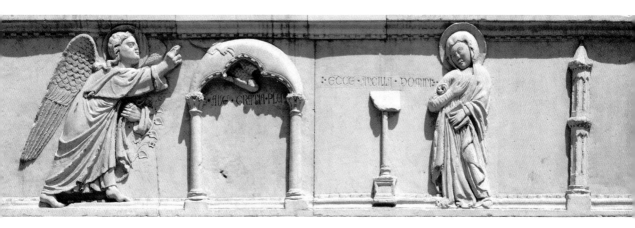

WHAT'S IN A NAME? CHRISTIAN PLACES OF WORSHIP

There are many types of building used for Christian worship. All constitute part of "the Church", but differences in function mean that they have different names. These are the most common:

ABBEY – a religious community, or house, of monks or nuns presided over by an abbot or abbess. The name can be retained even when the religious community has gone, as is the case in Westminster Abbey.

BAPTISTERY – a building, separate from the main body of the church, or a structure within the church, which is dedicated to baptism.

BASILICA – the name originally given to a king's audience chamber, from the Greek *basileos* or "king". The Roman form of basilica – a long central nave with two side aisles, but no transept – was adopted for some early Christian churches, and now the word refers either to churches with this structure, or to certain Roman Catholic churches granted specific privileges by the pope.

CATHEDRAL – a church containing a *cathedra*, or bishop's throne.

CHAPEL – originally a separate room in which relics were preserved, a chapel can be a separate space adjoining a church. The latter tradition arose to increase the possibilities of worship, because early churches were only supposed to include one altar and have one mass per day. It can also be a place for worship in an essentially private institution, or which does not have regular services, or display the consecrated host. It is applied to some Protestant churches as a way of distancing them from what Protestants might see as the ritualistic excess of Roman Catholicism.

CHURCH – a place of Christian worship or a community of Christians who worship together.

CONVENT – a group of people, monks or nuns, who live together, or the building in which they live. In English it refers specifically to female institutions, but this is not necessarily the case in other languages.

MINSTER – originally the church of a monastery, or a house of secular canons (clergy who, unlike monks, did not follow a set "Rule"), "minster" could be applied to a large church or cathedral without monastic connections.

MONASTERY – a place where monks or nuns retire from the world for prayer and contemplation.

PRIORY – a religious house presided over by a prior or prioress, who could be independent, or subordinate to an abbot or abbess in another house.

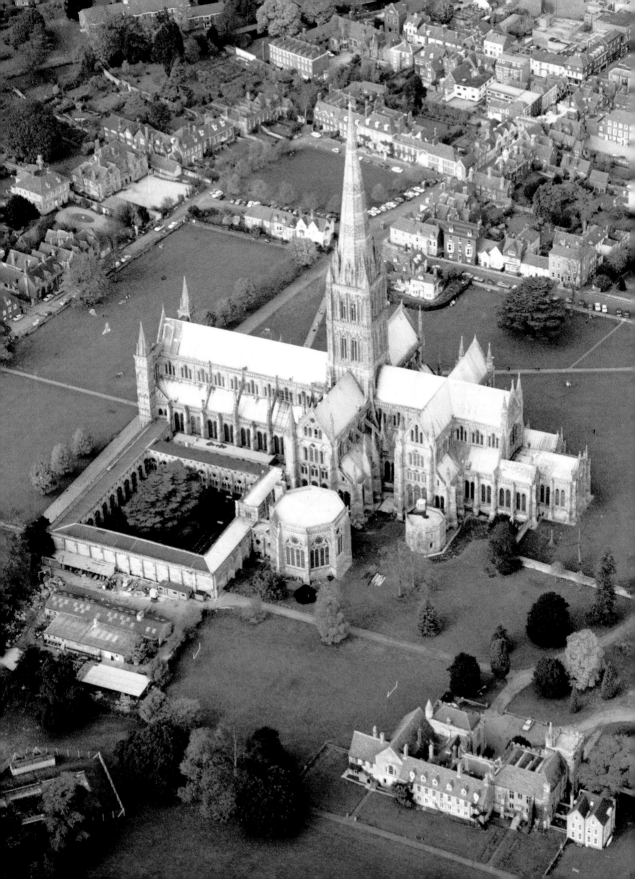

is Mary. In this way we see that Mary and the tabernacle – an image of the Church – are one and the same. If the Church is the "house of God", then so was Mary (who housed Jesus in her womb). This relief explains not only the significance of the Virgin, but also the importance, holiness and essential grace of the Church itself. Indeed, Mary was often associated with Ecclesia, a personification of the Church (see page 106).

To cover all of these aspects – of structure, of meaning, of faith and of history – in one book is impossible. We will therefore explore more general ideas in the hope that they will enable the reader to understand what he or she sees in the vast majority of the world's churches, and to be able to interpret the relevance of the different aspects of the holy buildings visited. The book has three sections, effectively representing object, subject and style. An exploration of the physical structure of a church, describing the different elements of a church's building and contents, is followed by an assessment of the variety of subjects which can be represented on and in the fabric of the church. The last section reveals how these objects and subjects vary across history, and how the styles of construction and representation develop with the evolution of beliefs and of the forms of worship.

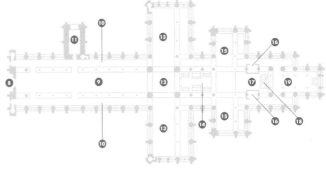

◐ SALISBURY CATHEDRAL

1220–1320, SALISBURY, ENGLAND

In 1219 a procession returning to the cathedral in Old Sarum, the original settlement of Salisbury, was barred entry to the city and the bishop decided that the best way to avoid this problem recurring was to build a new cathedral nearby, but outside the old city walls. The construction took less than forty years to complete. The west front was added by 1265, and the cloisters and chapter house were completed by about 1580. The tower and steeple were constructed on top of the original, very short, lantern tower and finished in 1320: at 123m (404ft) Salisbury has the tallest spire in the United Kingdom.

CHURCHES – PLACES OF CONSTANCY AND CHANGE

Just as every church has a different history, each will have its own peculiarities and differences in structure and arrangement. However, these are all variations on a theme and the words used to describe different parts of the church building and their functions are more or less constant and universal. The main body of Salisbury Cathedral was built in a relatively brief period of time – less than forty years – and is remarkably consistent stylistically. However, the interior arrangement has been adjusted several times due to modifications in the forms of worship (see pages 178–183) as well as changes in taste (see page 206). Nevertheless, the integrity of its external structure means that it functions as a good model for comparison with other churches.

1	Spire	8	West front	14 Choir
2	Tower	9	Nave	15 Choir transepts
3	Chapter house	10	North and south aisles	16 Chantry
4	Cloisters	11	North porch	17 Presbytery
5	Double transepts	12	Crossing	18 Altar
6	Clerestory	13	North and south	19 Lady chapel
7	Sacristy		transepts	

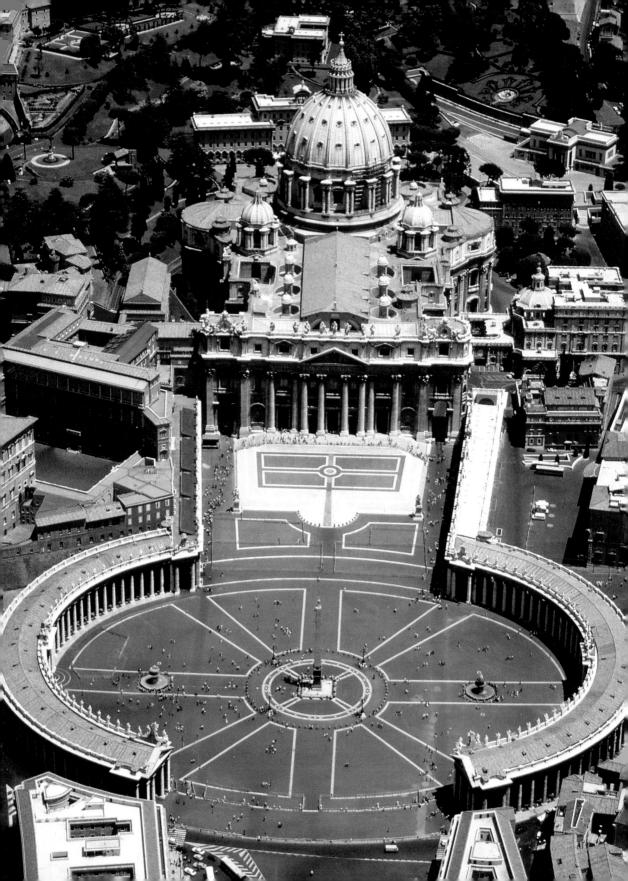

OUTSIDE
& IN

PART ONE

———————○———————

Regular visitors to churches, who are used to their art and architecture, may find much of what can be seen there not only familiar but perhaps obvious, whereas those for whom the experience is comparatively new may find it hard to pick out precisely what is relevant or important. The likelihood is that members of each group will always find something new, because every element of a church or cathedral has a reason to exist. This "thing" may be structural – to do with the physical nature of the building – or it may relate to its Christian symbolism. However, it is important to remember that the former follows on from the latter: the structure of the building is related to its function, and in itself is used to convey meaning. Thus each physical element of a church – its external construction and its interior "furniture" and decoration – has both a practical and a theological explanation. In this section we will consider these "physical" elements of the church – the different "things" which you would see when visiting – starting from the outside and then going in. This virtual tour must, of course, be generic, as every church is different, but the focus is on the features which are most relevant in a wide range of buildings of different periods and from divergent branches of Christianity.

◖ ST PETER'S BASILICA
1506–1667, ROME, ITALY

Like many churches, St Peter's in Rome has undergone a long evolution. Emperor Constantine built the first church in the 4th century to mark the site where St Peter was believed to have been buried. The present structure was started in 1506 by Bramante, and continued by Michelangelo (among others). The colonnades in front of the basilica, added by Bernini in 1667, were conceived as arms embracing the piazza and welcoming the faithful.

LOOKING UP TO GOD

Often the first thing you see of a church is not the main body of the building but the structures which project from it – towers, steeples and domes. This is intentional. In part, these structures advertise the presence of the church, and remind the faithful not only where they should go to worship, but also that they should worship. Religious observance was not restricted to the Sunday services: worship was considered part of everyday life. The highly visible towers, steeples and domes prompted people to remember their religious obligations. If this seems threatening, that is also part of their function: if you can see the church, then the church – and God – can see you. However, it also implies that you are safe within the protection of the church. When the Italian artist and scholar Leon Battista Alberti wrote his influential book *On Painting* in the mid-1430s, he praised the architect Filippo Brunelleschi, whose engineering skill had enabled the completion of the dome of Florence Cathedral. Alberti described the dome as, "such a large structure, rising above the skies, ample to cover with its shadow all the Tuscan people". The image is one of protection, not unlike the Madonna of Mercy, in which Mary protects those who shelter beneath her mantel.

In modern cities, with their tower blocks and skyscrapers, churches are less and less dominant in the skyline, but those

◯ LINCOLN CATHEDRAL
11TH–14TH CENTURIES, LINCOLN, ENGLAND

The imposing towers of Lincoln Cathedral were once all topped with wooden spires. The one on the main tower reached a height of 160m (524ft) and was the tallest in Europe, until it was brought down by a storm in 1548. The less imposing spires on the two west towers survived until 1807, when they were removed for reasons of safety.

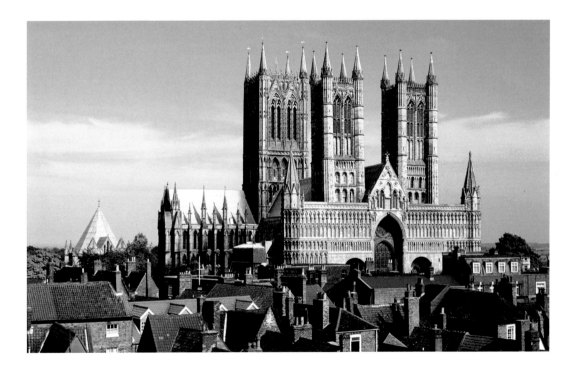

◉ STEEPLE OF ST PETER'S CHURCH
14TH CENTURY, ZURICH, SWITZERLAND

The civic functions of the steeple of St Peter's church in Zurich are almost as important as its religious symbolism, pointing up to God. The clock, with a diameter of 8.7m (28.5ft), is said to be the largest church clock face in Europe, and is clearly visible across the city. The weather vane is painted white and blue – the city colours of Zurich – and the oriel windows, projecting at the base of the spire, were used for fire-watching as late as 1911. Unlike many European cities, Zurich has never suffered a major fire – and perhaps because of this successful record the tower of the church is now the property of the city of Zurich, whereas the nave, which was rebuilt in the early 18th century, still belongs to the Swiss Reformed Church (see illustration, page 199).

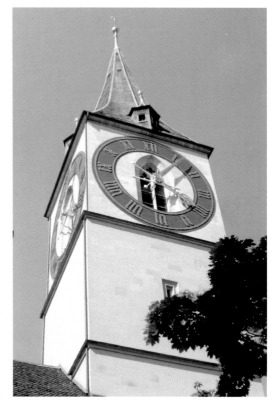

built in the centre of medieval cities (and frequently atop a hill, as Lincoln Cathedral is) tower above the surrounding buildings. To this day the churches can be the first things that one sees on approaching an old town or city. This protective aspect, watching over the citizens, would be evident to travellers returning home, or arriving at the city for the first time, while the church's dominance would also function as a warning to approaching armies. The presence of numerous towers and steeples would remind any visitor whose intention was not benign that they were in a holy place, protected by God. In addition to these messages, churches were difficult and expensive to build. Thus, in addition to advertising the city's sanctity, a large number of churches would have advertised the city's wealth, its engineering prowess, and, almost certainly, its power. The height and number of a city's towers and spires are therefore a measure of its holiness, its wealth and its strength – both morally, and, by implication, militarily.

Towers, spires and steeples

Another function of a church tower is to contain the bells, which became a regular feature of worship from the sixth century onward. The bells told people the time of day, in conjunction with the clocks, which are a regular, though not universal, feature of church towers. Bell-ringing also announces the times of services, as they can be rung shortly before worship begins. Celebrations, whether personal, civic or national, are also marked with a peal of bells – or the bells might be tolled in mourning as a sign of respect for the dead, or rung as a warning in times of danger, such as the threat of invasion or fire.

A spire – the tall, narrow, conical structure whose base is usually round, square or octagonal – on the other hand does not have any practical function. Spires and steeples (the combination of a spire and a tower) are effectively aspirational structures which draw our attention upward, toward the heavens and so, of course, to God. Either structure can carry symbolic elements, such as a cross, and also frequently include weathervanes, which have a civic function (telling people the wind direction) as well as a religious one (reminding of God's presence in all directions, and of the extent of his creation).

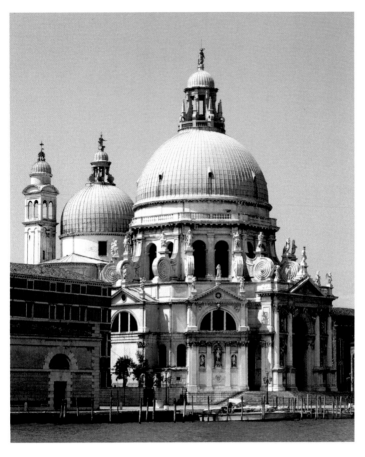

◯ SANTA MARIA DELLA SALUTE
Baldassare Longhena, 1631–1681, VENICE,
ITALY

Two of the requirements of the competition
to decide which architect should build this
church were that it should make a good
impression without costing too much,
and that the interior should have an even
distribution of bright light. Longhena
achieved the former by building most of the
structure with brick (only the architectural
details, sculptures and façades are stone),
and the latter was resolved by buttressing the
dome with the large spiral volutes. Rather
than being unnecessary baroque decoration,
the volutes allow the drum underneath the
dome to be pierced by large windows, thus
letting light flood in throughout the building.

They also prompt us to remember that whichever way the
wind blows, we should not be driven "off course" but should
stick to the true path that leads to salvation, even if we are
victims of "Fortune" (see page 35).

Domes

The use of domes goes back to classical antiquity, the most
notable surviving example being the Pantheon in Rome, a
temple to all the gods built in AD125 for Emperor Hadrian.
It is not certain how the interior of the dome was originally
decorated, but one suggestion is that it was painted blue,
with stars picked out in gold in imitation of the night sky.
For Christians the dome has the same meaning, representing
the vault of heaven coming down to Earth (see "Sacred
Geometry", pages 104–107). The first and most striking dome
of Christendom was constructed for Emperor Justinian at the
church of Holy Wisdom (Hagia Sophia) in Constantinople
(modern-day Istanbul), which was completed in 537 (the
current dome, soaring above the nave and admitting streams
of heavenly light, is a later replacement – see page 136). The
idea that the dome is an image of heaven is made explicit
in the decoration of Santa Maria dei Miracoli, Saronno (see
illustration, page 89), which includes representations of God
and the heavenly host looking down from on high.

From outside we see this heavenly form resting on the
church, its shape as near to a hemisphere as the architect
could achieve, reminiscent of the perfectly spherical heavens
which surrounded the Earth in early cosmologies. The dome
effectively crowns the church, which is particularly relevant
in churches dedicated to the Virgin Mary, who is believed

by Roman Catholics to be the Queen of Heaven. When he came to explain the shape of Santa Maria della Salute in Venice, the architect Baldassare Longhena said, "The mystery contained in its dedication to the Blessed Virgin made me think . . . of building it in a circular form, that is to say in the shape of a crown to be dedicated to the Virgin".

Keeping it up

Although today we have a surprisingly large number of churches and cathedrals, particularly in the medieval centres of European cities, these represent only a fraction of the numbers built in the first two millennia of Christian history. Many have been lost through poor construction, neglect, deliberate destruction (politically or religiously inspired), or have become redundant and perhaps assigned other uses.

⊙ GARGOYLE
16TH CENTURY, MILAN CATHEDRAL, ITALY

If the walls and roof of a church are designed to contain and protect its contents – whether that be the congregation, the fixtures and fittings, or more importantly the treasures and relics – one of their most important functions is to keep rain out. Although churches were invariably built with pitched roofs that the rain would simply run off, water running down the walls could result in damage. Consequently, rainwater was funnelled through spouts designed to take it away from the walls so that it fell directly onto the ground. These spouts were decorated with stone sculpture, very often in the form of a grotesque creature with the water coming out of its mouth. These spouts are called gargoyles, from an old French word *gargouille* meaning "throat" (it is related to the English words "gargling" and "gurgling"). Other forms of grotesque sculpture used to decorate churches are commonly referred to as "gargoyles" (see pages 116–117) but, strictly speaking, they are not, because they have no practical function.

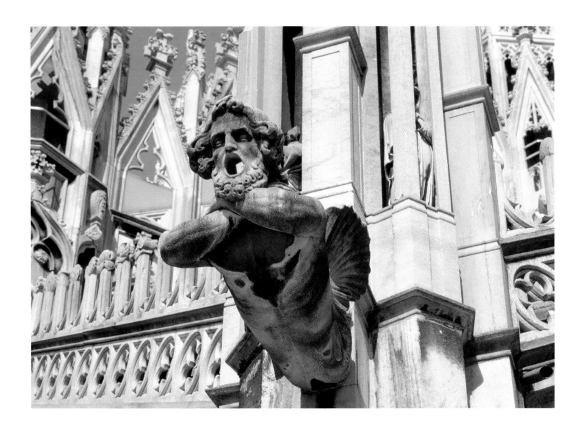

Of those built well enough to have survived, there are relatively few which have not been expanded, rebuilt or altered after their initial construction.

The building materials can be wooden, brick, concrete or flint. Most in this book are built of stone, although many, like Santa Maria della Salute (see illustration, page 16), are basically brick structures which use stone for the major architectural features and the main façade. If there was no local source of stone it could be delivered if there was sufficient money. The stone used for St Paul's Cathedral in London (see illustrations, pages 196–197) came from Portland in southwest England, whereas the Normans who began Norwich Cathedral (see pages 32–33 and 124–125) preferred to import stone from Caen, in their native France. The materials could affect the structure: church towers tend to be round in places where there is little or no stone available, because stone is used to strengthen the corners. (It was also suggested that the round shape was safer, as the devil couldn't hide in the corners.)

As well as enclosing the church, the walls also need to support the roof. With early churches the tendency was to make the walls thick and solid, although the introduction of different forms of buttress meant that the building did not need to be so substantial. In addition to supporting weight, the walls could also "carry" meaning: even before heading inside, the decoration of the main façade can often tell us a lot about the dedication of the church, while the structure of the façade can hint at the building's internal layout, the cathedral at Orvieto (overleaf) providing a prime example.

◐ CHARTRES CATHEDRAL
13TH CENTURY, CHARTRES, FRANCE

Flying buttresses are a feature of many Gothic buildings. The buttresses can be especially dramatic in France, where they frequently surround the apse of a church and add to the impression of both height and delicacy. Around the apse is an ambulatory – a processional route – from which chapels radiate, and the two tiers of buttresses visible here transfer the weight of the roof and vault down to the exterior walls of these radiating chapels, and to the walls that divide them.

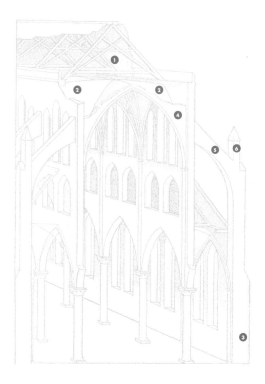

STRONGER & HIGHER

Even though the roof of a church – labelled ❶ in the diagram above – was often relatively light, and made out of wood, the vault ❷ could be made out of stone, and so the church's walls were often remarkably thick, with the windows remaining small. However, the walls could also be strengthened with buttresses, (labelled ❸ above, and visible at the bottom of the walls in the photograph, opposite). The buttresses add weight and width to the wall, and counteract the outward push of the roof, caused by the weight of the vault pressing down on the ribs ❹. As the church builders became more skilled, they became more daring, and realized that buttresses further out from the roof would be better at containing the outward thrust, as they were effectively leaning into the building. This resulted in the invention of "flying" buttresses ❺, so-called because they have space underneath them. This open structure transfers the weight of the roof down to the ground in much the same manner as an arch: indeed, each flying buttress is effectively half an arch. The buttresses allowed the builders to make structures that were both stronger and higher. With the buttresses bearing the weight of the roof, the walls were relieved of their supporting function and windows could become far larger. Pinnacles, such as the one labelled ❻, may appear to be purely decorative, but in fact they provide much needed weight, effectively helping to "pin" the buttresses to the ground and making them more stable.

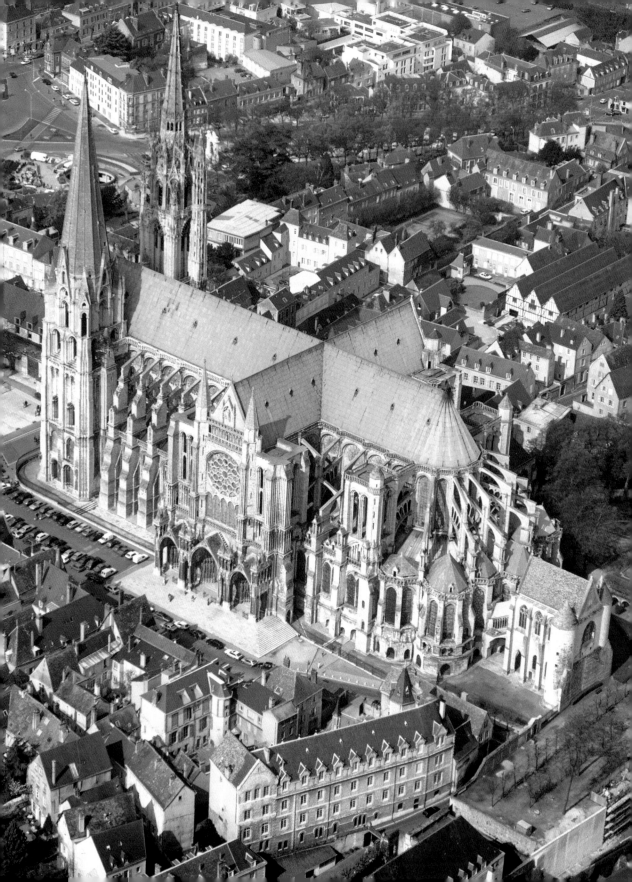

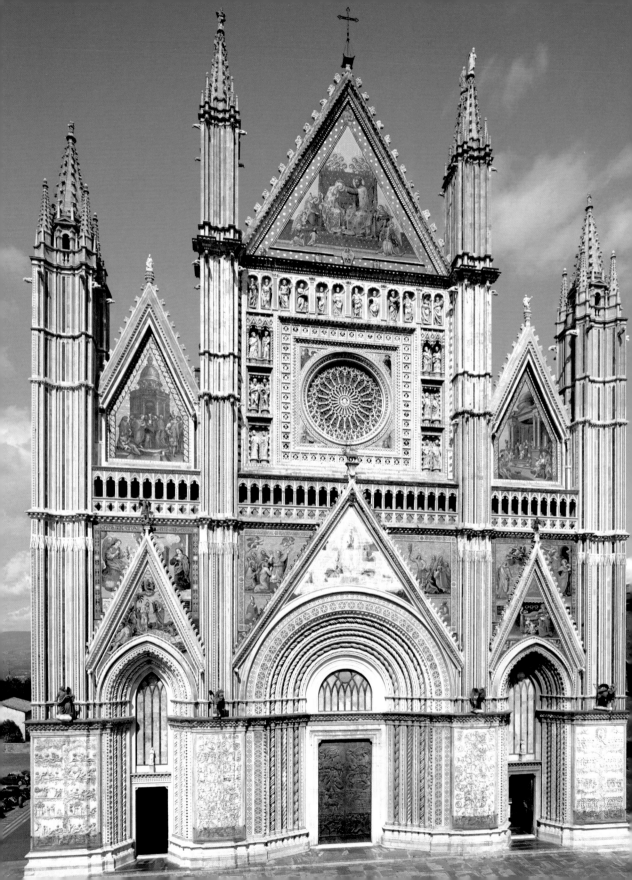

FAÇADE OF ORVIETO CATHEDRAL

Lorenzo Maitani and others, 1310–1970, ORVIETO, ITALY

Lorenzo Maitani not only designed the structure of the façade, but was also responsible for the relief carvings which flank the three doors, illustrating stories from Genesis to the Last Judgment. The doors themselves, made by the Sicilian sculptor Emilio Greco and installed in 1970, represent scenes from the life of Christ. The façade is a good example of how much we can learn about a church from outside.

Its tripartite structure reflects the interior layout: a central nave with two side aisles, each of which has a door at the west end. And as the cathedral is dedicated to the Virgin Mary the majority of the mosaic decoration relates to her life, as told in the *Protevangelium of St James*, and, later, *The Golden Legend*. There was once a sculpture of the Virgin and Child above the main door, now removed for conservation.

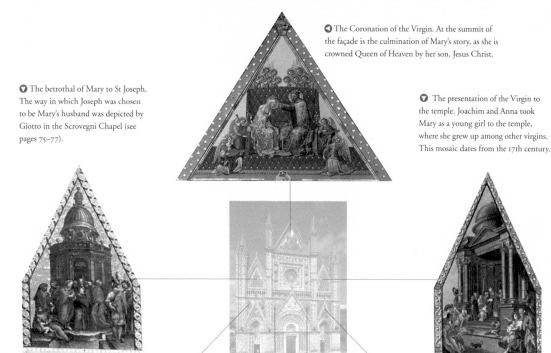

◐ The Coronation of the Virgin. At the summit of the façade is the culmination of Mary's story, as she is crowned Queen of Heaven by her son, Jesus Christ.

◐ The betrothal of Mary to St Joseph. The way in which Joseph was chosen to be Mary's husband was depicted by Giotto in the Scrovegni Chapel (see pages 75–77).

◐ The presentation of the Virgin to the temple. Joachim and Anna took Mary as a young girl to the temple, where she grew up among other virgins. This mosaic dates from the 17th century.

◐ On either side of the main door, the apostles watch in amazement as the Virgin's body is carried up into heaven by angels. (The central scene of the Assumption was in need of restoration when this photograph was taken, and papers have been stuck onto the mosaic to stop the tesserae from falling off.)

◐ The Annunciation of Christ's birth (Gabriel on the left, Mary on the right) is opposite two scenes showing Mary's birth. Mary being washed echoes the baptism of Christ (just below the Annunciation).

◐ The Birth of the Virgin: St Anna lies in bed, while midwives wash the newborn. The birth is announced to Mary's parents Joachim and Anna in the spandrels above this mosaic to the left and right respectively.

HEADING INSIDE

"I am the door: by me if any man enter in, he shall be saved."
John 10.9

The words of Jesus reported in John's gospel remind us that any object – or for that matter any part of a building – can have symbolic meaning. The doors to a church are not just a physical entrance: they also function spiritually as part of the path toward redemption. If the church is seen as an image of "heaven on Earth", as for many it was and is, then the doors of the church are an image of the "gates of heaven" and can be decorated accordingly.

The west end

If a church is traditionally orientated, the main door is at the west (in many cases this door is only used for the most important occasions and ceremonies). As a result, the west end of the church has the main façade, which is often the most decorated. In examples such as Lincoln Cathedral (see illustration, page 14) the façade is extended on either side, far beyond the width of the nave, to magnify the cathedral's size and scale, creating a sense of enormous grandeur.

In many respects the façade is a form of screen in front of the church, similar to the screens which many churches have in front of the chancel or presbytery (see pages 51–53). And in the same manner this "screen" can be richly decorated with sculptures, preparing the worshipper for the message of the Bible that will be experienced within. The façade can also express the interior form of the church, as it does in both Orvieto and Pisa cathedrals (preceding page and page 154). Like Orvieto, Pisa has a tripartite structure, with a high central section and lower sections symmetrically on either side. This is repeated in the doors, the central one being larger than the two that flank it. This tells us that the interior of the church has a large central nave and two smaller side aisles.

Sculptural decoration varies in complexity, but regularly it tells us about the church, and especially its dedication. For example, the façade of St Paul's Cathedral in London (see illustration, page 197) includes a relief of the conversion of Paul on the road to Damascus in the pediment located above the west door. In other examples the decoration reminds us from the outside all the lessons that are to be learned within. These frequently include images of the Last Judgment, in which the faithful are shown entering the "gates of paradise" at the end of time, the door to heaven being shown directly above the door to the church: a reminder not only to enter the church, but also to lead a righteous life when not there.

In some churches the decorative scheme can extend around the whole building, as it does in Chartres (see page 19). The north, south and west portals of the cathedral combine to tell stories and depict figures from the Old Testament to the New Testament, and from the birth of Christ, through his ascension into heaven, to the death and assumption of the Virgin and beyond, including stories of the saints and eventually the Last Judgment. If not on sculptures set around the doors, stories can be told on the doors themselves. Bronze doors were favoured in the Roman Empire for the impression they gave of wealth and splendour, and this taste continued through the Byzantine church and the Renaissance era up to the present day.

Transitional spaces

The doors themselves may not give direct entry into the church. Some buildings have a narthex, a transitional space

○ **PÓRTICO DA GLORIA**
"Master Mateo", 1168–1188, SANTIAGO DE COMPOSTELA, SPAIN

Among the carvings in the tympanum, pride of place is given to Christ. Saint James ("Santiago" in Spanish) is directly below, on the trumeau, the pillar that divides the church doorway.

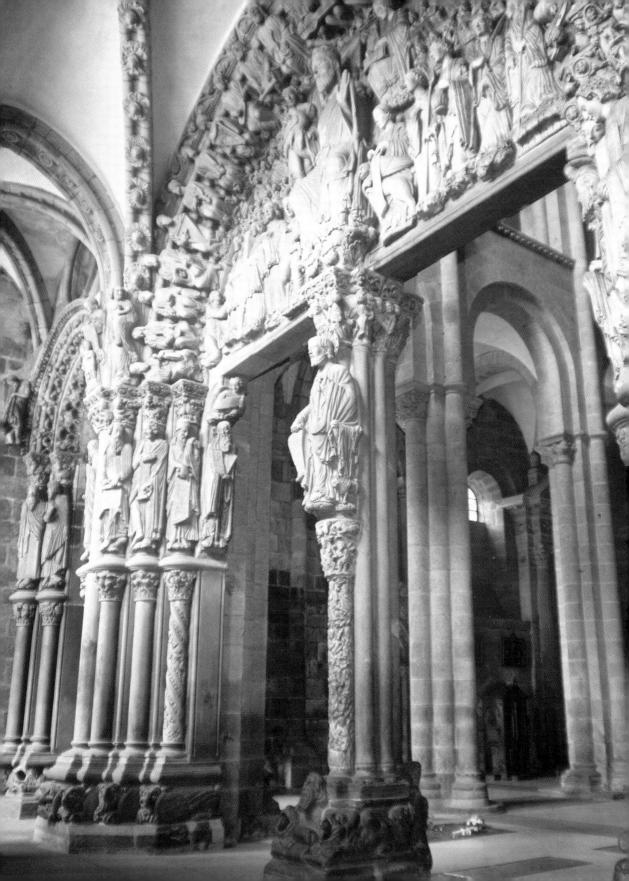

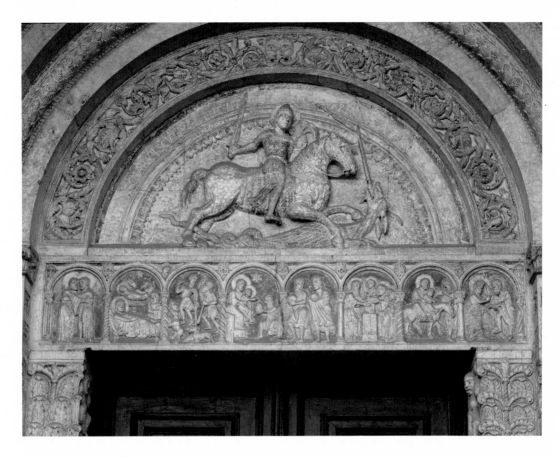

○ WEST DOOR OF THE CATHEDRAL OF ST GEORGE
"Niccolò", 1135, Ferrara, Italy

An inscription around the tympanum tells us that this is the work of the sculptor Niccolò, and it appears to date the sculpture to 1135. However, this date could also refer either to the start of the building or to its completion and dedication.

1 **Tympanum (the semicircular area between the lintel and the arch):**
The image of the legendary killing of a dragon tells us that the cathedral is dedicated to St George. Ferrara's first cathedral was far smaller, and outside what is now the city centre. A new and far larger building was constructed to house relics of St George that had arrived in Ferrara shortly before.

Lintel (the stone "beam" above the doorway):

2 **The Visitation** – after the Annunciation Mary visits her cousin Elizabeth, who is also expecting a child: John the Baptist.

3 **The Nativity** – the birth of Jesus.

4 **The Annunciation to the Shepherds** – an angel (in the spandrel above left of this scene) tells the shepherds about the birth of Jesus.

5 **The Adoration of the Magi** – having followed the star (above Jesus' head) the three wise men pay him homage: the first is kneeling in the same section as Jesus and Mary, the other two follow on in the adjacent section.

6 **The Presentation at the Temple** – Jesus is presented at the temple in accordance with Jewish law, and is recognized as the Messiah by the high priest Simeon.

7 **The Flight into Egypt** – warned by an angel (who appears in the spandrel above right of the scene) of the approach of Herod's soldiers, Joseph leads Mary and Jesus to safety in Egypt.

8 **The Baptism of Christ** – John, the son of Mary's cousin Elizabeth (seen in the Visitation), baptizes Jesus in preparation for the beginning of his ministry.

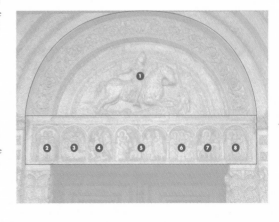

which, in some early churches, was reserved for recent converts to Christianity ("neophytes"), who, before baptism, were not allowed into the full body of the church. The word narthex is still used, although the area denoted no longer has the same function. The space can be a small, enclosed one, darker than the church itself, encouraging the faithful to move forward into the light – that is, to God's truth – although it can also be an area at the back of the church divided from the nave by a row of columns.

Other churches have a "Galilee chapel". The name is biblical and there are two suggestions as to its origin. At the Resurrection the disciples are told that Jesus "goeth before you into Galilee: there shall ye see him" (Mark 16.7). The chapel was part of the route of processions during Sunday services, and by entering the church through the "Galilee"

it became explicit that the participants were coming into the presence of the resurrected Christ. Alternatively, as the procession was part of the mass, it represented Jesus' journey from Galilee to Jerusalem prior to being crucified.

The Galilee chapel is not unlike a porch, which was an important feature of most English parish churches. As a transitional area between the church and the secular world, the porch was often used for secular business: contracts made there were not only legally binding, they had been conducted in the sight of God and thus even less likely to be broken. At different periods in history baptism and marriage have taken place in the porch, each representing a form of entry into a new phase of life. A church porch still has an administrative function, being one of the most common places to find the notice board giving news of activities within the parish.

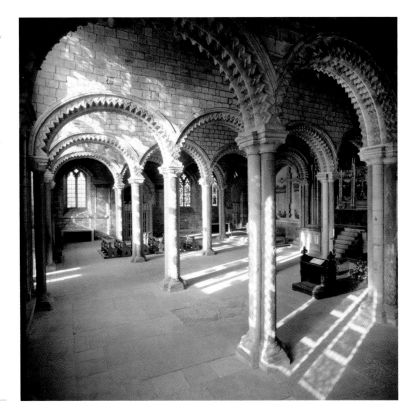

◐ GALILEE CHAPEL
1170–1175, DURHAM CATHEDRAL, ENGLAND

Durham Cathedral is unique in having a Galilee chapel that doubles as the Lady chapel – a chapel dedicated to the Virgin Mary, which in English cathedrals is often behind the High Altar. Although Romanesque architecture would most commonly be described as "solid", "massive" or "monumental", here the echoing arches convey a surprising sense – given the period – of elegance and delicacy.

FROM FLOOR TO CEILING

A church interior can vary from intimate to overwhelming, from subdued to exuberant, and from dark to light – each in its way a different expression of holiness and spirituality. Every element of a church – its building, its decoration and its contents, from floor to ceiling – will contribute to this initial impact.

Beneath your feet

Even if the floor is not necessarily the first part of a church you will notice, it frequently includes elements of fundamental relevance. The dead have long been buried in churches, and so the floor often includes tomb markers, or slabs, which could be lifted to allow access to burial vaults beneath the church. Although these markers were made of stone, richer families often embellished theirs with bronze,

and such "brasses" were especially popular in medieval England. However, burial within the church has not always been popular. Among others, Napoleon Bonaparte did not approve and he encouraged the building of communal cemeteries on the edges of towns. Because, for a while, Napoleon's domain was extensive, these cemeteries are a common sight across Europe. Nevertheless, in some churches the practice continues to this day, and it is also not unusual to include memorial slabs, in remembrance of the deceased, in a church even if they do not mark the site of a burial.

A church floor might include inlaid depictions of stories from the Bible, although most are decorated with simple patterns, either with stone or ceramic tiles. These narrative scenes or patterns can be in mosaic, made up of small square tesserae, or larger, geometrically shaped pieces of stone of

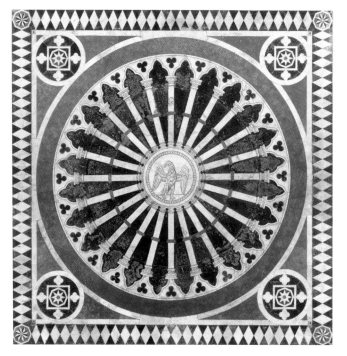

◀ SIENA CATHEDRAL FLOOR
14TH CENTURY, SIENA, ITALY

The floor of Siena Cathedral is inlaid with different coloured stones and incised with linear engravings called *sgraffito*. The decoration includes biblical narratives, saints and sibyls, as well as sections like this which appear to be purely ornamental. Although the central eagle could be the symbol of St John the Evangelist, it is in fact a reference to Siena's allegiance to the Holy Roman Emperor.

▶ CHARTRES CATHEDRAL
13TH CENTURY, CHARTRES, FRANCE

From floor to ceiling the interior of a church reminds us of God's message. Whether it is the labyrinth inlaid into the floor (a symbol that the virtuous life is not necessarily straightforward), the aspirational height of the vaulted ceiling or the heavenly blue of the stained glass windows, our physical movement through the building brings us spiritually closer to God.

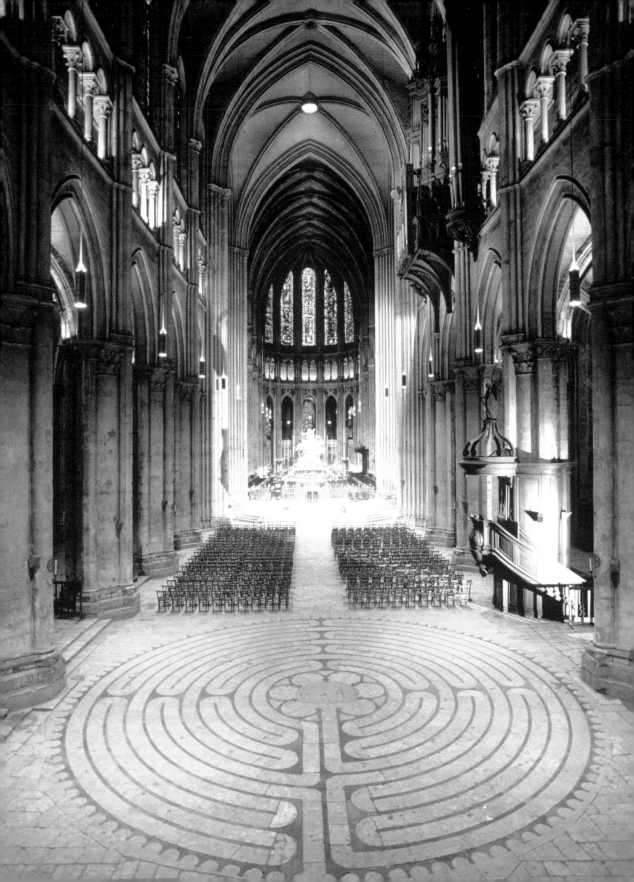

different colours. The latter are often referred to as "cosmati pavements", said to be named for the Cosmati family who worked in Rome in the twelfth and thirteenth centuries, although the derivation may owe more to the type of work that they did. One of the standard patterns included in such pavements can be interpreted as the structure of the universe, or cosmos – hence "cosmati" for the family and "cosmatesque" for the type of work they did. Examples are common in Italy, but there are few north of the Alps – the most important exception is in Westminster Abbey in London.

This sense of the floor as a ground plan of the universe gives rise to other more metaphorical forms of "mapping", a notable example being the maze or labyrinth set into some church floors, including that at Chartres Cathedral. Unlike modern mazes it is not possible to get lost – there are no dead ends. The twisting, turning path at Chartres represents our journey through life, and inevitably it leads to God at the centre. The route can be followed on foot as an act of devotion, although especially committed Christians would perform this task on their knees as an act of penance, the physical discomfort which it entails expressing an acknowledgement of their sins. Processions through the church, or the observation of the Stations of the Cross (see pages 48–49), could fulfil a similar function.

Heavenly vaults

Ceilings can also take on an instructive or inspirational function. Like domes, ceilings can represent the vault of heaven, and sometimes they are painted blue and decorated with gold stars to resemble the sky. Ceilings can also be decorated with geometric patterns, depictions of holy characters, narrative, and even subjects of an apparently secular nature – the wooden ceiling of St Machar's in Aberdeen being an interesting example (see illustration, opposite).

Ceilings have a variety of forms. It is relatively unusual that they are flat: even a wooden ceiling is more likely to be arched in imitation of vaulted stone ceilings (St Machar's, Aberdeen, and St Michael's, Hildesheim, are two notable exceptions). Other forms of ceiling were developed in order to distribute the weight of the roof above. That of St Edmund's, Southwold (see illustration, page 41) is known as a hammerbeam roof: the beams project horizontally from the top of the wall and are supported underneath by brackets.

continued on page 32

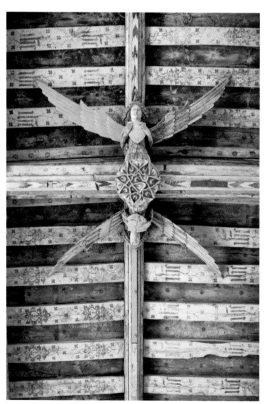

◗ ANGEL ROOF
15TH CENTURY, HOLY TRINITY CHURCH, BLYTHBURGH, ENGLAND

Angel roofs were particularly common in East Anglia, England, and they survive in a number of different forms. Whereas the angels in St Edmund's Church, Southwold (see illustration, page 41), project from the hammerbeams in the roof, at the nearby Holy Trinity Church in Blythburgh the angels decorate the central ridge and project instead from bosses whose swirls are a medieval stylization of clouds. Each angel holds a shield that would originally have shown the coat of arms of one of the patrons.

● CATHEDRAL CHURCH OF ST MACHAR

14TH–15TH CENTURIES (CEILING: *James Winter*, 1519–1521), ABERDEEN, SCOTLAND

"The princes of the people are gathered together . . . for the shields of the earth belong unto God" Psalm 47.9

As well as being one of only two surviving medieval wooden ceilings in Scotland, the decoration of the ceiling of St Machar's, Aberdeen, is unique. Whereas most roof bosses inside churches tell religious stories, here there are forty-eight shields depicting coats of arms. The central row represents members of the Church, starting at the east end with Pope Leo X, whose papacy ran from 1513 to 1521. After the pope come the arms of the archbishops and bishops of the Church in Scotland. On the south side (on the right of the picture) are the shields of King James V and the nobility of Scotland, whereas on the north are those of the Holy Roman Emperor Charles V and the kings of Christendom, starting with France and Spain, and then, fourth in line, King Henry VIII of England. The enclosed arch at the east wall originally opened onto the crossing of the cathedral underneath its tower, from which extended the transepts and choir. During the Civil War Royalist soldiers removed some exterior stonework, and this eventually led to the collapse of the central tower in 1688. The coats of arms imply that the worldly powers, both Church and state, are united to pay homage to Christ: the arms of Pope Leo X would have been just in front of the Crucifixion on the *pulpitum*. It is fascinating to think that in 1521, while this ceiling was being installed, Pope Leo X not only excommunicated Martin Luther but also awarded King Henry VIII the title "Defender of the Faith". Whereas King Henry VIII's England had broken from Rome by 1535, the Scottish Reformation did not occur until a formal break with the papacy in 1560.

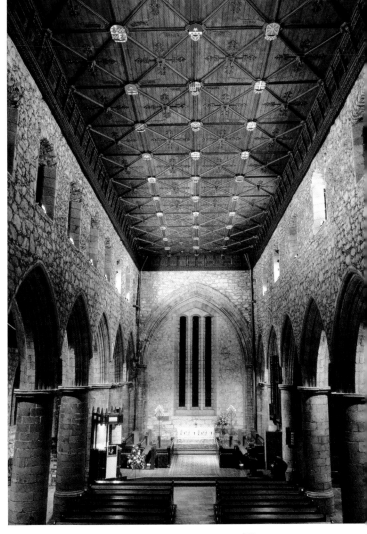

The Emperor
(Charles V)

The Pope
(Leo X)

The King of Scots
(James V)

THE TREE OF JESSE

C.1230, St Michael's, Hildesheim, Germany

The Tree of Jesse is one of the most commonly depicted Old Testament prophecies in Christian art, and is derived from the book of Isaiah (11.1): "And there shall come forth a rod out of the stem of Jesse, and a branch shall grow out of his roots." The interpretation of this verse, that one of Jesse's descendents would be the Messiah, led to the depiction of Christ's antecedents in the form of a family tree. On the ceiling in Hildesheim, Adam and Eve are near the entrance to the church, just above the west door. As we move toward the depiction of Christ in majesty, we are also moving toward the altar of the church, and so toward our salvation. The whole church was severely damaged during the war, and the ceiling only survived because it was removed for safekeeping in 1943. The figure of Christ was recreated when the ceiling was replaced, as the original had been destroyed when the crossing of the church collapsed in 1650.

▶ There are forty-two circles around the edge of the ceiling containing representations of the descendants of Jesse, down to and including Joseph, as listed in the third chapter of the gospel of Luke.

▼ The trunk of a tree appears to grow out of Jesse's side, a literal representation of a metaphorical idea. Jesse is asleep: this may be a reference to Adam sleeping when God removed his rib to create Eve.

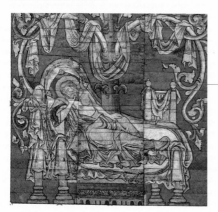

◖ Most of the rectangles to the right and left of the tree depict prophets, whose teachings are inscribed on their scrolls. This is Isaiah, whose scroll reads "Ecce Virgo", the first part of his prophecy of the Virgin birth: "And behold, a virgin shall conceive and bear a son" (Isaiah 7.14).

◗ The Virgin is holding a spindle with red thread, a reference to the *Protevangelium of St James*, which tells of her childhood with other virgins weaving the veil of the temple. Her gesture, which echoes that of Eve holding the apple, underlines her role as the New Eve (see page 74).

◗ This figure is labelled "NATAN", or Nathan, the son of David from whom Joseph was descended, according to Luke's gospel. However, it is worthwhile remembering that few people would have been able to read this from the ground, and that the decoration was made for the glory of God as much as for the instruction of man.

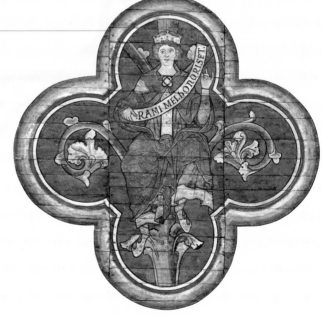

◗ King Solomon is enthroned on the branches of the tree. He was the son of King David, and the grandson of Jesse, all three of whom are represented. Not only does this emphasize that Jesus was of the house of David, as prophesied, but also that he came from a line of kings. As well as being theologically important, it was also politically relevant, because genealogy and kingship were fundamental to 13th-century society.

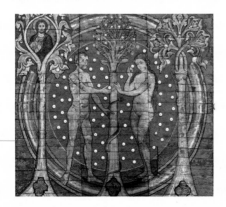

◖ Adam and Eve stand on either side of the Tree of Knowledge, and Eve's hand is raised, holding the forbidden fruit. A depiction of Jesus is included in the Tree of Life, on the left.

Further brackets rest on top of the beams to support the roof, thus distributing the weight of the roof to the walls and leaving a high, open space in the centre of the church – the height being important to create a sense of awe and, as a result, spirituality. The hammerbeams are often decorated with carved angels, reinforcing the idea of the ceiling as an image of heaven.

Wooden ceilings were chosen because they were light, easy to support and relatively cheap. However, wood was also susceptible to both fire and moisture, and therefore stone was preferable. Stone was considerably more expensive, because in addition to the cost of the material money had to be spent on walls or buttresses that would be strong enough to take the weight. A variety of types of stone vaulting developed, from the relatively simple quadripartite vault to the more elaborate fan vault (see box, below).

In addition to wood and stone, ceramics such as brick or tiles were also used. Byzantine engineers developed a system of brick vaulting using what were effectively hollow, cylindrical tiles. Hollow meant lighter, thus reducing the load on the walls. Another advantage of brick was that it could be covered in mosaic, a technique employed to its greatest advantage in St Mark's Basilica in Venice (see page 137).

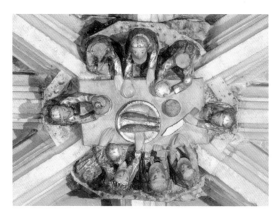

◉ NORWICH CATHEDRAL
11TH–15TH CENTURIES, NORWICH, ENGLAND

The 1,106 bosses of Norwich Cathedral were carved and painted *in situ*. There are more than 250 in the nave alone (right), where they tell the biblical story of humankind, starting with the Creation at the east end, and moving west through the Old Testament and New Testament (including the charming Last Supper boss, above), before finishing with the Last Judgment in the west. The Romanesque wooden ceiling and roof were destroyed by a fire in 1463, and the present stone vaulting was begun in 1470. Although it is Gothic in style, the "new" ceiling harmonizes well because it has the same rhythm as the Romanesque nave beneath, and springs from the same piers and composite columns.

CEILINGS OF INCREASING COMPLEXITY

The main weight of a vaulted stone ceiling is supported by the ribs, which act in the same way that arches can support areas of wall. Where diagonal ribs meet, there is a boss, which is the structural equivalent of a keystone in an arch: it supports the two ribs leaning against it. The gravity the boss exerts downward also helps to stabilize the ribs by weighing them down, effectively holding the ribs onto the wall or buttress that is supporting them. There are many different types of stone vault, which gradually increased in complexity during the Gothic era. Illustrated here (right) are three of the most commonly found types.

QUADRIPARTITE VAULT
The simplest form of stone ceilings, such as those in Chartres and Durham (see illustrations, pages 27 and 147) are known as quadripartite because the area of roof between the parallel sets of ribs are subdivided into four parts by a pair of diagonal ribs that cross in the centre.

LIERNE VAULT
More complicated vaulting includes short sections of ribbing that is not necessary to support the ceiling, but is added for decorative effect. These are known as lierne ribs, and give their name to lierne vaulting, which was common from the 13th to 15th centuries: a prime example of lierne vaulting is the ceiling of Norwich Cathedral.

FAN VAULT
Developing from the lierne vault was the fan vault, in which all the ribs radiate equally from the supporting bracket. Two notable examples, for the Bell Harry Tower in Canterbury Cathedral and King's College Chapel in Cambridge (see illustrations, pages 2 and 160), were designed and built by the same man, John Wastell.

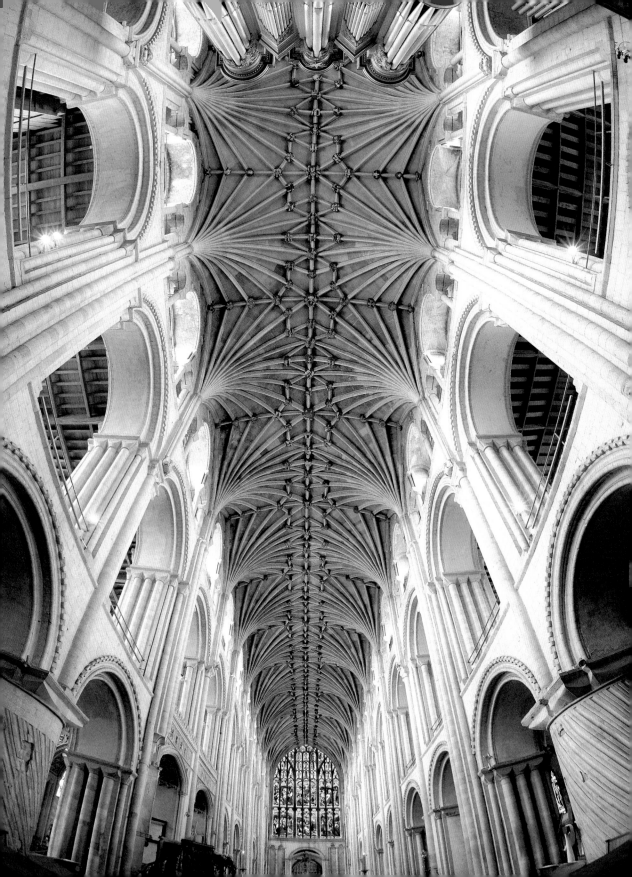

WALLS & WINDOWS

There is an inverse relationship between windows and walls – the larger the windows, the smaller the space that is left between them. In early churches windows tended to be small: the walls needed to be strong to support the roof, and glass was scarce and therefore expensive. Windows could remain unglazed in the warm Mediterranean climate where Christianity was born without presenting too much of a problem. However, the small openings could be closed by very thin slices of alabaster, which is translucent and admits a warm, yellowish glow: a reduced light that creates a sense of holiness (a function later performed by stained glass). The large areas of wall that remained could be decorated

◉ MAUSOLEUM OF GALLA PLACIDIA

5TH CENTURY, RAVENNA, ITALY

Even if this building was designed as a mausoleum for Galla Placidia, daughter of the Roman Emperor Theodosius I, it is certain she was never buried here. The alabaster slabs in the small windows allow just enough light to see the imagery on the rich mosaic that decorates every surface. One of the main focuses is this figure of a saint, often thought to be Lawrence, who was martyred by being burned to death on a grill. However, it is probably Victor, who was tortured in the same way, before being beaten and left to die in prison. In the cupboard are books labelled "Mark", "Luke", "Matthew" and "John" – the four gospels. The stance of St Victor expresses his willingness to witness to his belief in God through his own suffering, while the yellow glow coming from the alabaster appears to be emanating from the raging fire beneath.

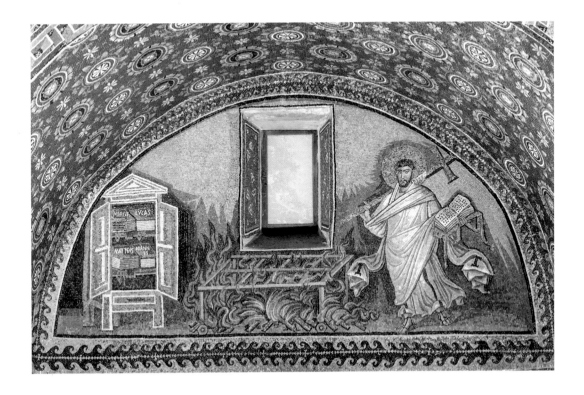

with mosaic, as in the mausoleum of Galla Placidia (see illustration, left), or with paintings, either painted onto the wall when the surface was dry (murals) or onto wet plaster (fresco). Fresco is better suited to dryer environments: for example, even within Italy there are more frescoes in inland Florence than there are among the islands of the Venetian lagoon. Where the climate is particularly hot, the walls are sometimes clad with tiles: this has become a particular feature of Portuguese churches, with their colourful glazed tiles or *azulejo* (see illustration, page 111).

In early churches, one of the functions of the windows was to admit light to allow the congregation to see what was depicted on the walls. Sadly, relatively few early wall paintings survive. In part this is the result of the technique, as plaster can easily be damaged by moisture and frequently needs replacing. The dearth of early wall paintings is also the result of changes in taste over time, which led to the redecoration of the church with more up-to-date images – or it was a reflection of changes in worship. This was especially true during the Reformation, when iconoclasts encouraged the wholesale destruction of imagery (see page 179). In a few cases, however, where a painting was simply whitewashed to remove it from view, modern restoration has been able to reveal it again. In other cases, such as the remarkable Wheel of Fortune mural in Rochester Cathedral, paintings have survived as a result of changes made within the building which pre-dated the Reformation.

Although wall paintings were common in the north of Europe, by the thirteenth century the development of flying buttresses meant that the walls were gradually dissolved: some Gothic churches, from the inside at least, appear to be almost entirely constructed of glass, filling the interior with an astonishing richness of colour. As well as transforming the atmosphere, the glass can also be used to tell stories and convey messages. The windows in churches were not designed for the view beyond: they do not inspire us to look out onto the world, but to look in on ourselves, and, like the walls, they surround us with God's message.

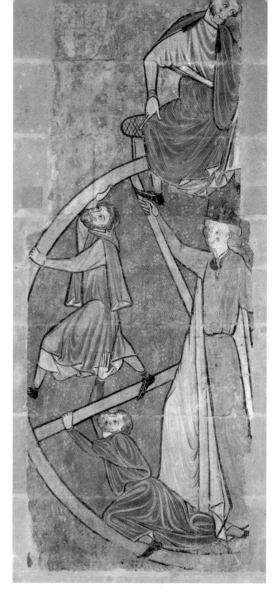

◐ WHEEL OF FORTUNE
13TH CENTURY, ROCHESTER CATHEDRAL, ENGLAND

This painting is one of the finest surviving 13th-century murals in Britain. Although all of the surrounding imagery was destroyed during the 17th-century Civil War, a pulpit had been installed in front of this section and it was only discovered when the choir was restructured in the 19th century. Despite the Church's insistence that we are dependent on God for everything, secular subjects such as this were not uncommon: they remind us that we cannot control our own fate, and so should put our trust in God.

STAINED GLASS

"The pictures in the windows are there for the purpose of showing simple people who cannot read the Holy Scriptures what they must believe." Abbot Suger of St Denis

Although stained glass would never have achieved its exalted status without official Church support, influential thinkers such as Abbot Suger realized that glass could be used, quite literally, to enlighten the illiterate. The fact that light is such an important symbol for the Church was crucial (see pages 108–110), and with the use of glass this became a more specific symbol. In the same way that Mary gave birth to Jesus, the Light of the World, and yet remained a virgin, light can pass through glass without altering the glass. When the glass is coloured, the symbolism deepens: the light takes on the same colour as the glass, just as God had "passed through" Mary, and took on her nature, humanity, in the form of Jesus.

The technique of stained glass developed slowly. Small sections of different coloured glass are held together with strips of lead, which give the familiar bold black outlines. Initially only a few colours were available, but the simplicity which resulted greatly enhanced the clarity of the image. Although each separate section of glass is a different colour,

details such as faces, or folds in drapery, were painted on. To increase the range of colours, the glass could be "stained" by applying a silver oxide and then fired in a kiln. With the development of a greater realism in Renaissance painting, similar innovations were applied to glass. This led to the introduction of "picture windows", which relied as much on painted imagery as on a variety of coloured glass. By the seventeenth century much of the "painting" was applied using glass enamel: richly coloured glass was ground into a powder, painted onto clear glass and then fired.

Further major innovations did not occur until the nineteenth and twentieth centuries, when American artists such as Louis Comfort Tiffany started to use opalescent glass, and when colour variation was achieved by etching.

◐ SOUTH ROSE WINDOW
Jean de Chelles and Pierre de Montreuil, 1260, NOTRE DAME, PARIS, FRANCE

The South Rose Window was paid for by King Louis IX, the only French monarch who has been recognized as a saint. The central image would have been Christ in Majesty, surrounded by the twelve apostles, but the original glass is now scattered around the window, the result of severe damage and several restorations.

ROMANESQUE
Single openings with broadly rounded, semicircular tops.

EARLY ENGLISH
Tall, thin lancets are grouped together in twos or threes.

DECORATED
The vertical elements of the tracery develop into either geometric or curvilinear forms at the top.

PERPENDICULAR
The vertical elements of the tracery continue in parallel to the top of the window.

THE EVOLUTION OF TRACERY

As stained glass evolved, so did the windows which contained it. Early churches tended to have single apertures, wheareas Gothic architecture allowed ever more complex forms. In Britain, Early English architecture tended to arrange tall thin apertures, or lancets, in groups. Each of these was effectively an individual window, because the lancets were separated by the wall at its full thickness. Later, as the walls were pierced by ever-larger holes, a thin stone framework known as the tracery was inserted to hold the glass, and to create patterns within the aperture. These four examples are a simplified history of the different types of window seen in Britain between the 10th and 15th centuries.

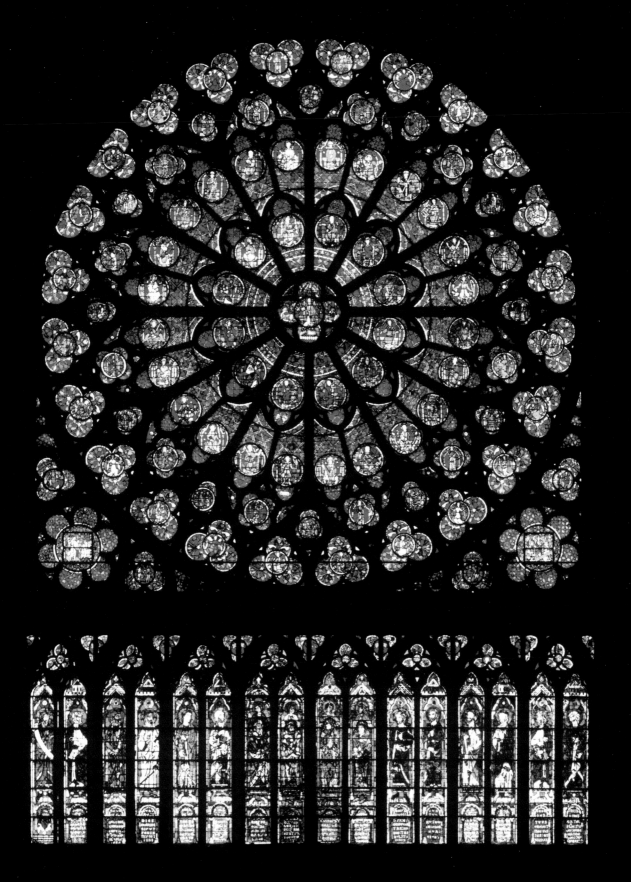

THE GOOD SAMARITAN WINDOW

C.1210, CHARTRES CATHEDRAL, FRANCE

One of the world's greatest repositories of stained glass is Chartres Cathedral. The speed with which the cathedral was rebuilt after a fire in 1194 – it took less than thirty years – was the result of enormous local support, which provided the necessary money. This included what was effectively the sponsorship of all of the windows, which were endowed by the city's guilds partly to demonstrate their devotion to God, and partly to show their own wealth. Of the 186 windows, 152 still have their original 13th-century glass, and there are more than 10,000 different images. Not only does this body of work illustrate almost all the Bible, but also the lives of the saints and the exposition of numerous theological ideas. In some of the windows stories from the Old Testament are interpreted as precursors ("types") of stories in the New Testament, a common practice (see pages 74–77), whereas in other windows Jesus' own words were interpreted in the light of the biblical narrative. For example, in a window sponsored by the shoemakers' guild, the parable of the Good Samaritan is compared to the creation and fall of humankind, an interpretation of the parable that can be found in the writings of St Augustine and the Venerable Bede, among others. The pilgrim who leaves Jerusalem on a journey to Jericho is interpreted as the soul on its journey from heaven to Earth. When the pilgrim is attacked, it is as if the soul's journey through life is disrupted by the sin introduced into the world by Adam and Eve. The window is divided into twenty-four panels, which can be read here, using the red numbers, from bottom to top and from left to right.

◎ The Good Samaritan window was one of two endowed by the shoemakers' guild, and at the very bottom of the window, in sections 1–3, members of the guild can be seen at work. Even if they are not exact representations of the men, these images have the same function as more realistic portraits of donors, such as that of Richard de Visch van der Capelle on page 114. (See also pages 124–126.)

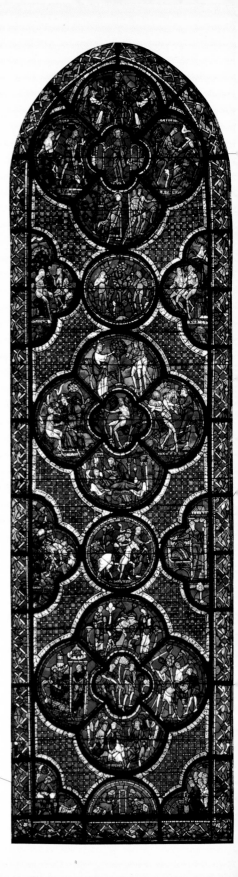

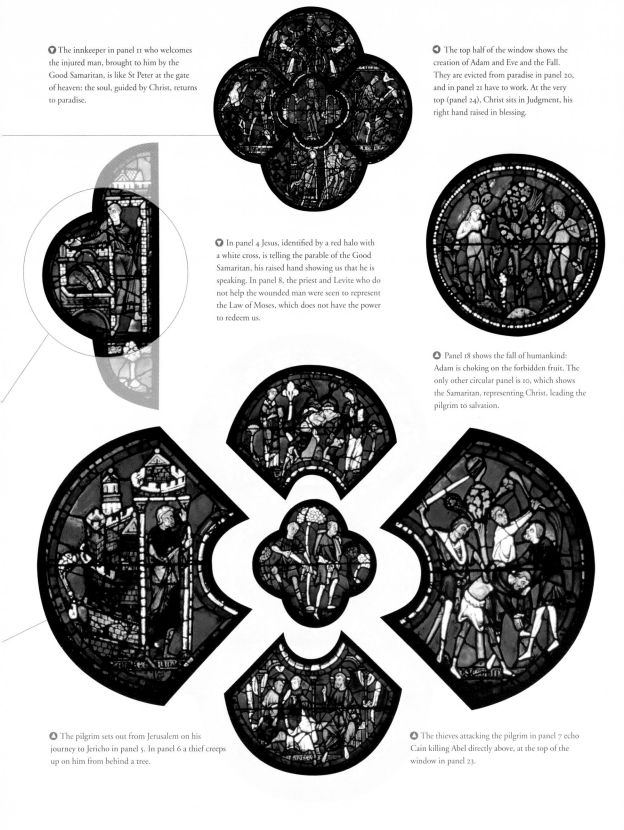

The innkeeper in panel 11 who welcomes the injured man, brought to him by the Good Samaritan, is like St Peter at the gate of heaven: the soul, guided by Christ, returns to paradise.

The top half of the window shows the creation of Adam and Eve and the Fall. They are evicted from paradise in panel 20, and in panel 21 have to work. At the very top (panel 24), Christ sits in Judgment, his right hand raised in blessing.

In panel 4 Jesus, identified by a red halo with a white cross, is telling the parable of the Good Samaritan, his raised hand showing us that he is speaking. In panel 8, the priest and Levite who do not help the wounded man were seen to represent the Law of Moses, which does not have the power to redeem us.

Panel 18 shows the fall of humankind: Adam is choking on the forbidden fruit. The only other circular panel is 10, which shows the Samaritan, representing Christ, leading the pilgrim to salvation.

The pilgrim sets out from Jerusalem on his journey to Jericho in panel 5. In panel 6 a thief creeps up on him from behind a tree.

The thieves attacking the pilgrim in panel 7 echo Cain killing Abel directly above, at the top of the window in panel 23.

IN THE NAVE

Contained within the walls and windows, and between the floor and ceiling, are the fixtures and fittings essential to the life of a church. These include the structures used during the important ceremonies a church hosts, from cradle to grave, and they illustrate the ways in which everyday life can be part of the worship of God. These furnishings are most likely to be found in the nave, which has historically been the part of a church made most accessible to the general public.

The word nave comes from the Latin *navis*, meaning "ship", reminding us that the congregation is on a journey through life, during which the Church will protect and guide them in the same way that a ship protects its passengers on the stormy seas. Maritime associations run deep in Christianity. Jesus carried out much of his teaching around the Sea of Galilee, and several apostles were fishermen. Jesus' calming of a great storm was one of the ways in which his followers came to recognize him as the Messiah (Mark 4.35–40).

● ST EDMUND'S PARISH CHURCH
15TH CENTURY AND LATER, SOUTHWOLD, ENGLAND

Like many British churches after the Reformation, St Edmund's gradually fell into disrepair – and was then further damaged by 18th-century modifications. The church was finally restored in the late 1920s by the architect F.E. Howard, who declared it could be a model for the whole of England of what a parish church should be.

1 **LECTERN:** A reading desk on which the Bible could be placed. This neo-Gothic example, by F.E. Howard, is inspired by a number of Gothic originals. The four evangelists, authors of the four gospels, are carved on the shaft.

2 **PULPIT:** The sermon is preached from the pulpit, which is raised to provide the congregation with a better view. Although this is an original medieval pulpit, some would say that it was over-restored in the 1920s.

3 **FONT:** The 15th-century octagonal font is close to the entrance of the church, because baptism represents entry into the life of the Church. The steps – for priest, parents and godparents – and the font cover (said to be the tallest in England) are the work of Howard, replacing originals which had been damaged and destroyed respectively.

4 **HATCHMENT:** A hatchment is just one type of funeral monument. It shows the coat of arms of the deceased (in this case James Robinson, who died in 1836), and was installed in the church after having been displayed during the funeral service. Hatchments were once common in Britain and the Netherlands, and can often be seen in 17th-century Dutch paintings of church interiors.

5 **PEWS:** Seating arrangements in churches have changed regularly. Initially there were no seats, but pews became more frequent from the Reformation onward when the emphasis was on the spoken word, and therefore, for the congregation, on listening. These pews date from the mid-19th century.

6 **ROOF:** The wooden roof is supported by hammerbeams, which are decorated with angels (see page 28).

7 **SOUTHWOLD JACK:** A "Jack" is a figure used to strike a bell. This one dates from the late 15th century, and is dressed in armour similar to that worn during the Wars of the Roses. Originally attached to a clock, the Jack would probably have struck the hours and the quarters. Time was important in churches not only to mark the time of services, but also as a measure of our lives.

The chancel of St Edmund's is illustrated on page 51

THE WORD OF GOD

"In the beginning was the Word, and the Word was with God, and the Word was God." John 1.1

Preaching has always been fundamental to Christianity as it was the basis of Jesus' own practice. On one occasion, known as the Sermon on the Mount (Matthew 5–7), so many people had gathered that Jesus "went up into a mountain" so that everyone could see him and hear him. The pulpit has the same function as that original mountain. Indeed, the word "pulpit" comes from the Latin *pulpitum*, which was a raised wooden platform for speakers, or a stage for actors. (It also gives its name to a type of screen commonly found in larger churches – see pages 52–53). In the early Church, an *ambo* fulfilled a similar function: the subdeacon would read the epistles, while the deacon read the gospels, each standing on the steps leading up to the *ambo* on either side. For practical reasons this led to the introduction of two *ambo*s, one on either side of the choir. The lectern effectively replaces the function of one of the *ambo*s, because it is simply a reading desk – an angled shelf on which to rest the Bible.

In a large church the pulpit may be located halfway down the nave, enabling more of the congregation to hear the preacher. In Protestant churches in particular, where the spoken word is accorded greater relevance, the pulpit may take an even more central position (see page 199), and after the Reformation pulpits were often built higher to enable the preacher to speak not only to the congregation in the nave, but also to those gathered in the galleries built above the side aisles. Some pulpits were even built in several tiers: sermons were preached from the top, while the lower levels were used for Bible readings and announcements.

Lecterns often include an eagle supporting the reading desk because it is the symbol of John the Evangelist, whose gospel opens with an overt reference to Jesus as the Word of God – the eagle therefore supports the Word. Occasionally the bird is a pelican, which was once believed to feed its young from its own breast, a form of self-sacrifice linked to Christ (see page 118) – its use on lecterns may result from the misidentification of St John's eagle, or simply that its outstretched wings make an ideal support for an open book.

⊙ **LECTERN**

C.1150, STADTKIRCHE, FREUDENSTADT, GERMANY

In this lectern the Bible is supported not just by the eagle, the symbol of John the Evangelist, but by the winged lion, ox and angel, which are the symbols respectively of Mark, Luke and Matthew, the other three evangelists. In addition to this, the reading desk is itself supported by four male figures, representing the saints themselves, carved in the bold, rounded forms of the Romanesque style.

◐ PULPIT

Hendrik Francs Verbruggen, 1699,
St Michael and St Gudula, Brussels,
Belgium

This remarkable structure could almost
define the word "Baroque" on its own: bold,
dramatic, intense, excessive. Two flights of
stairs on either side lead from the nave to the
pulpit itself. The sounding board (or "tester")
above the pulpit is intended to contain the
preacher's voice and reflect it out to the
congregation. On the underside of the tester
is a depiction of the Holy Spirit descending:
this is a common feature, and one that implies
that the preacher is divinely inspired. What
makes this pulpit remarkable are the myriad
sculptures surrounding it. At the bottom right
Death, in the form of an airborne skeleton,
chases Adam and Eve from paradise after the
Fall, while the Archangel Michael, a more
traditional figure here, wields his sword on
the left. The tester is apparently held up by
flying angels, and it bears the triumphant
figure of Mary as the Immaculate Conception.
She is shown in accordance with a passage
in the book of Revelation (12.1): "And there
appeared a great wonder in heaven; a woman
clothed with the sun, and the moon under
her feet, and on her head a crown of twelve
stars." At her feet is the Christ child, who
holds, with her, a spear in the shape of a cross,
with which they pierce the head of a serpent.
The message of the pulpit is that humankind
fell as a result of Adam and Eve, and death is
the consequence of sin. Jesus, with the help
of Mary, defeats sin, and we are redeemed.
Effectively Jesus and Mary represent a new
Adam and a new Eve: a fresh start enabling
us to return to the perfection God intended.

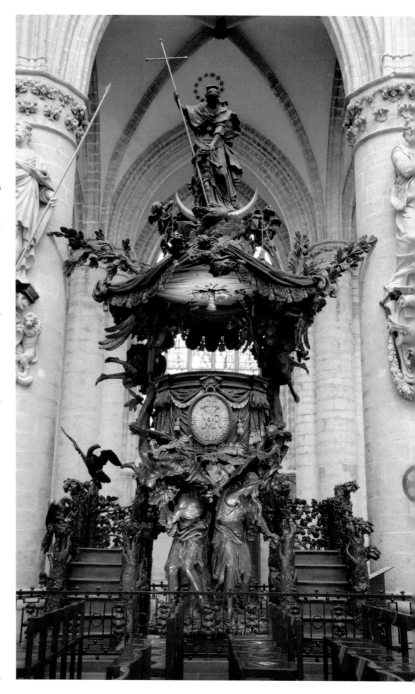

THE WATER OF LIFE

"Except a man be born of water and of the Spirit, he cannot enter into the kingdom of God." John 3.5

Before he began his mission, Jesus was baptized by his cousin John in the river Jordan. This "washing clean" symbolizes a purification of the soul and marks a new beginning. As it was an act in which Jesus himself had participated, baptism has been maintained as a sacrament by nearly all Christians, even after the Reformation (see pages 179–183). Most images of Christ's baptism show Jesus standing in the river with John the Baptist pouring water over his head. Usually the water is quite shallow, but in early images Jesus is depicted as if almost completely submerged. Baptism can still be carried out by complete immersion (the original Greek word *baptizo* translates as "immerse") but it is more regularly accomplished by sprinkling water over the head. Depending on which

technique is used, the size of the baptismal font will inevitably be different, although the one recently installed in Salisbury Cathedral was designed to allow both (see page 130).

Most baptisms in the early Church were by full immersion, and the large font would be located in a separate building or one adjoining the main church, a distinct space because recent converts were not supposed to enter the church until they had been baptized. With the development of infant baptism from the ninth century, and the growth in baptism by sprinkling, fonts became smaller and were moved inside. Nevertheless, even today most fonts tend to be near the entrance to the church, because baptism is seen as a formal and ritual welcome into the Church, as well as a cleansing from sin. However, there are some branches of Protestantism in which the act of baptism is considered so central that the font has been brought to the middle of the church.

The appearance of fonts can vary widely, although most are either circular or octagonal. The circle represents continuity and perfection, and is used to symbolize heaven – baptism cleanses us of our sins and allows the possibility of eternal life. The octagon represents the eighth day, the day after the apparently endless cycle of seven-day weeks reaches its final conclusion with the Day of Judgment – so again it can represent our future in paradise. Fonts are often decorated with the image of the baptism of Christ, and can

◀ **FONT**
Richard of Durham, 12TH CENTURY, ST BRIDGET'S, BRIDEKIRK, ENGLAND

The imagery on this font is derived from earlier, pre-Norman prototypes. As well as showing the baptism of Christ on one of the shorter sides, it is almost unique in including a self-portrait of the artist with a hammer and chisel in the act of carving. The inscription, with a combination of Scandinavian and early English runes, is a witness to the mixed population in England at the time, and can be translated: "Richard carefully wrought me, and to this perfection brought me."

also include scenes from the life of John the Baptist, or of other biblical accounts of baptism. An eight-sided font might show baptism as the first of the seven sacraments (all of which are illustrated), with the eighth side given over to a more generic image, such as an angel. This was once the case with the font in St Edmund's, Southwold (see pages 40–41), although the relief sculpture was razed flat after the Reformation.

Water the cleanser and purifier

The cleansing role of water recurs throughout Christianity. On entering a Roman Catholic church it is traditional to cross yourself with water that has been blessed, and for this purpose there are normally holy water stoups just inside the doors. These stoups have rarely survived in Protestant churches which were once Catholic. The vessels used during the mass were ritually washed, and this was done in a *piscina*, effectively a small basin near the altar and usually next to the *aumbry*, or cupboard, in which the vessels were stored. The *piscina* and aumbry were often in the vicinity of the *sedilia* (see illustration, pages 50–51).

In monasteries the monks were expected to wash their hands before meals. Although this is a standard, hygienic practice today, it was not at all common in medieval times. As well as having a symbolic relevance, in terms of cleansing from sin, it also meant that monks often enjoyed substantially better health than much of the rest of the population, even though they would not have known the reason why. The refectory, or dining room, was located off the cloister, thus it is usual to find a *lavatorium*, or area for washing, in the cloister itself. The *lavatorium* is often located in the southwest corner of the cloister, or along the west side, and can usually be seen even when the function of the monastery has changed. It can sometimes be set into the inside wall of the cloister – as it is, for example, in Norwich Cathedral – or it can project into the courtyard, forming what is effectively a separate room, as it does in Santa Maria, Poblet (right).

◑ LAVATORIUM
12TH CENTURY, CISTERCIAN ABBEY OF ST MARY, POBLET, SPAIN

Although apparently simple, this beautifully tiered fountain is a simple reminder that the early Cistercian monks had the most advanced plumbing of their time. Water issues from a small basin at the top, and then flows from the middle to the bottom in thirty-four jets of water. It is similar in appearance to many illustrations of the Fountain of Life (see pages 172–173)

IN MEMORIAM

"All you that do this place pass bye
Remember death for you must dye
As you are now then so was I
And as I am so shal you be
Thomas Gooding here do staye
Wayting for Gods Judgment daye."
Inscription, Norwich Cathedral

The inscription on Thomas Gooding's memorial stone makes it clear that tomb monuments have at least three purposes. The most obvious is to mark a place of burial. However, not all memorials are related to tombs: people are sometimes commemorated even when they are buried far away, so a second purpose is to act as a reminder of the deceased person, taking the form of either a celebration of their life and achievements, or a request for our prayers on behalf of their souls (or, of course, both). The third, as the verse so clearly states, is to remind us of our own death, and the ensuing eternity in heaven or hell after the Day of Judgment, thus encouraging us to lead a good and holy life.

Burial was not a lavish affair for all: the poor would often end up in an unmarked pauper's grave. To have been buried in a church at all implies a certain status, but even given that, Gooding's tomb is a modest affair: a simple line and text inscription in a flat slab.

This was a common form of memorial, marking the place of burial or entry into a family vault. Wealthier people could make their presence felt with a larger monument, including a sarcophagus and a sculptural portrait of themselves in marble or bronze, or even both in the case of Dutch leader William the Silent (see illustration, right). Each corner obelisk of William's monument stands on a skull: whether we are rich or poor, a skeleton (used as a *memento mori*, or "reminder of death") is common to us all.

◔ MEMORIAL TO THOMAS GOODING
16TH CENTURY, NORWICH CATHEDRAL, ENGLAND

Thomas Gooding's memorial is a simple engraving in a flat piece of stone, set upright into a wall. This has led to the suggestion that Gooding was buried upright, which would not be unknown, though it is more likely that this slab was originally set in the floor and may have been moved as a result of other developments within the building.

◗ TOMB OF WILLIAM THE SILENT

Hendrick de Keyser, 1614–1620, Nieuwe Kirk, Delft, The Netherlands

The bronze effigy of William the Silent ❶ holds a baton of office in his right hand, and sits as he might have done when surveying his troops. Looming over his shoulder is a winged personification of Fame ❷ blowing a golden trumpet (literally "trumpeting" his fame), with a second, wooden, trumpet – a sign of infamy – lowered in its left hand. In between Fame and the seated bronze effigy, William is also represented in white marble lying dead on his bier, a type of portrait known as a *gisant*. As if two portraits were not enough, his coat of arms ❸ is portrayed prominently at the top of the monument. William is accompanied by four virtues. Liberty ❹ holds a hat (although this is her most common attribute, it does not usually take this form: the French use a Phrygian bonnet, soft but pointed), whereas Justice ❺ carries the more conventional scales. At the back (unseen here) are Prudence and Religion. The choice of virtues reflects William's position as the leader of the Dutch revolt against Spanish rule, which the Dutch viewed as acting prudently to establish a just political system – one that resulted in their liberty and freedom of religious worship.

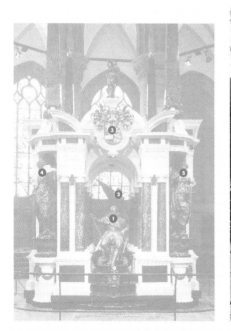

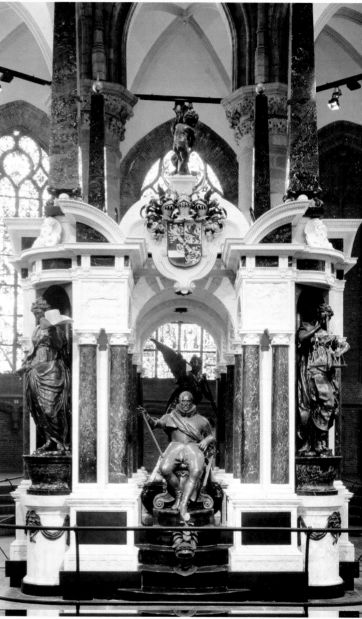

DIFFERENT DEVOTIONS

The features so far discussed are common to most churches, but not by any means all. Quakers (the Religious Society of Friends), for example, are Christians but they do not believe in any sacraments or rituals, seeing them as "empty forms": elements that appear to show belief but might not necessarily include belief. And, similarly, the Quakers have no clergy, because all people are considered equal: every person in a Quaker meeting can be moved to minister by the Holy Spirit. One consequence of this is that a Friends' Meeting House will not include signs of faith: it is instead a simple, calm and uncluttered space suitable for silent prayer and contemplation.

Roman Catholic churches, on the other hand, may have significantly more features than an Anglican church such as St Edmund's (see pages 40–41). For example, holy water stoups (see also page 45) can take many forms, but the most common are either a small, freestanding font or a wall-mounted bowl, located just inside the doors. Roman Catholics believe that the consecrated host (the bread or wafer used during the mass) is the actual body of Christ (Corpus Christi), and because this is often kept in the church (or "reserved") even when there is no mass in progress, the faithful cross themselves with holy water and genuflect (briefly kneeling on one knee) as signs of respect on entering the physical presence of God. The host is often reserved in a tabernacle, with candles lit nearby to emphasize its presence. The tabernacle could be on the High Altar, although a side chapel is often dedicated to Corpus Christi, or to the Holy Sacrament, and the host may be reserved there, allowing for prayer and private devotion outside of the church's main rituals.

The Church of England – often described as a "broad" church – is becoming more tolerant of different forms of worship and some of these features can be found in many Anglican (or Episcopalian) churches. The same is true of the Stations of the Cross, a standard feature of Roman Catholic naves, but increasingly found in churches of other denominations.

I. JESUS IS CONDEMNED TO DEATH

THE STATIONS OF THE CROSS

Eric Gill, 1914–1918, WESTMINSTER CATHEDRAL, LONDON

Although the Stations of the Cross are now displayed in almost all Roman Catholic churches, the phenomenon is a relatively recent one. The origins of the Stations date back to the earliest days of Christianity, and the practice of making pilgrimages to the Holy Land (see page 155). It was common for pilgrims to visit all of the places associated with Christ's Passion, and although for many years there was no set route around them, there was a specific number of sites which could be visited. Gradually this journey took on a more defined sense of ritual and it became known as the Via Crucis or Via Dolorosa, the "Way of the Cross" or the "Way of Sorrow". An Englishman, William Wey, was the first to use the word "stations" to describe the set places along this journey at which the pilgrim would stop and pray.

In 1342 the Franciscan order was given the responsibility of taking care of the holy places, and it was at about this time that "indulgences" were attached to the sites. This meant that pilgrims performing the prescribed devotions would be freed from the pains of purgatory for a certain number of years – and thus would effectively get into heaven more quickly. It was also the Franciscans who were first granted permission to erect images representing the Stations of the Cross in their churches in the late 17th century, and by the mid-18th century all Roman Catholic churches were being encouraged to do

Of the two sacraments shared by the Protestant and Roman Catholic churches – baptism and holy communion – the outward signs are the font and the altar respectively. A third sacrament, not accepted as one by Protestants but sometimes practised nevertheless, is penance. In order to participate in the mass, Roman Catholics are required to repent of any sins they have committed since baptism, and will then receive absolution upon performing certain duties, which usually include prayer. Penance takes place in the confessional, which, by nature of its function, is often nondescript, even anonymous. However, by the eighteenth century, Baroque and Rococo designers did not hold back even here.

◐ CONFESSIONAL
BASILICA OF OUR LADY, AGLONA, LATVIA

Confessionals include an enclosed space for the priest, and a more-or-less external area on which the penitent kneels. The confessional is usually symmetrical to increase efficiency, with a space on either side of the priest's enclosure: while one worshipper is confessing on the left, the previous one can leave from the right, and the next arrive. This example is portable, and is used during the annual pilgrimage to Aglona on 15th August (the Assumption of the Virgin), which is attended by as many as 100,000 people.

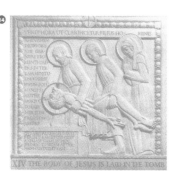

The number of Stations of the Cross has varied across time, as have the places or events they represent, but it is now established as fourteen:

1 Jesus is condemned to death
2 Jesus is given the Cross
3 Jesus falls for the first time
4 Jesus meets his mother
5 Simon of Cyrene is made to carry the Cross
6 Jesus' face is wiped by Veronica
7 Jesus falls for the second time
8 He meets the women of Jerusalem
9 Jesus falls for the third time
10 Jesus is stripped of his garments
11 The Crucifixion
12 Jesus dies on the Cross
13 His body is taken down from the Cross
14 His body is laid in the tomb

so. The reason was that relatively few people could make the pilgrimage to the Holy Land. However, by setting up symbolic references to each site – which can be paintings, sculptures, or simply crosses marked with a number – inside a church, believers could make miniature pilgrimages as a sign of their devotion. In some cases chapels representing each station are erected, frequently on hillsides, or on specifically devotional stairways, to increase the sense of exertion and therefore devotion. These three examples form part of a full series (listed, right) carved by Eric Gill for the Roman Catholic Cathedral of Westminster, which was built between 1895 and 1903, and which is still, gradually, being decorated today.

CLOSER TO GOD

Access to the "holiest of holies" is limited in many religions, and the altar in a church has often been restricted to the priesthood. The sanctuary – the holy area around the altar – is within the chancel (although often these two are not distinct), the latter taking its name from the Latin *cancelli*, meaning "lattice" (implying that it is enclosed by a screen). The chancel can also be referred to as the presbytery, an area restricted to the clergy (from the Latin *presbyter*, meaning "an elder", which also gives us the word "priest").

In the Orthodox Church the chancel is closed from view by the iconostasis (see page 143). The nave represents Earth, whereas the chancel is an image of heaven, and as such tends to be more elaborate. At appropriate points during an Orthodox service the central doors of the iconostasis are opened so the congregation can see the priest officiating, allowing a symbolic glimpse of heaven during our earthly existence. Even in the West, the sanctity of the chancel means that it is physically higher and frequently more highly decorated.

▶ ST EDMUND'S PARISH CHURCH

15TH CENTURY AND LATER, SOUTHWOLD, ENGLAND

This is the same church seen on page 41, but here the view is in the opposite direction, standing in the nave and looking at the High Altar.

1 **SCREEN:** Originally the chancel of most churches would have been separated from the nave by a screen: in the West, many of these have been removed over the centuries, but in Orthodox churches they remain essential. The screen in St Edmund's is continuous across the chancel and the two chapels at the ends of the side aisles. The central section includes paintings of the twelve apostles: St Andrew, with his diagonal cross, and St Peter, with his keys, can be seen to the left of the central door.

2 **SEDILIA:** Scarcely visible here is a set of three seats, called the *sedilia*, used by the clergy during the mass. To the left of these are the *piscina*, for washing the chalice and paten used for the wine and bread, and the aumbry, a cupboard in which they are stored.

3 **CHOIR STALLS:** The choir would sit in the chancel to sing the services, as they do now to lead the congregation in worship.

4 **ORGAN:** Organs can be located almost anywhere in a church, though a position close to the choir is advantageous.

5 **ALTAR:** Although an altar may seem to be the most obvious focal point of a church, this depends on the denomination. The altar's form can vary, and may or may not include a *reredos* or altarpiece as it does here.

6 **ALTAR RAIL:** In the Anglican Church the position of the altar or communion table has varied since the Reformation. Although at first the altar was freestanding, and in the nave, in 1634 Archbishop of Canterbury William Laud decreed that it should be moved to the east end of the church, and that a "rayle" be installed in front of it, "neere one yard in height, so thick with pillars that doggs may not get in".

7 **PROCESSIONAL CROSS:** A cross is regularly carried in procession in front of the priest, and when not in use may be displayed next to the altar (this one was a gift from Emperor Haile Selassie of Abyssinia – now Ethiopia).

8 **EAST WINDOW:** As the High Altar is traditionally at the east end, the window above it receives the light of the rising sun, a symbolic reference to the Resurrection. This window depicts the life and death of the church's patron St Edmund. The window was made in 1954 to replace one destroyed during the war, and it is the last work of England's great neo-Gothic architect Sir Ninian Comper, who taught F.E. Howard, the man responsible for the restoration of the church in the late 1920s.

The nave of St Edmund's is illustrated on page 41

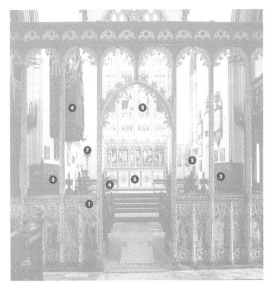

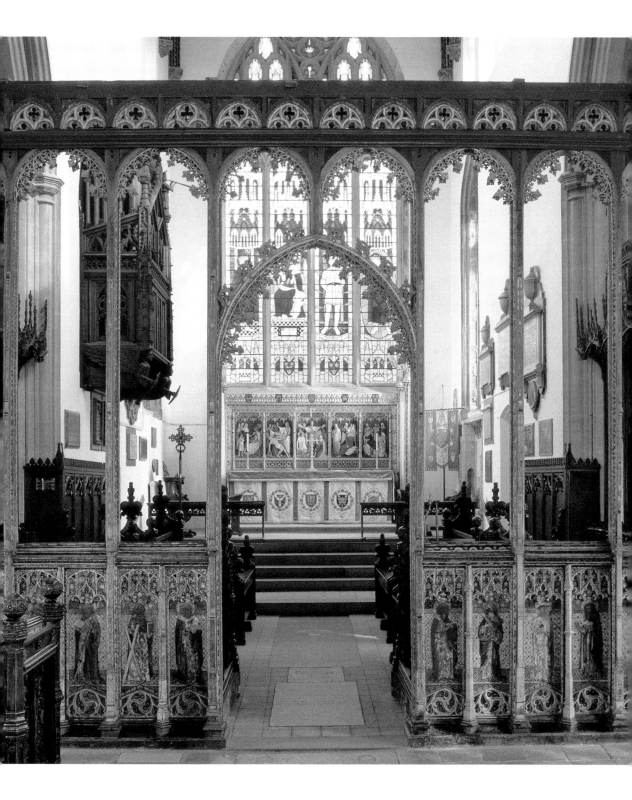

THE DIVISION OF SPACE

There are many ways in which the spaces within a church are differentiated. The central nave is divided from the side aisles by the arcade. Archways were often enhanced by making them more solid or obtrusive than was necessary in order to mark the transition from one space to another. Varying levels can be used: the chancel can be given a higher status by having stairs leading up to it; or the sanctuary, if this is separate from the chancel, can be on a higher level, and is often demarcated by an altar rail; and steps are also used to lead down to the crypt, which is clearly on a different level.

Light could also be used to differentiate space. In St Edmund's, Southwold, the side aisles do not run the full length of the church, which enables windows to be inserted on the side walls of the chancel to allow more light onto the altar. Andrea Palladio achieved the same effect in Venice where the chancel of Il Redentore has more (and larger) windows than the nave (see illustration, page 182), and as these windows cannot be seen from the nave they give the chancel an almost mysterious glow.

However, the most obvious way to divide space was to use screens. Side chapels, which were spaces for specific, often private, devotion (family burials, for example) were frequently separated from the nave and many of these partitions remain intact. At one time screens existed in all

◐ THE INSTITUTION OF THE CRIB AT GRECCIO
The St Francis Master (Giotto?), 1297–1300, SAN FRANCESCO, ASSISI, ITALY

St Francis was responsible for popularizing the Christmas crib or nativity scene. He realized that if people could see Jesus as a helpless baby they would be more likely to respond to the message of humility that the story conveys. According to the saint's biographer, Thomas of Celano, the first time that Francis did this, onlookers apparently saw the model of Jesus come to life.

◑ *PULPITUM*
15TH CENTURY, YORK MINSTER, ENGLAND

The decoration on the *pulpitum* at York is original, including the fifteen sculptures of the kings of England from William the Conqueror to Henry VI (there are seven to the left of the archway, and eight on the right). This view looks east, from the nave, through the screen, toward the High Altar. The organ is a relatively recent addition, dating to 1832.

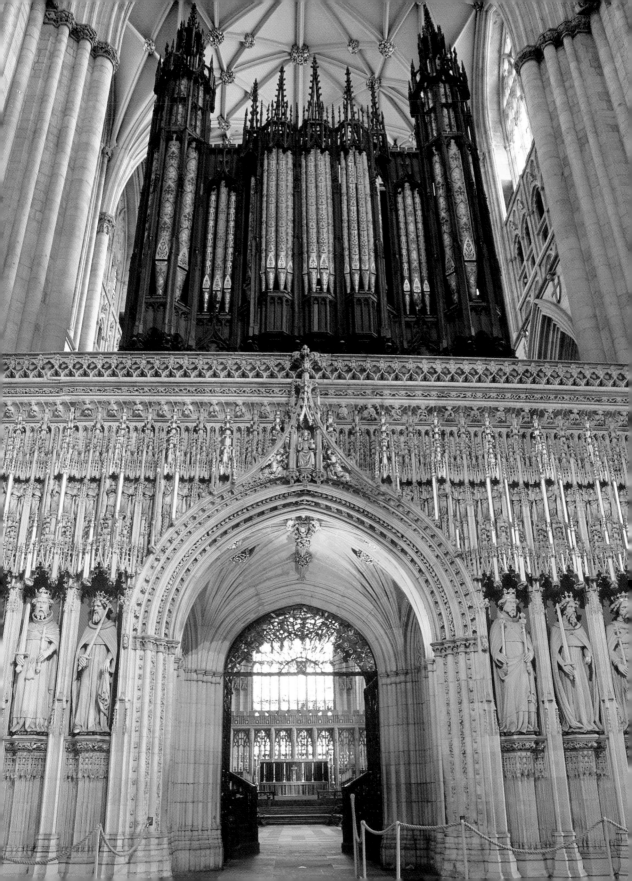

THE SANCTITY OF CRYPTS

The idea of having a crypt under a church derives from the practice of marking holy sites by building churches on top of them. The first basilica of St Peter was built on a hillside, and excavations there in the mid-20th century showed that the slope of the hill was levelled off so that the basilica could be in exactly the right place, with its High Altar directly over St Peter's tomb. A basilica was also built above the catacombs in which St Agnes was buried, and Constantine's daughter Costanza had her mausoleum built to be near it (see page 107). However, when the tomb of St Agnes was finally located, a second church was built nearby in the mid-7th century with the altar directly above it, and the original basilica was left to fall into ruin. From the mid-8th century crypts were built to imitate this circumstance: the body of a revered saint, or their important relics, were placed in a shrine in the crypt directly underneath the altar, thus making the altar mark a holy site which had not previously existed. To accommodate this development many Romanesque churches were built on more than one level. At the east end of the nave there are often central steps going up to the *pulpitum*, and going down on either side into the crypt.

Like catacombs, crypts were deemed suitable as places of burial because they were at a lower level. However, people came to favour entombment in a crypt because they liked to be buried near the bodies of saints. It was assumed that the saints would already be in God's presence, effectively putting the

newly deceased closer to God. Although not the same as burial vaults beneath a church, there is little real difference.

The construction of crypts to house the bodies of saints became less common from the 12th century onward, as relics were increasingly housed near the chancel. Although some relics of St Thomas Becket had been enclosed in precious caskets (see illustration, right), his body was buried in the crypt of Canterbury Cathedral. In 1220 a new chapel was built, and the remains were moved up (or "translated") to be housed in a shrine behind the archbishop's throne: the relics would be seen as granting him authority. The Becket shrine (destroyed at the Reformation) would have had an equivalent position to that of St Edward the Confessor in Westminster Abbey, the only shrine in England that still contains its original relics.

⬥ CRYPT

1240–1260, ST PROCOPIUS, TREBIC, CZECH REPUBLIC

The basilica at Trebic replaced the chapel of a Benedictine monastery. The presence of the monks at Trebic led to a market there, and the wealth generated by this helped to fund the construction of a larger church: although the majority of the structure retains the Romanesque style of the earlier building, the crypt is already clearly Gothic.

churches to separate the nave, or worldly part of the church, from the chancel, and from the mysterious nature of the rituals performed there.

One type of screen, the *pulpitum*, derives its name from a raised dais (see page 42). A fresco (see page 52) by Giotto, or someone close to his style, shows why: on the far left, a set of stairs goes up to a pulpit, from which to preach to the congregation in the nave. Within the chancel the altar is given greater prominence by being enclosed within a canopy or *ciborium* (a word now used more often to refer to a covered chalice containing the sacrament). An interesting feature of the fresco is that a large number of the lay public are inside the screen. (The men, that is – the women are excluded but visible through the central doorway. It was common practice in the early Church for men and women to worship separately, and in some cases women were seated in an upper gallery, usually known as a *matroneum*.)

In a particularly adept piece of illusionism, a painted crucifix is fixed to the top of the screen: we see it from the back, leaning outward toward the nave. As well as showing us how a wooden panel could be made and attached, this detail also explains another term used for this form of partition: a rood screen. The archaic word rood is related to the English word "rod" and refers to the wooden cross on which Jesus was crucified. A rood screen was therefore one on which a crucifix was displayed, and it is the screen which divides the nave from the chancel (and so can be called a chancel screen).

Strictly speaking, a rood screen is not the same as a *pulpitum*. A rood screen was installed in churches without a *pulpitum*, or, in those larger buildings – monasteries and cathedrals – which did have one, a rood screen would be built one bay to the west (and would also have had an altar to the west at which the congregation could worship).

◐ THE BECKET CASKET
C.1180, VICTORIA AND ALBERT MUSEUM, LONDON

This enamelled box, made in Limoges, is decorated with scenes of the infamous murder in 1170 of Archbishop Thomas Becket, as well as his subsequent burial and his soul being taken up to heaven. Relics of the saint (canonized in 1173) were so highly prized that they were sent around the world in caskets like this one, the most splendid example to survive.

SEATING

". . . the weakest goes to the wall."
William Shakespeare (*Romeo and Juliet*, Act I, Scene I)

As part of an insult at the opening of *Romeo and Juliet*, Shakespeare uses a common figure of speech from the time. The expression is always assumed to derive from the fact that there was no seating in the nave of a church: the only place to sit was on benches against the wall, so the congregation would have stood during the service (although there are

several paintings which suggest that, for sermons at least, they sometimes sat on the floor). The elaborately patterned floors of some churches (for example, on pages 26 and 27) suggests there would not have been any form of permanent seating: it would have made the decoration pointless. However, Shakespeare was writing some time around 1595, and pews had already been introduced.

In 15th-century England it was common to carve the bench ends with flowers, known as "poppyheads", and these carvings have this name even when they are not flowers. There are some particularly fine examples in Holy Trinity, Blythburgh (see page 28), which appear to depict the seasons, the seven acts of mercy and the seven deadly sins.

Pews for the people

After the Reformation pews for the congregation became standard. The new emphasis on the spoken word rather than ritual, most notably the sermon, meant that seating would have been welcomed to aid concentration. Pews were boxed off and allocated to families according to their social standing, with the highest in status located closest to the pulpit. Rent was often charged on the box pews, generating income which contributed to the church's upkeep, and because each pew belonged to a specific family it was possible to tell if anyone was not in church (in some parishes non-attendance resulted in a fine, leading to the bizarre situation whereby you were paying to go to church and paying again not to).

◖ SEDILIA
16TH CENTURY, WYMONDHAM ABBEY, NORFOLK, ENGLAND

The three seats here are for the priest, deacon and sub-deacon. This example, made from terracotta, is considered to be the memorial of Elisha Ferrers, the last prior and first vicar of Wymondham (pronounced Wind'm), when King Henry VIII removed its monastic status in 1538. In other examples of *sedilia* the height of the seat or the degree of decoration can show the status of each occupant.

DEVOTION AND DIVERSION

Monks and nuns were – and are still – required to attend services throughout the day, in some cases starting with Matins at 2am and continuing at regular intervals until Vespers (around 5pm) and Compline (6pm). Church liturgy requires those attending to stand for certain important parts of the service, thus it is hardly surprising that near-exhausted monks or nuns found themselves in need of such earthly comforts as seating. To make things easier for the worshippers, especially for those who were aged and infirm, the seats of their stalls would fold up, and the underside of each one had a small shelf on which the person could perch during the longer stretches of the liturgy (the position of these, in between the armrests, can be seen in the illustration, right). As these shelves were seen as offering some form of respite, or "mercy", they became known as misericords (*misericordia* means "act of mercy").

One of the most charming features of church decoration is the way in which these misericords were often embellished. Because the carvings were not seen either when the misericord was down, or when the monk was perching on it, the woodcarvers got away with some remarkable images, which range from the moralistic, through the absurd to the downright profane. A German misericord (below, left) from Cologne Cathedral shows a horned devil grasping a sceptre as a sign of his authority – or maybe it is just a mace to beat an unsuspecting monk. An example from the French school (below, right) shows two peasants in a cart being pulled along by a man – hardly a usual occurrence, exemplifying the fact that such images often play on the theme of "the world turned upside down", in which things happen in unexpected ways. They are both comic and moralizing: we learn how things are (and should be) by seeing what unnatural oddities result when the established order is upset.

It is not obvious why such scenes were permitted, as many of them included the sorts of monsters and chimeras that Bernard of Clairvaux had criticized as "creatures of beautiful deformity" back in the 12th century (see page 116). Undoubtedly the existence of such carvings is related to the fact that they were generally hidden (and this also favoured their survival during the Reformation). However, they also seem to be related to the sorts of anecdotes that priests would include in their sermons to keep people listening, including tales about the sorts of foolish people the congregation might know, fables which involved animals behaving in anthropomorphic ways, and warnings about the ever-present temptations of the devil.

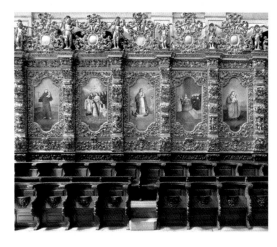

◑ CHOIR STALLS

18TH CENTURY, CONVENT OF THE BLESSED MAFALDA, AROUCA, PORTUGAL

Mafalda was a daughter of King Sancho I of Portugal. She was briefly queen consort of Castile and after her marriage was annulled, at the age of twelve she joined the convent at Arouca, where she is buried.

◑ TWO MISERICORDS

(LEFT) COLOGNE CATHEDRAL, GERMANY; (RIGHT) MUSÉE CLUNY, PARIS, FRANCE

The Cologne misericords were mainly carved in the 14th century, although some date from the 19th century and later, when the cathedral was completed. This example depicts a horned devil. The French example of peasants being pulled in a cart dates from the 15th century.

Chairs for the clergy

In the chancel seating had been common from the outset. In early churches the bishop and officiating clergy would be seated in the tribune, set in the apse of the church behind the altar, with the bishop seated in the centre (the bishop's throne, or *cathedra*, from which a cathedral gets its name, is still located in this central position in Norwich Cathedral, see page 125). In later buildings the altar was set against the east end of the church, so the clergy were seated to the side. There is often built into the south wall of the chancel a set of three chairs or benches, known as the *sedilia*, which fulfils this function – the seats being for the priest, the deacon and the sub-deacon. In larger church buildings, including monasteries and cathedrals, the monks or lay clergy would be located in the choir, with seating arranged on either side and behind the *pulpitum* (thus gathered on three sides around the altar). The bishop would sit alongside the choir, although his throne would be far grander and more elaborate, to emphasize his status. This traditional arrangement was maintained in Basil Spence's design for Coventry Cathedral, built after the Second World War (see illustration, page 208), where it is possible to see lights hovering above the choir stalls like a flock of birds, and the high flight of these at the back left of the choir marks the position of the *cathedra*.

Probably the most important single "seat" in Christendom is the *Cathedra Petri*. For many years it was believed to be the chair from which St Peter himself preached, the prime bishop's throne. Although the chair is now known to be Byzantine, there may be some fragments of acacia wood enclosed within it that come from one used by Peter, the first head of the Church. A monument to house it was designed by Gian Lorenzo Bernini, and installed in St Peter's in 1666 (in the background of the illustration, page 66). The wooden chair is encased within a giant bronze throne supported by four doctors of the church – saints Ambrose and Augustine, far left and right, from the Western Church, and Athanasius and John Chrysostom, on the inside left and right, from the Eastern Church. The light streaming from the dove in the window directly above is a reminder that the pope's authority is God-given, and his words inspired by the Holy Spirit.

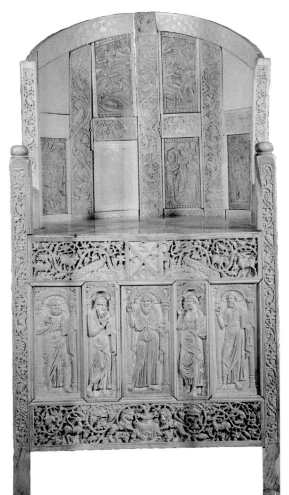

◖ MAXIMIAN'S *CATHEDRA*
C.550, MUSEO ARCIVESCOVILE, RAVENNA, ITALY

The ivory panels of this throne were probably carved in Constantinople and shipped to Ravenna for Maximian, the bishop of Ravenna, who was responsible for building Sant'Apollinare in Classe (see pages 140–141), and for the completion of San Vitale. (Maximian appears next to the Byzantine Emperor Justinian, who appointed him, in the mosaic from San Vitale on page 138.) The *cathedra* was a gift from Justinian to celebrate the consecration of San Vitale, and would have been placed in the church's curving apse. The *cathedra*'s front panels depict John the Baptist flanked by the four evangelists; other panels show stories from the Old and New Testaments.

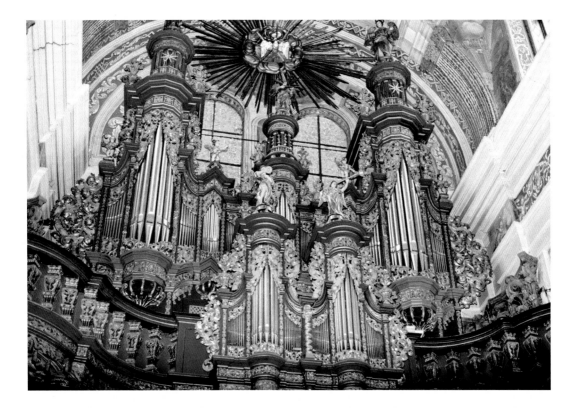

CHRISTIAN MUSIC – THE JOY OF EXULTATION

"Music is a fair and lovely gift of God which has often moved me to the joy of preaching."
Martin Luther

Luther's positive attitude to music was not shared by all Protestants. Ulrich Zwingli, who led the Reformation in Switzerland, went as far as having the organs in churches burned because he thought that music was too frivolous for Christian worship. John Calvin, the most influential of the second generation of Protestants, was happy for hymns to be sung in unison, but he did not want the voices accompanied by instruments, a practice which was continued in Calvinist churches across the world for many years. Even the Roman Catholic Church, which has always encouraged music as a part of worship, is aware of its potential pitfalls. In 1903 a papal decree laid down what is permissible and what is not: stating, among other things, that, "Sacred music should possess… sanctity and purity of form… It must be holy, and must therefore exclude all profanity, not only from itself but also from the manner in which it is presented by those who execute it".

Singing formed part of the tradition of Christian worship from the earliest days. In a letter to the Roman Emperor Trajan in about 112, Pliny the Younger describes Christians gathering before sunrise to sing a hymn to Christ. In the New Testament there are various references to the singing of the heavenly hosts (see, for example, the angelic choir and orchestra in Gaudenzio Ferrari's image of the vault of heaven on page 89).

Music is valued because it can so clearly express human emotion, and also because the sung voice can communicate more clearly and easily than the spoken voice in certain acoustics. The doctors of the church all interested themselves in music. Ambrose composed hymns, and Augustine wrote an unfinished treatise "On Music". However, it was Gregory the Great who was perhaps the most influential. It was during Gregory's papacy (590–604) that Gregorian chant – the melodious form of song that took his name and which is still used to this day – was perfected.

By the 9th century organs had been introduced to accompany the singing, and musical forms of worship have continued to evolve ever since. In some cases music is central to worship. The English preacher Charles Wesley (1707–1788) wrote more than 6,000 hymns, and his attempts to reform the Church of England led to the foundation of the Methodist Church, in which a typical service can be described as a "Hymn Sandwich".

○ ORGAN
Johan Mosengel, 1721, Sanctuary of St Mary, Swieta Lipka, Masuria, Poland

The beams of light radiating from the Holy Spirit on the wall above the organ implies that the music is inspired by God. If that, combined with the ebullient forms and rich colouration of the organ, is not dramatic enough, there are mechanisms to ensure that the angels can move.

THE ALTAR

An altar is any surface on which a sacrifice or votive offering can be made, and they exist in many religions. For Christians, the sacrifice was Jesus' own: dying on the Cross to save humankind from its sins. Prior to his death Jesus celebrated the Last Supper with the apostles, when he "took bread, and blessed, and brake it, and gave to them, and said, Take, eat: this is my body. And he took the cup. . . And he said unto them, This is my blood of the new testament, which is shed for many." (Mark 14.22–24).

During the mass, this act – the Eucharist or Holy Communion – is performed by the priest and the altar takes the place of the table used at the Last Supper. The nature of the sacrament is disputed by Roman Catholics and

Protestants. For Roman Catholics, when the bread is blessed by the priest transubstantiation occurs and the bread *becomes*, through a mysterious process humans cannot understand, the body of Christ. For Protestants, the bread merely *represents* Christ's body. One result of this is that for Roman Catholics the sacrificial nature of the mass is highly important, hence the term altar. However, in Protestant churches where the sacrament is celebrated as Holy Communion, or the Lord's Supper, it takes place on a Communion Table, which may not be distinguishable from any other table.

The early churches were built in holy places (notably above the tombs of martyrs), possibly in accordance with a biblical verse: "I saw under the altar the souls of them that were slain for the word of God" (Revelation 6.9). If a new church was to be built on a fresh site the location was sanctified by taking the body of a martyr there, such as happened in 386 when Ambrose translated the bodies of saints Protasius and Gervasius in order to consecrate the church now known as San Ambrogio Maggiore in Milan. To this day every Roman Catholic altar is supposed to contain the relic of a saint.

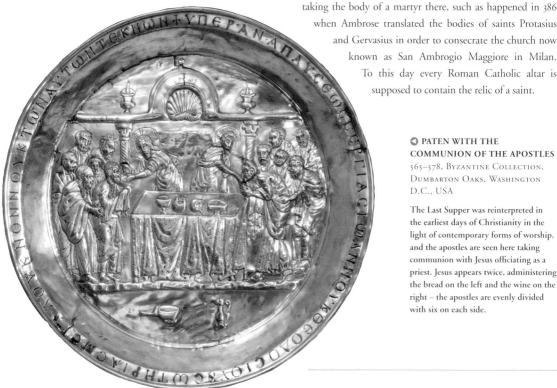

 PATEN WITH THE COMMUNION OF THE APOSTLES
565–578, Byzantine Collection, Dumbarton Oaks, Washington D.C., USA

The Last Supper was reinterpreted in the earliest days of Christianity in the light of contemporary forms of worship, and the apostles are seen here taking communion with Jesus officiating as a priest. Jesus appears twice, administering the bread on the left and the wine on the right – the apostles are evenly divided with six on each side.

ST STEPHEN WALBROOK
Christopher Wren, 1672–1677, LONDON, ENGLAND

Precisely what an altar is, or can be, within the Anglican
Church was tested in law in 1986 after Peter Palumbo
commissioned Henry Moore to carve a new altar for the
church of St Stephen Walbrook in the City of London.
The altar was completed in 1972, exactly 300 years after
Christopher Wren had started construction. Wren gave
the church the first classical dome in England, making
the building seem like a trial run for St Paul's Cathedral
– and some would say that, with its smaller scale, the
building is far more successful. Although Wren's design
is effectively centred on the dome, the original altar,
which has the Ten Commandments, the Lord's Prayer
and the Apostles' Creed painted on the retable, can
be seen at the east end. Moore's altar, roughly circular
with irregular forms cut into the sides, is placed directly
under the dome, and was part of a deliberate move on
behalf of the rector of the church, Chad Varah, to open
the service to the congregation: rather than turning his
back on the congregation, as he would at a traditional
altar, the priest could officiate over the altar. The
circular shape of the altar fits the central planning of the
church, and implies a greater degree of openness and
equality, as well as suggesting that God should be at the
centre of all things, not pushed to one side.

For Henry Moore the shape of the altar and its
position under the dome was related to the Dome of
the Rock in Jerusalem – traditionally seen as the place
where Abraham was prepared to sacrifice his son Isaac,
an important precursor for Christians of God's sacrifice
of his only son Jesus. However, the altar's irregular and
unconventional shape was not popular with everyone.
To some it looked too pagan and too sacrificial, and they
tried to ban the installation. Canon Law stipulates that:
"In every church and chapel a convenient and decent
table, of wood, stone, or other suitable material, shall
be provided for the celebration of Holy Communion."
The London Consistory Court ruled that, although a
beautiful object, it was not "a convenient and decent
table" (admittedly, it does weigh 10 tons). However, the
case was then taken to the highest ecclesiastical court
in Britain, the Court of Ecclesiastical Cases Reserved,
where the judges ruled that Moore's scuplture could be
interpreted as a "table". In addition to many layers of
theological debate, and of aesthetic judgment relating to
the placement of a 20th-century object in a 17th-century
building, in the end it came down to the fact that the
word "table" is not, in itself, precisely defined.

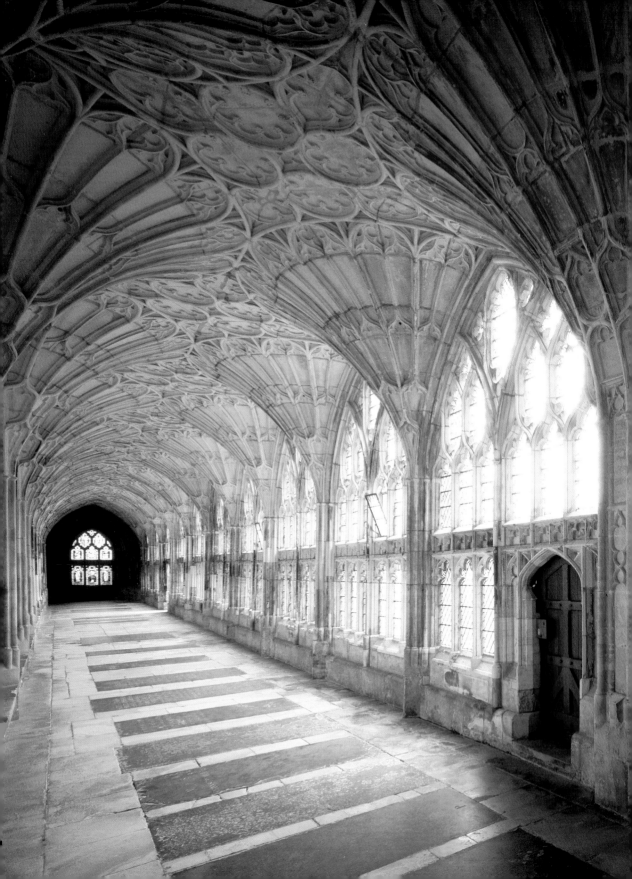

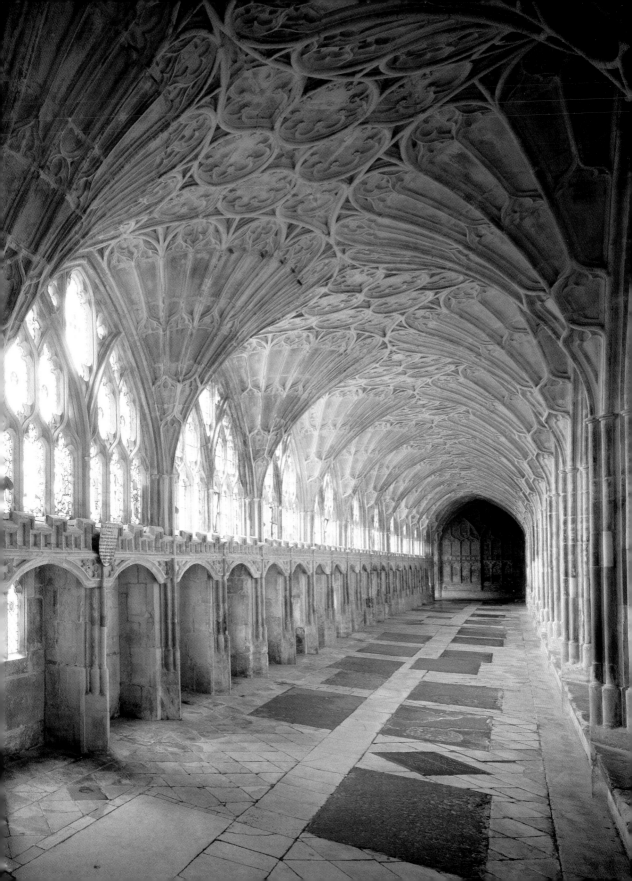

LIFE & WORK

A considerable proportion of any church building is given over to functions which are not specifically part of the act of worship, at least from the point of view of the congregation. Prior to the service the priest or minister will prepare in the sacristy, or vestry. Although these are not always accessible, there are some notable exceptions: the Basilica of San Lorenzo in Florence, for example, has two that are. The old sacristy was designed by Filippo Brunelleschi, and doubled as a funeral chapel for Giovanni de' Medici. The new sacristy, on the other hand, designed by Michelangelo, was built primarily for the burial of four of Giovanni's descendents.

For monks, the main routes of communication from their place of worship to their living quarters lay through the cloisters (see illustration, pages 62–63). Traditionally the cloisters would have been built on the south side of the church (although this can vary, particularly if there was no land available to the south). The cloisters gave access to the library, the dormitories or cells, the refectory and the chapter house, as well as providing a sheltered area for exercise, and for processions.

Libraries were essential to monasteries: as centres of prayer and contemplation, the nature of truth was of prime importance. It was therefore necessary to study not only Christian texts, but also pagan material, in order to be able to refute it. The monasteries kept learning alive through what has, inaccurately, been called the "dark ages", and when the humanist scholars of the Renaissance wanted to find classical texts, they inevitably turned to the monks. Several monastic libraries are still used by scholars and sometimes open to the public – these include the Biblioteca Laurentiana, which, like the new sacristy, was designed by Michelangelo for San Lorenzo in Florence, and an elaborately decorated example in the Benedictine Abbey of Metten in Bavaria (see page 102).

As the decoration of the buildings was designed to encourage devotion among their users, there is frequently a relationship between decor and the function of the space. For example, refectories often included an image of the Last Supper: Leonardo da Vinci's famous version was painted for the refectory of Santa Maria delle Grazie in Milan. Before eating, the monks were required to wash their hands, and a *lavatorium* can be found in most cloisters, usually in the southwest corner, or along the west range (see page 45).

The most usual location for the chapter house was halfway along the east range. It was effectively a meeting room in which the monks gathered daily, usually after mass in the morning. The abbot or prior would read from the Rule – the instructions according to which the monks organized their community – and it was the practice of reading a chapter each day which gives the room its name. The meetings were also used to discuss administrative matters, including the day's work, and for the public confession of sins. Chapter houses can also be found in non-monastic cathedrals, like Wells, where they had a more or less administrative function.

◑ **CLOISTERS**
14TH CENTURY, GLOUCESTER CATHEDRAL, ENGLAND

These richly decorated cloisters, with their perfect fan vaulting, benefited from the burial here of King Edward II, in what was then St Peter's Abbey. A widespread belief in the cruelty involved in his murder had given him an unofficial reputation as a saint, which attracted numerous pilgrims to the abbey and generated substantial sums used for extensive rebuilding. The abbey avoided the fate of most other monasteries, and in 1541 King Henry VIII raised its status to that of a cathedral, in recognition of the burial there of his "renowned ancestor".

◑ **CHAPTER HOUSE**
1306, WELLS CATHEDRAL, ENGLAND

In a secular, or non-monastic, cathedral the Chapter is effectively a committee that advises the bishop. Each member of the Chapter would have had their own seat, arranged in order of seniority: at Wells, there are more than forty seats. The window traceries are a good example of the geometric style, the earlier phase of Decorated Gothic (see page 36).

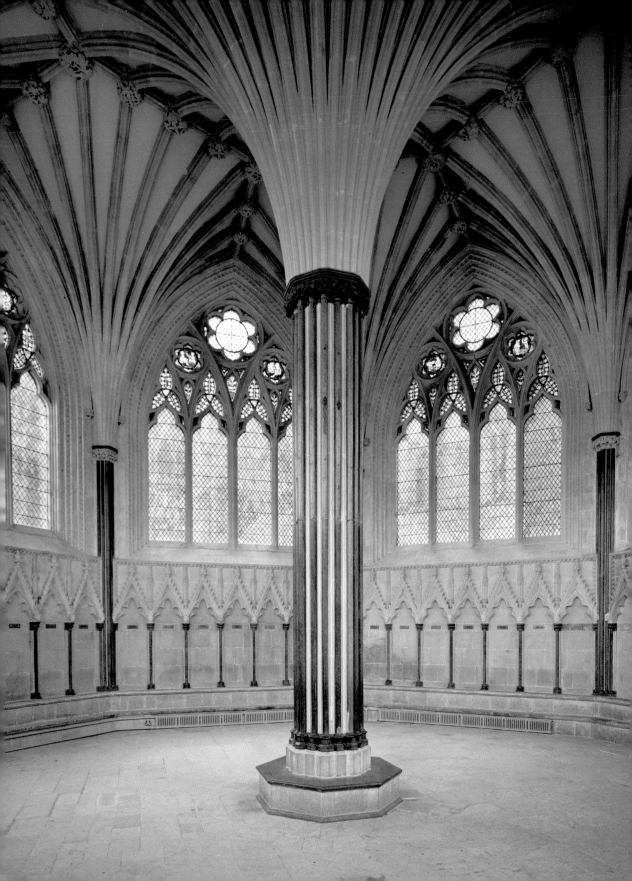

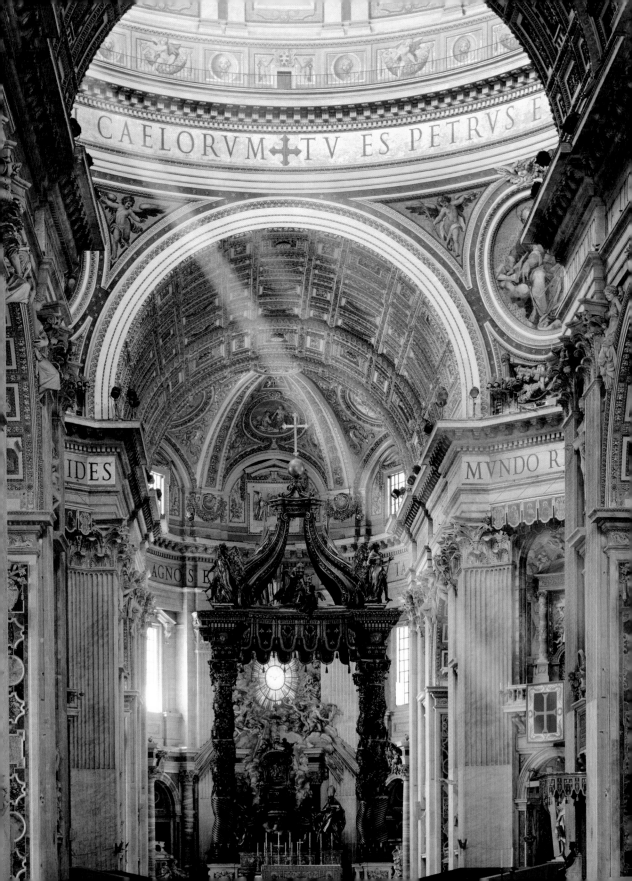

THE THEMATIC
DECODER

PART TWO

Inlaid in mosaic around the base of the dome of St Peter's basilica in Rome
are Jesus' words to St Peter: "TU ES PETRUS" (petrus means "rock" or
"stone"). Jesus continues, ". . . thou art Peter, and upon this rock I will build
my church… And I will give unto thee the keys of the kingdom of heaven."
(Matthew 16.18–19) This biblical statement is the basis of the Church's
authority, and for Roman Catholics it justifies the primacy of the papacy.
Thus it is with the Bible that we will start our exploration of the different
ideas expressed by the decoration of churches. From the Bible we learn about
God: the Holy Spirit, in the form of a dove, can be seen in the yellow window
that is part of Bernini's Cathedra Petri. *Jesus, as both God and Man, deserves*
particular attention, as does Mary, his mother. The prophets, angels and
demons are all mentioned in the Bible, as are the earliest of the saints (the
quotation above explains St Peter's standard attribute, a pair of keys).
Then follows a discussion of different qualities, including geometry, colour and
light (seen opposite in an almost mysterious beam that illuminates a bronze
sculpture of St Peter enthroned at the bottom right). The section concludes by
considering who created these churches, and why they wanted to build them.

○ **ST PETER'S BASILICA, WITH THE *BALDACHINO* AND *CATHEDRA PETRI***
Gian Lorenzo Bernini, 1624–1633 and 1656–1666 respectively, Rome, Italy

Bernini's *baldachino* is a form of *ciborium*, or canopy, emphasizing the dignity of the High Altar,
and placed directly above the tomb of St Peter. Although it looks as if it was designed to frame
the *Cathedra Petri* (St Peter's Throne) at the east end of the basilica, the *baldachino* was made
earlier. The relationship between the two monuments, which changes as you walk through the
basilica, shows how brilliantly Bernini could manipulate light and space for dramatic effect.

THE BIBLE

To use Bible stories as the basis of the decoration of churches might be said to contradict the holy book itself. Christianity is unlike the other two major monotheistic faiths, Judaism and Islam, in that it has accepted visual representation in its places of worship. This is actually in contravention of the second commandment, as recorded by Moses, which states: "Thou shalt not make unto thee any graven image, or any likeness of any thing." (Exodus 20.4) The Roman Catholic Church has always justified the use of imagery – whether paintings, sculptures or stained glass – because these can be understood even by the illiterate, and are often described in church writings as "the Bible of the poor". It was certainly one of the reasons that Abbot Suger advocated the installation of stained glass (see page 36). However, not all branches of Christianity agree with the use of visual representation, and there has been more than one historical outbreak of iconoclasm (the destruction of images), notably in Byzantium (see page 139), and later as a result of the Protestant Reformation (see pages 178–179).

Nevertheless, many denominations of Protestantism have now relaxed the strict ban on representation, and the Bible is, naturally, one of the major sources of subject matter. However, precisely what constitutes the Christian Bible is not entirely straightforward. The principal division is between the Hebrew scriptures (the Old Testament) and the later gospels, epistles and other texts which constitute the New Testament. However, there are other scriptures which are described as apocryphal, a word meaning "hidden" or "secret", which nowadays is used to imply "spurious" or "of doubtful origin". Which of these other texts are considered to be canonical varies from one denomination to another.

Vulgate and King James versions

The word "bible" comes from the Greek word *biblos*, meaning "book". The Jewish scriptures, which form the basis of the Old Testament, were written in Hebrew, Aramaic and Greek, with the books of the New Testament being written in Greek. The earlier Hebrew and Aramaic texts were translated into Greek, and this secondary Greek later translated into Latin. It was Jerome (c.347–420) who went back to the original languages and translated them directly into Latin, to avoid some of the confusions which had arisen. This translation was to become the basis of the Vulgate Bible, still in use by the Roman Catholic Church.

The most important of the early English translations was commissioned by King James, and first published in 1611. It is referred to as the Authorized, or King James, Version, and, along with the works of William Shakespeare, it is commonly seen as the basis of modern English. There are a number of differences between the Vulgate and the King James: the book of Psalms is ordered differently, and whereas the books of Judith and Tobit are included in the Vulgate, in the King James Version they are found in the Apocrypha.

However, as far as the decoration of churches is concerned, it is not as important where these stories appear so much as how they are interpreted. Many apocryphal texts, excluded from the biblical canon, were popular and influential. For example, only four gospels are included but others existed. The book of James (also known as the

continued on page 74

● EMBOSSED GOSPEL COVER
14TH CENTURY, NATIONAL HISTORY MUSEUM, SOFIA, BULGARIA

Decorated canonical texts were often exhibited in churches as a reflection of the respect accorded them. The central image of this cover is the Crucifixion, with the Virgin and St John the Evangelist at the foot of the Cross, as mentioned in the gospels. Just above Jesus' hands are stylized faces representing the sun and the moon, which were regularly included in images of the Crucifixion as a reference to the verse, "The sun shall not smite thee by day, nor the moon by night" (Psalm 121.6), a sign that "the Lord shall preserve thee from all evil" (Psalm 121.7). Along the top and bottom of the cover are scenes from the life of Christ.

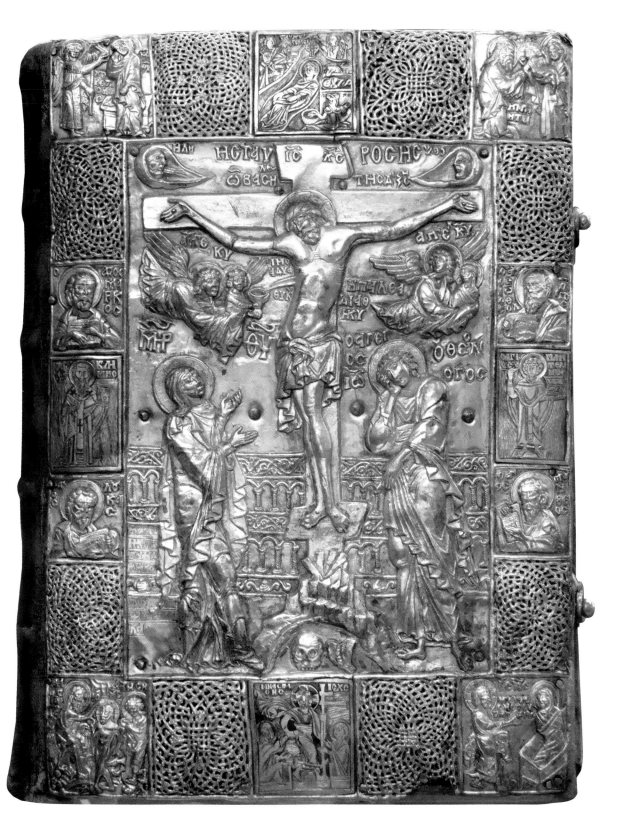

THE CREATION DOME

1220S, ST MARK'S BASILICA, VENICE, ITALY

The atrium of St Mark's contains one of the most thorough illustrations of Old Testament stories, including this dome with scenes from the first three chapters, starting in the centre and spiralling outward. The mosaics were based on a particularly richly illustrated manuscript in which almost every verse has its own picture. Known as the Cotton Genesis, after its 17th-century owner, Sir Robert Cotton, it was made in Constantinople in the late 5th or early 6th century, and was seized by the Venetians when they sacked the Byzantine capital in 1204. Using this book as a source of illustrations two decades later – in the atrium largely constructed from architectural elements also looted from Constantinople – the Venetians were effectively asserting their dominance over the Eastern Empire. The Bible is being used here to make a political statement.

❶ The illustrations start with the first two verses of the Bible: "In the beginning God created the heaven and the earth. And the earth was without form, and void; and darkness was upon the face of the deep. And the Spirit of God moved upon the face of the waters." (Genesis 1.1–2)

❷ God is shown beardless, and with a cruciform halo, in line with the earliest representations of Jesus. This is the first day of creation: "And God said, Let there be light: and there was light." (Genesis 1.3) The light radiates from two circles, which represent night and day. God is accompanied by one angel.

❸ God, now with three angels, creates the plants. This is the third day: the preceding pictures show him separating heaven and earth (day two), and then separating the land from the water, which happens earlier in the third day.

❹ The story continues in the middle ring of pictures with the creation of the sun, moon and stars on the fourth day.

❺ The fishes and birds created on the fifth day include closely observed representations of real creatures, as well as a sea monster.

❻ On the sixth day God creates animals and then man. Although this is described in the first chapter of Genesis, there is more detail in the second chapter: "And the Lord God formed man of the dust of the ground. . . ." (Genesis 2.7) Adam is shown here as a lifeless figure made of earth, in the company of six angels.

❼ "And on the seventh day God ended his work which he had made; and he rested on the seventh day from all his work which he had made. And God blessed the seventh day. . . ." (Genesis 2.2–3) We see God resting, seated on a throne, blessing one of seven angels: if it had not been clear before, this tells us that the angels in the previous scenes represent the days of creation. In a tradition rarely cited in the Church, each day of the week is presided over by one of the seven archangels.

14 Genesis 3.23 states that God sent Adam out of Eden ". . . to till the ground from whence he was taken". This type of image, with Adam and Eve working as a direct result of their wrong, was common. During the peasants' revolt in 1381 the English priest John Ball took it as an illustration of the equality of all men: "When Adam delved and Eve span, Who was then the gentleman? From the beginning all men by nature were created alike, and our bondage or servitude came in by the unjust oppression of naughty men."

13 God evicts Adam and Eve from the garden. In most representations St Michael does this: the mosaic is a literal representation of the verse: "So he drove out the man; and he placed at the east of the garden of Eden Cherubims, and a flaming sword which turned every way, to keep the way of the tree of life." (Genesis 3.24) Notice how the flaming sword takes the shape of the Cross, which is also referred to as the tree of life: in one story, it is even said to be made from the same wood.

12 Adam and Eve kneel before God sitting in judgment. The serpent slinks down the tree following God's edict: ". . . upon thy belly shalt thou go. . . ." (Genesis 3.14)

11 After the Fall Adam and Eve hide from God, clutching the fig leaves to themselves in their shame: Eve appears to be trying to disguise herself as a tree.

10 Having named all the birds and beasts, Adam has found no partner. God has put him to sleep, and is removing a rib, which he will use to create Eve, further to the right. In the next scene they are introduced to one another.

9 The reclining figures pouring water from jugs are personifications of the four rivers in the Garden of Eden: this form of representation comes from the classical depiction of a river god. To the left, God brings Adam into Eden.

8 In later images, notably by Michelangelo on the ceiling of the Sistine Chapel in the Vatican, the "Creation of Adam" and "God giving life to Adam" are one and the same, but this mosaic continues the story from the penultimate image: "And the Lord God formed man of the dust of the ground, and breathed into his nostrils the breath of life; and man became a living soul." (Genesis 2.7) The breath of life – or soul – is seen as a small winged person.

Protevangelium) and others like it were the major sources for understanding, among other stories, the early life of Mary.

Not all of the Bible has been illustrated, while particular episodes which are deemed important for Christian theology appear more often than others. One decorative scheme that is particularly thorough is the mosaic ceiling in the atrium of St Mark's Basilica in Venice, in which several stories, often simplified to one basic image, are elaborated in great detail.

While the creation dome in St Mark's (see preceding pages) is a straightforward illustration of the first three chapters of the Bible, the ways in which stories are depicted, or in which they are shown in relation to one another, can tell us a lot about the way that the text was interpreted, and reveals what was important about the story for the people for whom the work was made, the "patrons" (see pages 120–122). In this way the works are not unlike an illustrated sermon, conveying a specific message about a particular story.

It was important to the authors of the New Testament to show that Jesus was the awaited Messiah, whose coming was prophesied throughout the Old Testament. The relationship between the two books was elaborated by even the earliest of commentators, weaving a tapestry of interlinking threads in which almost every incident in the Jewish scriptures was seen as a precursor of something in the gospels. This is referred to as typology – the person or event in the Old Testament is the "type" or model for something in the New Testament, which is the antitype, or counterpart. Thus God giving life to Adam was a type for Jesus giving new life to Lazarus, whom he raised from the dead. Similarly Abraham, who was asked to sacrifice his son Isaac as a sign of his love for God (at the last minute an angel stopped him, and pointed to a ram as an alternative sacrifice), was the type for God the Father's willingness to sacrifice his only son Jesus on the Cross. The antitypes of Adam and Eve are somewhat surprising: Jesus and Mary, who are often interpreted as a new Adam and a new Eve. Although they are effectively opposites, they represent type and antitype because Adam and Eve gave us a start, whereas Jesus and Mary allow us a new start, giving us a second chance to get things right (see page 43). Giotto's decoration of the Scrovegni Chapel employs typological interpretation with great subtlety, and he takes this form of interpretation much further: his ability to connect narratives both horizontally and vertically on the wall, and sometimes across the chapel, is a confirmation of his genius.

Stories could also be interpreted allegorically. Jesus' parables were clearly intended as such, and we have already seen how the Good Samaritan window in Chartres (see pages 38–39) interprets the parable as an allegory of the soul's journey through a sinful world and its return to paradise, led by Jesus. Other images which purport to illustrate a Bible story are often based on ideas that exist outside the canonical scriptures. Some of the best examples of this are depictions of the Adoration of the Kings. The Bible does not mention kings visiting Jesus, let alone the number three – "there came wise men from the east to Jerusalem" (Matthew 2.1). The number was settled at three, in part because these men brought three gifts (gold, frankincense and myrrh), and in part because of the theological significance of the number (see pages 104–107). The promotion from "wise men" to "kings" increases their status, and therefore the importance and relevance of the story, and also because it fulfils an Old Testament prophecy: "Yea, all kings shall fall down before him: all nations shall serve him." (Psalm 72.11)

⊙ THE SCROVEGNI CHAPEL
Giotto di Bondone, c.1303–1305, PADUA, ITALY

Giotto's frescoes were painted for the chapel in the palace of Enrico Scrovegni, intended as a gift to God to pay for the sins of Scrovegni's father. Reginaldo was so famous as a usurer (he lent money on interest) that Dante included him in his *Inferno* in the seventh circle of hell. The frescoes tell the story of the life of the Virgin in the upper tier, the childhood and teaching of Christ in the middle tier and Christ's Passion and Resurrection at the bottom, with the Last Judgment taking up the whole of the west wall. In the narratives all movement takes place from left to right, leading us through the story, and Giotto uses the backgrounds to link or comment on the stories: notice how the hill that leads down to the head of the crucified Christ can be seen as continuous with that in which Lazarus has been buried in the higher tier, but also continues as a downward slope behind the Resurrection.

THE SCROVEGNI CHAPEL

1 Moses strikes a rock with his staff, and water gushes out, giving the Israelites in the wilderness something to drink. To the right, at the wedding of Cana, Jesus turns water into wine. Not only does Jesus provide for his people as Moses did, he goes further. As well as the literal interpretation of the story as a miracle, the wine would have been seen as prefiguring the Last Supper.

2 God gives life to Adam, and, to the right, Jesus raises Lazarus from the dead. The implication of this juxtaposition is that whereas God gives us life, we can have new life in Jesus Christ. Notice how the Old Testament "God" is made to look like Jesus, as he is in the St Mark's dome (see pages 72–73), although here his appearance is the more familiar bearded one.

3 Mary and Martha kneel, astonished that their brother Lazarus has been revived. Their positions, and the colours of their robes, echo the section above where people kneel in front of the temple altar. Mary is also seen kneeling in the same red cloak in the image beneath.

4 Lazarus, still wrapped in his shroud, emerges alive from his tomb. In the scene below, the resurrected Christ is likewise shown as a vertical figure clad in white: Giotto has deliberately created this visual echo to link the two episodes, both of which show a dead man restored to life.

5 Jonah is swallowed by the whale, only to be spat out onto the shore three days later – in the same way Christ died, and on the third day rose from the dead. The quatrefoil showing Jonah comes in between the Crucifixion and the lamentation over the dead Christ, and reminds us that Christ will triumph over death.

6 Mary, looking in sorrowing disbelief at the dead Christ, is in the same position in the Nativity, further along the opposite wall, where she looks in joyful disbelief at his birth. Christ is horizontal, in the next scene he is vertical, and in the next, the Ascension, he is up in the air: Giotto elaborates the narrative using Jesus' position and location within the frame.

7 This image is not a reference to the Old Testament: it derives from the suggestion in medieval bestiaries that lion cubs were born dead, but that life was breathed into them by the lioness. This was presumably a misunderstanding of the way in which the mothers lick their cubs clean at birth, but there is clearly a link to the idea of resurrection, which occurs in the next image.

8 An angel sitting on the tomb points toward the risen Christ. Giotto is subtly and ingeniously combining two parts of the story. In the first Mary Magdalene comes to the tomb, but finds it empty, and an angel tells her of Jesus' resurrection. In the second she does not initially recognize Jesus, thinking that he is the gardener.

9 Mary Magdalene kneels in recognition of the risen Christ. Her red cloak is pulled over her head. In the preceding scene it is round her waist, and her hair is tied up, whereas before that, at the Crucifixion, she is shown with her hair flowing freely and the red cloak around her ankles: Giotto movingly illustrates her repentance by changing the way she is dressed.

10 Jesus carries the flag of Christ Triumphant, which demonstrates his triumph over death. The red of his suffering, in the shape of a cross, is set against the white of his purity. The flag became associated with the crusaders, and, as a result, with St George.

11 According to the *Protevangelium of James*, in order to find who should marry the Virgin all eligible bachelors were told to bring rods to the temple. Giotto uses the same building in three adjacent images to tell us that all three events happen in the same place (only the first two are included here).

12 This painting is the illustration of a dramatic pause: nothing is happening. The kneeling priest in red echoes Mary Magdalene kneeling in astonishment at the resurrection of Lazarus in the centre, and in recognition of Christ at the bottom. They await a sign from God, in the same way that, in the bottom image, Jesus tells Mary not to touch him because he has not yet gone up to heaven. The waiting is over in the next images: Joseph's rod blooms as a sign that he should marry the Virgin, and Jesus ascends to heaven.

13 The vices are depicted on the left wall of the chapel (left and right are defined by facing the altar). This is the same side as the depiction of hell in the Last Judgment, which is painted on the west wall of the chapel. In this detail Infidelity is chained to a false idol: on the opposite wall is the virtue of Faith.

14 Injustice presides over a landscape which has gone to seed and where criminal acts take place. Opposite, Justice is shown in an altogether more ordered setting.

ONE GOD IN THREE PERSONS

Christianity, like Judaism before it, is a monotheistic religion: it advocates a belief in only one God. However, as Christians believe that Jesus was not only the Messiah prophesied in the Jewish scriptures, but also the Son of God, the nature of that one God is fundamentally different. According to a fundamental doctrine of Christianity, although there is one God, he exists in three persons – the Holy Trinity. God is triune: the Father, the Son and the Holy Spirit.

Debates about the nature of this Trinity have continued over the two millennia of Christian history, and are at the roots of the division between the Eastern and Western churches, but they are based on biblical authority – Jesus himself sent his disciples out "in the name of the Father, and of the Son, and of the Holy Ghost" (Matthew 28.19). It remained for the Church to explain these complicated ideas to the general population of believers, with art being arguably the most important means of communication.

The three persons of the Trinity can be represented separately. God the Father is often shown as an old man with a white beard, enthroned in heaven, although the "God" of the Old Testament is often shown as "Jesus" – the result of a lack of definition between "the Father" and "the Son" in the Old Testament. Jesus is shown as a young man, and in the earliest images is beardless. However, from the eleventh century, with a few notable exceptions, he is shown with long, dark hair and a beard, and a halo that is either cross-shaped (cruciform) or has a cross on it. Jesus wears red and blue, until the Resurrection, when he wears white.

The Holy Spirit is most frequently shown as a dove, on biblical authority: when Jesus was baptized "the Holy Spirit descended in a bodily shape like a dove" (Luke 3.22). As such the Holy Spirit appears in images of the baptism of Christ (page 24), the Annunciation (page 87), and Pentecost, when tongues of fire descend on the apostles after Jesus' ascent into

◖ THE HOLY TRINITY
St Michael's Church,
Doddiscombleigh, England

Although iconoclasts did not destroy this image of the triune God, comparison with other versions suggests that the yellow glass below the central figure may have replaced an image of Mary sitting at the feet of the Trinity: Protestants considered the Roman Catholic devotion to the Virgin to be especially idolatrous. This representation shows the three persons as separate beings, whereas doctrine accepts they are one. As if to illustrate this explicitly, there is a rarer form which shows the Trinity with one body and three heads. However, commentators such as St Antoninus, bishop of Florence in the 15th century, considered it "monstrous" and said the image should not be used.

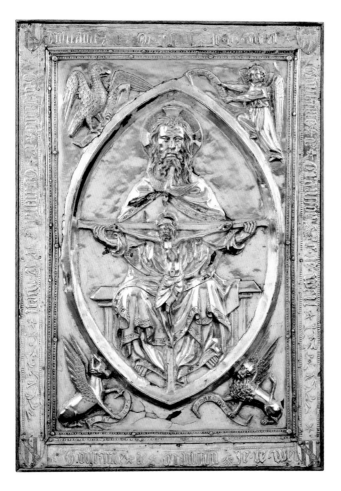

◐ **RELIQUARY PANEL**
Robinet (?), c.1370, Museé d'Art et d'Histoire, Fribourg, Switzerland

This is the front cover of a reliquary diptych, which was made up of two wooden panels containing compartments to hold the relics of saints. (The back cover shows the Virgin Mary and St John the Baptist.) The decoration includes the name and coat of arms of Guillaume de Grandson, as well as his personal motto, "*je le weil*" ("it is my will"). As well as showing the Holy Trinity in a form known as the "mercy seat" (not to be confused with a misericord, see page 57), the symbols of the evangelists are included in the four corners with each one holding a scroll bearing the appropriate name. Matthew is represented by an angel, in the top right corner; Mark by a winged lion, in the bottom right; Luke by a winged ox, in the bottom left; and John by an eagle, in the top left corner. (See also pages 92–97.)

heaven, and they are inspired by the Holy Spirit to preach in different languages (pages 87).

The dove also appears in most representations of the Trinity. One type of image, known as the "mercy seat", emphasizes the paternal and protective nature of the Father, as well as reminding us of the sacrifice of the Son: God the Father, with a long, flowing beard, supports the Crucified Christ, with a dove flying in between. Enthroned in heaven, God may appear differently. Often we see two men, one old, one young, seated side by side, with a dove flying overhead (pages 190–191). In another less common example, intended to demonstrate the equality of the three, the persons of the Trinity are shown as identical kings all seated on one throne.

However, giving a face, or faces, to the Trinity was not enough to explain its nature: how can one God exist in three persons? A common diagrammatic motif (see background, opposite), known as the "Trinity shield", expresses all that most church-goers needed to know. Triangular in shape, the three corners are labelled "The Father", "The Son" and "The Holy Spirit". In the centre is the word "God". Connecting the three names are the words "is not", so the diagram reads "The Father is not The Son", for example. Leading from the outside to the centre is the word "is", so "The Father is God", "The Son is God", and "The Holy Spirit is God". The diagram may not explain how this can be so – that is a matter of faith. The diagram tells us what that faith should be.

JESUS: GOD & MAN

Because Jesus was present on Earth he is more frequently depicted than either the Father or the Holy Spirit, and he is shown in a wider range of situations – the Christian gospels being concerned with his birth, life, death and resurrection. As well as depicting stories from Jesus' life, imagery was also used to explain who, or what, he was. There are different implications to the descriptions "the Son of God" and "God the son": the former is more human, the latter more divine, and this created debate within the early Church. Thinkers such as Arius, a Christian from Alexandria, Egypt, in the late third and early fourth centuries, believed that the "Son of God" had to have been a created being. In 325 the Council of Nicaea deemed this belief to be a heresy (a term coined earlier to denounce the Gnostics for something which goes against the orthodox, or correct, belief). Nevertheless, in some branches of the Church Arianism continued for several centuries. Nicaea established that God the Father and God the Son were of one substance, so must have existed together before Creation.

In 451 the Council of Chalcedon elaborated a fuller understanding of Jesus, accepting that he had two "natures", human and divine: he was both God and man. Once more art was used to show us ideas that are difficult for us to comprehend. Murillo's painting known as *The Two Trinities* is a particularly clear exposition of the two natures of Christ. St Augustine, one of the Doctors of the Church, also came up with the clever analogy of a lit candle. The wax represents Jesus' body, while the wick, hidden by the wax, is his soul. The flame is his divinity. This comparison explains why extinguished candles are sometimes depicted in images of the Annunciation: as Christ becomes human his divinity is temporarily hidden from view.

Seeing Jesus

Relatively few images focus on the precise nature of Christ: more are concerned with his life on Earth. Pictures were seen as "the Bible of the poor" because most people could not read, and it was thought that they would understand the stories far more clearly by seeing them than they would by listening to them being read. St Francis was particularly important in this respect, and he founded the Order of Friars Minor (better known as the Franciscans) with the specific aim of preaching to the impoverished and uneducated. He realized that the easiest parts of the gospels for people to empathize with would be the moments of Christ's greatest humanity: his birth and his death. St Francis's popularization

TWO BLESSINGS

In paintings, sculptures and stained glass Jesus is regularly shown in the act of blessing. The gestures depicted are derived from Church practice, and include several distinct forms. In one version ❶ used in the Eastern Church, and also common in images inspired by the art of Byzantium, the fingers spell out the letters *ICXC*, *IC* and *XC* representing the first and last letters of the Greek words for Jesus Christ. The forefinger is straight (*I*) while the middle finger is slightly bent (*C*), the thumb crosses over the fourth finger (*X*), and the little finger is bent (*C*). In another ❷, rather than crossing the fourth finger, the thumb holds it down with the little finger: these three digits represent the Holy Trinity. The remaining two fingers represent the two natures of Christ, human and divine, and in some subtler representations the middle finger is slightly bent to be the same length as the first finger, implying that Jesus' divine nature is stooping to the human.

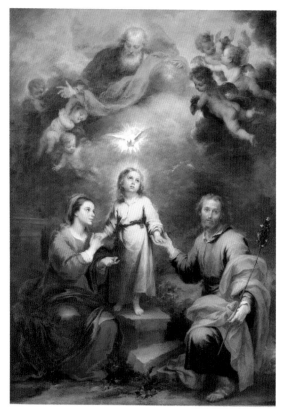

◐ THE TWO TRINITIES

Bartolomé Esteban Murillo, C.1675–1682, THE NATIONAL GALLERY, LONDON, ENGLAND

Jesus stands directly underneath God the Father, while the Holy Spirit hovers in between. This central, vertical axis (circled in red) represents God, the three persons of the Holy Trinity. At the bottom of the painting, Jesus is standing on Earth between his mother Mary, and stepfather Joseph: this horizontal axis (circled in green) shows his human family. The fact that Jesus is in the overlap between the two groups reminds us that he is both God and man.

of the Christmas crib (see page 52) originated with his belief that seeing Jesus as a helpless baby would help people to understand God's humility in taking human form.

Drawing on accounts from all four gospels, pictures of Jesus' life can be divided into different stages, or "cycles": his birth (starting from the Annunciation); his preaching and miracles (starting with the Baptism); and finally his Passion (from the Entry into Jerusalem to the Crucifixion and the Resurrection). The New Testament tells us little about the childhood of Jesus, apart from an episode in which he goes missing, but is eventually found at the temple in discussion with the elders. This story, known as "Christ among the doctors", was supplemented by popular folktales, such as Jesus riding on a sunbeam, and bringing clay birds to life, which very occasionally appear in church decoration.

Certain images emphasized Jesus' divinity, most notably the Transfiguration, when Jesus, accompanied by Peter, James and John, ascended a mountain to pray. Suddenly Jesus' face shone like the sun and his clothes looked brilliant and white. The prophets Moses and Elijah appeared talking to him, and the three apostles heard a heavenly voice say: "This is my beloved Son, in whom I am well pleased." At that moment the disciples had confirmation that Jesus was the Son of God. Depictions of this story give the viewer the same advantage. This is also true of representations of the Resurrection. However, the episode that best exemplifies the idea that "seeing is believing" is the Incredulity of St Thomas: the apostle needed to see Christ and touch him before he could believe in the Resurrection. Although we do not have Thomas's first-hand experience, the artists do their best to give us this proof: one of the reasons Renaissance artists started to paint more realistically was to enable us to see more clearly, and therefore believe more profoundly.

THE BOLOGNA COPE

LATE 13TH–EARLY 14TH CENTURY, MUSEO CIVICO MEDIEVALE, BOLOGNA, ITALY

A cope is the outer vestment worn by a priest during the mass. In paintings the cope, which is a form of cloak, is often used as one of the identifying features of a bishop. The example illustrated here may well have belonged to Pope Benedict XI, whose tenure was brief (1303–1304). The delicate embroidery in silk and gold thread, known as Opus Anglicanum or "English Work", was extremely popular in Europe and was exported from England in large quantities. In 1246 Pope Innocent IV wrote numerous letters to English abbots asking them to send him as much as they could, having declared that, "England is for us surely a garden of delights, truly an inexhaustible well". Two "cycles" are depicted on the cope: the Nativity and the Passion (that is, Christmas and Easter). There are twelve scenes of the former and seven of the latter – both numbers having symbolic meaning (see pages 104–107). The stories are not depicted in the traditional order, and their arrangement here may be due to the structure of the cope. When worn by the bishop, the scenes along the straight edges (at the top here) would have been at the front of the cope, whereas those in the middle would have hung down the bishop's back.

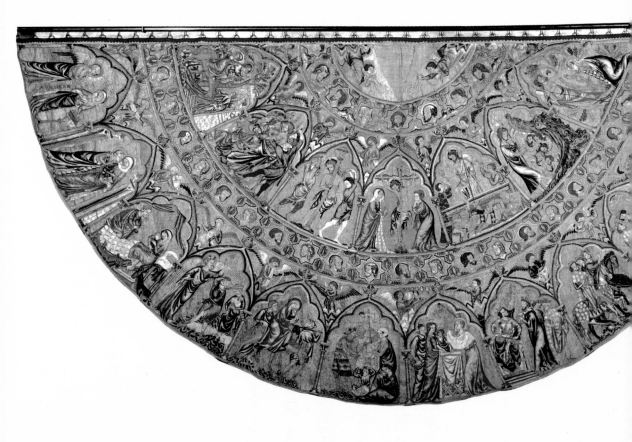

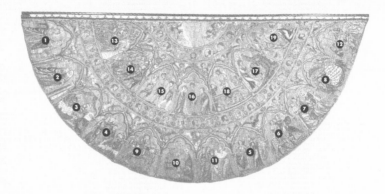

1 The Annunciation – the angel Gabriel tells Mary that she will be the mother of Jesus.

2 The Visitation – Mary visits her cousin Elizabeth, who is also expecting a child (John the Baptist).

3 The Nativity – the birth of Jesus.

4 The Annunciation to the Shepherds – an angel tells the shepherds about the birth of Jesus.

5 The Wise Men, or Magi, consult Herod – seeking a boy born to be king, they ask Herod if he knows of the boy's whereabouts.

6 The Magi follow the star – they continue their journey, having been asked by Herod to return and tell him where the new "king" is.

7 The Adoration of the Magi – the star has stopped above Jesus: one of the kings points toward it while another kneels in homage and presents his gift.

8 In a dream an angel warns the Magi not to return to Herod's court.

9 The Flight into Egypt – warned by an angel of the approach of Herod's soldiers, Joseph leads Mary and Jesus to safety in Egypt.

10 The Massacre of the Innocents – realizing that the Magi have not returned, Herod orders his men to kill all of the baby boys two years old and under. The story was interpreted as the sacrifice of the innocent children to save Christ, and it was thought that their souls went straight to heaven. Notice how this scene of sacrifice is directly under the Crucifixion.

11 The Presentation at the Temple – Jesus is presented at the temple in accordance with Jewish law, and is recognized as the Messiah by the high priest Simeon. This would have happened forty days after Christmas, and is celebrated on 2 February ("Candlemas"). Luke mentions the presentation immediately after the circumcision of Jesus, which is

celebrated on 1 January. Although the circumcision would not have taken place in the temple, it is sometimes depicted there. This may be the artist's intention, as it was the first time Christ shed blood: like the Massacre of the Innocents, this scene is directly below the Crucifixion.

12 The only non-biblical story is the martyrdom of Thomas Becket (see pages 55 and 152). In part this is the result of the cope's English origins, but is justified by the celebration of his feast on the day he was murdered, 29 December, during Christmas week.

13 The Entry into Jerusalem – Jesus enters Jerusalem on an ass, rather than a horse, to show his humility, and onlookers strew his path with palms, giving us the name of the day on which this occurred: Palm Sunday.

14 The Betrayal – after the Last Supper Judas betrays Jesus by identifying him to the soldiers with a kiss.

15 The Flagellation – prior to the Crucifixion, Pontius Pilate ordered that Jesus should be flogged.

16 The Crucifixion – Mary and John the Evangelist stand at the base of the Cross, in accordance with the gospels.

17 The Harrowing of Hell – according to the Apostles' Creed, Jesus "suffered under Pontius Pilate, was crucified, dead and buried; He descended into Hell". Here he steps into hell, conceived as a large mouth, to free those souls which had been waiting for redemption since the beginning of time. This episode is also called the Descent into Limbo.

18 The Resurrection – Christ steps effortlessly from the tomb while the guards sleep at his feet. Although this happened after the harrowing of hell, the image has been moved to give it prominence on the bishop's back.

19 *Noli me tangere* – the resurrected Christ appears to Mary who mistakes him for the gardener. When she realizes her mistake, he warns her not to touch him, as he is no longer part of this world but not yet part of the next. The episode is named after the words Jesus spoke to Mary: "touch me not" (John 20.17).

ALTAR OF THE HOLY BLOOD

Tilman Riemenschneider, 1501–1555, JAKOBSKIRCHE, ROTHENBURG,
GERMANY

This altar was constructed as an elaborate reliquary to contain and
display a drop of Christ's blood, a holy relic which brought many
pilgrims to Rothenburg. By making the altarpiece so open, the light
coming through the windows of the church becomes doubly important.
The real glass set into the back of the altarpiece enables the daylight to
illuminate the Last Supper, thus making the imagery more immediate
– the characters are lit by the same light as we are.

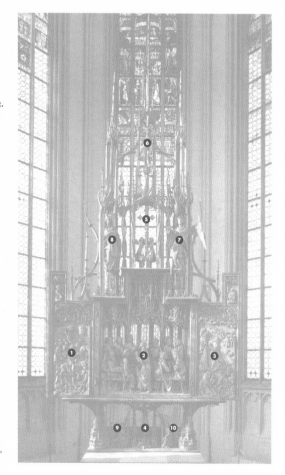

1　The Entry into Jerusalem – at the start of Easter week, on Palm Sunday,
Jesus enters Jerusalem riding on an ass.

2　The Last Supper – Jesus and the Apostles gather in an upper room to
celebrate the Jewish festival of Passover. Jesus has said that one of the
number will betray him, and Judas, given a prominent central position,
has stood up to leave. Judas holds thirty pieces of silver – the fee for his
betrayal – in his left hand.

3　The Agony in the Garden – after the Last Supper Jesus goes out to the
Garden of Gethsemane to pray for strength for the coming ordeal. Judas,
accompanied by soldiers, approaches through the garden gate at the top
right, while Peter, James and John sleep at the bottom.

4　The Crucifixion – Jesus was crucified at a site known as Golgotha, which
means "the place of the skull". The skull, shown at the foot of the Cross,
was believed to be that of Adam, and Christ's blood falling onto it was
symbolic of Adam's redemption.

5　The cross supported by two angels is a reliquary containing the "holy
blood". As well as being silhouetted by the light from the window behind,
which can be seen as the Light of God, the crystal vessel containing the
blood also has light passing through it.

6　The Man of Sorrows – this is not part of the Passion narrative, but a
symbolic representation reminding us of Christ's suffering. Christ stands
wearing the loincloth in which he was crucified, and the crown of thorns
used to mock him. He gestures to the wound in his side from which the
blood flows. The curving drapery of the loincloth echoes the trajectory of
the blood.

7　The Archangel Gabriel, announcing Christ's birth to the Virgin Mary, is
on the right. Although the majority of depictions of the Annunciation
read from left to right, a considerable proportion go the other way, but
there does not seem to be any significance to this variation.

8　Mary leans back, expressing her surprise and humility at the
Annunciation: the light streaming in through the windows now
represents the light coming into the world, and the "grace" with which
she is filled is the grace bestowed on us through the shedding of Christ's
blood (see pages 8–11).

9　The angel holds one of the instruments of the Passion, the column
to which Christ was tied for the Flagellation.

10　Although next to the Crucifixion, this angel holds a cross, another
of the instruments of the Passion.

MARY: MOTHER OF GOD

The Virgin Mary, like Jesus, is depicted more often than God the Father and the Holy Spirit – and only partly because of her important role in the Earthly life of Jesus. As his mother, she is present in all of the scenes of his birth and childhood, and a substantial number of the later stories. However, her prominence in art is due also to the special reverence accorded her in the Orthodox and Roman Catholic churches. The Bible says relatively little about Mary except that she came from the town of Nazareth, and was betrothed to Joseph. For Protestants the little biblical evidence there is suffices, and Mary is seen as the mother of Jesus, worthy of respect, but little more. Indeed, during the Reformation, and for many years thereafter, Protestants considered the attitude of Roman Catholics toward Mary as tantamount to idolatry, and images of the Virgin were particularly singled out for destruction (see, for example, the window showing the Holy Trinity on page 78).

Theotokos – the "God-bearer"

This special form of reverence predates the Reformation by centuries. The Third Ecumenical Council, held at Ephesus in 431, gave Mary the title *Theotokos*, which translates literally as "God-bearer", but which effectively means "Mother of God". One reason for this was the continuing concern about the nature of Christ – if Mary was accepted as the Mother of God, then there would be double assurance that Jesus was God. It would be another twenty years until the Council of Chalcedon established the idea of the two natures of Christ. The term *Theotokos* is still used within the Orthodox Church, and it is as the Mother of God that Orthodox Christians and Roman Catholics consider Mary to be due a higher form of reverence than other saints. As well as being the Mother of God, she is also seen as the mother of us all, and is often depicted as the Madonna of Mercy, protecting her people under her cloak.

❍ OUR LADY OF THE GATE OF DAWN

c.1630–1650, Vilnius, Lithuania

This image, highly revered by Catholics and Orthodox residents, was painted for a niche in the Gate of Dawn, the last remaining of the nine city gates of Vilnius, which after 1655 became the responsibility of the Carmelite monks from a nearby monastery. In 1671 the monks built a chapel to house the painting, and by 1761 seventeen miracles could be attributed to the intercession of Mary in answer to prayers said in front of the picture. As a result, the image was gradually "clothed" in gold and silver, with the crescent moon added in 1849 as a reference to the iconography of the Immaculate Conception. The rays of the sun are repeated from the painting itself, and in between them are twelve stars.

THE ANNUNCIATION

Veit Stoss, 1517–1518, Lorenzkirche,
Nuremberg, Germany

In the late 1520s Stoss's larger-than-lifesize Annunciation
could easily have been destroyed in the Reformation, just
as many other images of Mary in Nuremberg were. This
sculpture is sometimes given the title *The Annunciation
of the Rosary*, because it is framed by a representation
of prayer beads. A rosary traditionally has five sets of
ten small beads, each known as a decade, separated by
five large beads. When praying, each decade is used to
contemplate a different mystery, with prayers being said
as each bead passes through the fingers. For each small
bead a "Hail Mary" is said, and on the larger beads,
the Lord's Prayer, or "Our Father". There were fifteen
mysteries, so three circuits of the rosary would be "told",
which adds up to 150 "Hail Marys" – the same as the
number of Psalms – as well as fifteen "Our Fathers".
The mysteries are divided into three groups: the Joyful
Mysteries, which are taken from the Nativity cycle; the
Sorrowful Mysteries, from the Passion cycle; and the
Glorious Mysteries, which include the Resurrection, the
Ascension, the Descent of the Holy Spirit ("Pentecost"),
and the Assumption and Coronation of the Virgin.

1 **The Nativity** is one of only two roundels with scenes taken from the Joyful Mysteries.

2 **The Adoration of the Kings** and the Nativity were presumably chosen because they
follow from the Annunciation.

3 **The Resurrection**, from the Glorious Mysteries, is at the apex of the rosary, just under
God the Father.

4 **The Ascension** shows the apostles kneeling as Christ's feet disappear above them.

5 **Pentecost** – the Holy Spirit, though small, is visible hovering above the apostles.

6 **The Assumption of the Virgin** shows Mary surrounded by the apostles as she leaves
the ground.

7 **The Coronation of the Virgin** shows Mary and Jesus surrounded by a blue, flowing
background that represents the sky.

One result of this increased reverence was a desire to know more about Mary. The *Protevangelium of St James*, probably written in the middle of the second century, describes how Mary came to be born to Joachim and Anna, how as a child they took her to the temple where she lived alongside other virgins, and that eventually Joseph was chosen as her husband as the result of a sign sent by God (illustrated by Giotto in the Scrovegni Chapel, see pages 74–77). From this point on we return to the biblical narrative, when Gabriel appears to Mary and announces that she will be the mother of Jesus, the Son of God, through the agency of the Holy Spirit. In Veit Stoss's brilliant sculptural version (see illustration, page 87) God the Father is at the summit, with beams of light radiating downward, implying that Jesus, the Light of the World, is coming into the world, while the Holy Spirit has alighted on Mary's head. At the bottom of the image, hanging under the sculpture, the serpent holds an apple, symbol of the forbidden fruit.

The point of the incarnation – Jesus being made flesh – was that he would die on the Cross and then triumph over death to free us from the original sin introduced into the world by Adam and Eve. But this gave rise to a problem about the nature of Mary: as a descendant of Adam and Eve she should have been blighted with the same sin. But how could God, perfect in every way, be born of something sinful? Theologians realized that Mary had to have been free of sin, even though that was not possible prior to the Resurrection. She must therefore have been cleansed of sin through a special dispensation of God, or was never sinful in the first place. Two particular ideas emerged: Mary was conceived with sin, but was freed of it in her mother's womb; and Mary was conceived without a stain or mark of sin, which is the doctrine of the Immaculate Conception.

The doctrine is a separate idea from that of the virgin birth, which is the belief that Jesus was born to a virgin, Mary. The Immaculate Conception refers to the origin of Mary in her mother's womb, free of sin. That is not to say she was conceived without sexual intercourse: although a very few theologians considered the birth of Mary to be a virgin birth, this has never been a doctrine of the Church. The doctrine of the Immaculate Conception became Roman Catholic dogma (that is, a doctrine of faith that is not open to question) in 1854. Nevertheless, it had been widely depicted from the late fifteenth century onward, its standard form derived from a reference in the book of Revelation (12.1, see pages 43 and 212).

Other ideas follow from this. One of the results of original sin was that Adam and Eve had to work hard, grew old, got ill and died, as do we all (see pages 72–73). If Mary was free of original sin, she would not have grown old – which is why she appears so young in many images – and she should still be alive. So where is she now? Answers are provided in non-biblical texts, which tell us that initially Mary's soul was taken up to heaven by Jesus, and Mary, alive but with no soul, effectively went to sleep. When depicted this is called the Dormition of the Virgin. The apostles decided to bury Mary's body, which was subsequently carried up to heaven by the angels (the Assumption of the Virgin) where it was reunited with her soul prior to her coronation as Queen of Heaven. The remarkable dome decorated by Gaudenzio Ferrari in Saronno is an illustration of the Assumption. Although not known as an innovative artist, Ferrari pre-empts the developments of the Baroque by turning the subject into a drama taking place in real space: the Virgin, seen in the drum which supports the dome itself (at the bottom of this image), is shown surrounded by rays of light, standing on a small cloud and carried up to heaven by angels – her approach being celebrated by the angelic host singing and playing a multitude of musical instruments. In the centre God the Father reaches out to welcome her with open arms.

◐ **DOME WITH THE ASSUMPTION OF THE VIRGIN**
Gaudenzio Ferrari, 1535–1545, SANTA MARIA DEI MIRACOLI, SARONNO, ITALY

Nothing expresses the idea that a dome represents the vault of heaven as well as Gaudenzio Ferrari's decoration of Santa Maria dei Miracoli. To achieve this magnificent effect the artist used painting *and* sculpture: the figures of God the Father and Mary are three-dimensional, the wood being both carved and painted by Ferrari.

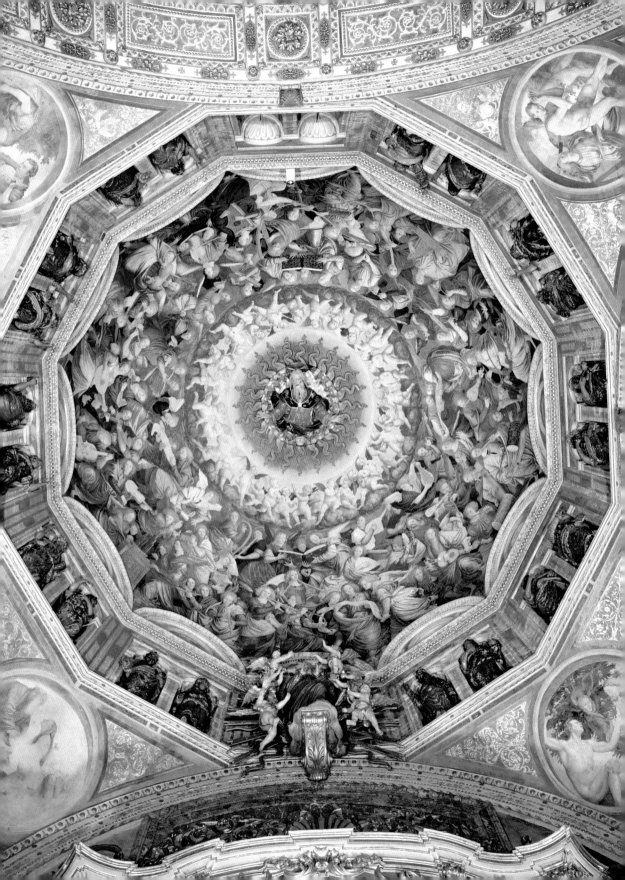

PROPHETS & SIBYLS

The prophets and sibyls are all supposed to have foretold the coming of Christ. Only the prophets are biblical in origin – all of them are contained in the Old Testament, with the exception of John the Baptist, a New Testament character who is often seen as the last in the line of Old Testament prophets. He baptized people in preparation for the coming of the Messiah, and is sometimes called "The Precursor".

There are four major prophets (Isaiah, Jeremiah, Ezekiel and Daniel), and twelve minor ones, whose writings make up the last twelve books of the Old Testament: all sixteen are depicted at the bottom of the South Rose Window in Notre Dame (see page 37). There were others who had prophetic experiences and some of the most significant are included in sculptural form on the North Porch of Chartres Cathedral (see illustration, right). Melchizedek, the priest and king who blessed Abraham and "brought forth bread and wine" (Genesis 14.19), carries a chalice or *ciborium* for this purpose: the relevance to the Last Supper is clear. Abraham is frequently represented about to sacrifice his son Isaac, which

he was asked to do as a sign of his love for God. An angel stopped this reluctant sacrifice, and pointed as a suitable alternative to a ram (shown under Abraham's feet). This episode was interpreted as a reference to God's willingness to sacrifice his own son, Jesus, on the Cross.

Moses is shown holding the tablets of the law (the Ten Commandments) and a column topped by a bronze serpent, which God had instructed him to erect when the Israelites were struck by a plague of snakes: all those who looked at the brazen serpent were cured, in the same way that all who look to Christ will be saved. (Moses is alternatively depicted with a staff, which he used to part the Red Sea.) The figure

◯ SIBYLS

Raphael, c.1511–1512, Santa Maria della Pace, Rome, Italy

Raphael painted these four sibyls, inspired by angels, for Agostino Chigi, the personal banker of Pope Julius II. The poses and sculptural forms show how strongly Raphael was influenced by Michelangelo's paintings for the Sistine Ceiling, executed for Julius, which include the most famous – and monumental – representation of the sibyls.

next to Moses is a priest and is sacrificing a lamb, symbolic of Christ (the "Lamb of God"). He could be Aaron, the brother of Moses, although he might also be Samuel, who anointed David as king. Indeed, the crowned figure next to the unknown man *is* David, holding a spear and now without the crown of thorns originally held in his missing left hand. This is a reference to Psalm 22, which is interpreted as prophesying the Crucifixion: verse 16 includes the words "they pierced my hands and my feet".

These characters were depicted in ways that emphasize their relevance to Christ and to Christian belief. They can be identified by their appearance, and the symbols or attributes which accompany them. Prophets can also be identified generically if they hold scrolls: New Testament characters are more likely to hold books. (This has a historical basis: it was only in the second century that what we know as a "book", the bound codex with pages that can be turned, was invented.) If they are not shown with specific attributes,

◐ PROPHETS

1200–1225, NORTH PORCH OF CHARTRES CATHEDRAL, FRANCE

From left to right, the five sculptures in the foreground represent Melchizedek (carrying a *ciborium* receptacle), Abraham, Moses, Aaron (or Samuel) and David.

their identification rests on being able to read the prophecy on their scrolls, although some artists label them explicitly.

The sibyls were female equivalents of the prophets (Greek *sibylla* means "prophetess"). They have no basis in scripture but derive instead from classical writings. Plato and Aristotle speak of "the sibyl", implying there was only one, although later classical authors refer to more. Christian theologians expanded the number to twelve to match the minor prophets, and because the number had potent symbolic significance. Despite their dubious origins, the sibyls appear regularly, especially in Renaissance Rome (see left), albeit less frequently than the prophets.

THE COMMUNION OF SAINTS

The word "saint" means, quite simply, "holy", and across Christianity it is generally accepted that any soul in heaven, and therefore in communion with God, is a saint. However, within the Roman Catholic and Orthodox faiths certain named saints are deemed worthy of respect and even reverence as a result of the exceptional virtue of their life or deeds. Furthermore, it is understood that they can intercede for both the living and the dead, thus prayers are offered to them (and pilgrimages were, and are, undertaken to where their remains are housed, such as those of the martryred Foy at Conques, see illustration below). The early disciples were all considered saints as a result of their first–hand experience of Christ. Anyone dying as a result of their belief in God – a martyr – is considered to have immediately entered heaven, and therefore automatically becomes a saint.

The number of saints represented in religious art is enormous, and they can be recognized either by their dress, or by the specific symbols or attributes which are associated with them. These saints are depicted in altarpieces and on buildings for reasons which vary from the personal to the political. Certain saints are more frequently represented than others, notably the Virgin Mary and John the Baptist. A few tend to occur in specific groupings. The four evangelists – Matthew, Mark, Luke and John – are among the most frequently depicted. Rectangular shapes are so commonly used in buildings and furniture that the evangelists can conveniently be arranged with one in each corner (see, for example, page 79), or on each wall. Their symbols originated in the book of Revelation, where four winged creatures are described around the throne of God: a man (or angel), a lion, an ox and an eagle, which came to represent respectively saints Matthew, Mark, Luke and John.

Another well-represented group of saints are the four Doctors of the Church: Ambrose, Augustine, Gregory and Jerome. They can be identified by their dress. Ambrose and Augustine were bishops, and so wear headgear known as a mitre. It can be hard to distinguish between the two, although Ambrose sometimes has a whip, a symbolic scourge of heresy, and Augustine may be depicted with some of his writings, such as his books *On the City of God* and *The Trinity*. Gregory was a pope and wears the triple tiara, a conical hat with three diadems worn by the pontiff until the second half of the twentieth century. Jerome, a papal advisor, is shown as a cardinal, in a red robe with a broad–brimmed red hat, even though the position of cardinal had not been instituted during his lifetime. The Orthodox Church has its own four Doctors, recognizing in particular the Three Hierarchs: saints Basil, Gregory of Nazianzus and John Chrysostom. With Athanasius, the four were recognized as

◖ RELIQUARY OF ST FOY
C.980, ABBEY CHURCH OF ST FOY, CONQUES, FRANCE

The rich decoration of this sculpture is a reflection of the respect accorded to Christian saints. While some saints were revered in an almost abstract sense, the physical remains of others – known as "relics" – were especially prized and provided one of the main focal points for pilgrimage (see page 155).

the Doctors of the Eastern Church by Pope Pius V in 1568. This led to the inclusion of saints John and Athanasius on the *Cathedra Petri* (see page 66).

The other main group of saints is the apostles. Rather than Judas, the twelfth figure represented is either Matthias, who was appointed by the other eleven, or Paul, who was a major figure in the early years of Christianity.

New saints

The number of saints is not fixed. Although the concept of "sainthood" evolved within the early Church, today there is a well-organized procedure in the Roman Catholic Church leading up to canonization, or inclusion in the canon of saints. The Church does not "make" saints, it "recognizes" them, and prior to becoming a saint a candidate will be beatified, meaning they are considered "blessed" by God.

Although saints continue to be recognized on a regular basis, there have been certain periods in history when the rate has been particularly high. Many of the thinkers who promoted the Counter Reformation received such recognition: the acceptance of new saints in itself helped to counter the beliefs of the Protestants. Ignatius of Loyola, the founder of the Jesuits, was beatified in 1609, and then canonized in 1622 by Pope Gregory XV. In the same year Gregory also canonized Teresa of Ávila, a Spanish visionary and Carmelite nun who had died in 1582. Her fervent visions and devotional writing were, like Ignatius of Loyola's *Spiritual Exercises*, of prime importance in revitalizing the Roman Catholic Church and rebuilding its authority. The late twentieth century saw a wider range of people being canonized, notably by Pope John Paul II, who sought to recognize the contribution of Christians outside Europe, and to provide role models for an ethnically diverse Church. Although according their representatives a different status, the Church of England had similar aims when it commissioned a series of sculptures of twentieth-century Christian martyrs, installed on the west front of Westminster Abbey in 1998.

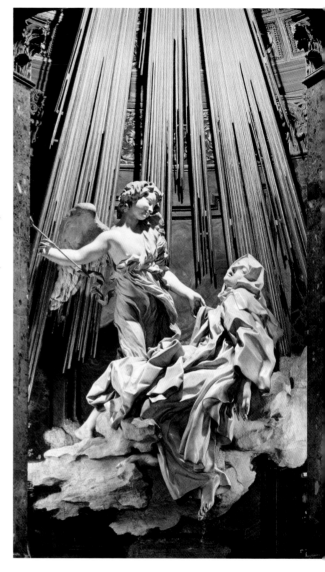

THE ECSTASY OF ST TERESA
Gian Lorenzo Bernini, 1647–1652, Santa Maria della Vittoria, Rome, Italy

Bernini illustrates St Teresa's vision of an angel as something we too can witness. The sculpture is framed, and exists within an oval space, almost like a bubble in the wall, which is lit from above by a skylight Bernini constructed outside the chapel. On either side of the chapel the donors sit in what appear to be theatre boxes, witnessing the spectacle in the same way that we do from the altar rail beneath it.

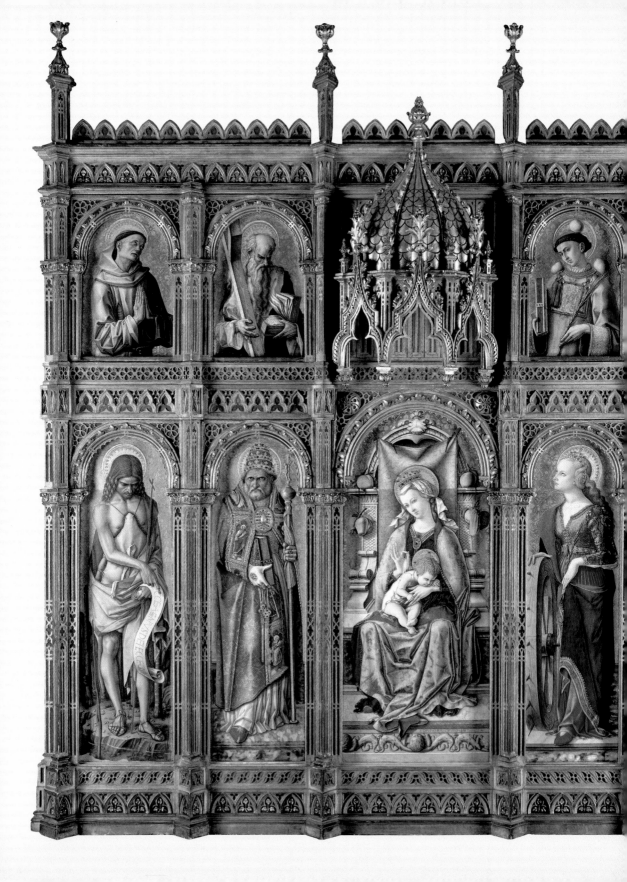

THE DEMIDOFF ALTARPIECE

Carlo Crivelli, 1474, THE NATIONAL GALLERY, LONDON, ENGLAND

This altarpiece is named after Anatole Demidoff, a wealthy Russian businessman who spent much of his life in Italy. He commissioned the frame in the mid-19th century, the elaborate canopy above the Virgin and Child disguising the absence of one of the panels, a Pietà that is now in the Metropolitan Museum of Art in New York. The saints depicted by Crivelli would have been chosen by the patrons of the altarpiece, which was commissioned for the High Altar of San Domenico in Ascoli Piceno, Italy – hence the inclusion of two Dominican saints.

1 ST JOHN THE BAPTIST – usually shown dressed in camel skin, carrying a cross made of reeds and sometimes carrying a bowl used for baptism. John frequently carries a scroll, identifying him as the last of the prophets, with the words "*vox clamantis in deserto*" ("a voice crying in the wilderness") or "*ecce Agnus Dei*" ("behold the Lamb of God"). He may also be carrying a lamb, and often points toward Christ, to the Bible, or to the lamb.

2 ST PETER – as the first head of the Church, Peter is shown here as a pope, wearing the triple tiara, a cope and carrying a crozier, an abstracted form of shepherd's crook (Jesus, seen as the "good shepherd", asked Peter to "feed my sheep", and to this day a priest will refer to his "flock"). Peter also carries the keys of heaven (see page 67). It is relatively rare to see Peter as a pope: more often he is dressed in yellow and blue, and has short grey hair and beard.

3 ST CATHERINE OF ALEXANDRIA – according to legend, Catherine was tortured with a spiked wheel (which God destroyed) and then beheaded. She is shown either with her wheel, which is often broken, or with a sword.

4 ST DOMINIC – the founder of the Order of Preachers, more commonly known as the Dominicans, is shown wearing the black and white habit of his order, and carrying a lily to signify his purity. Dominic sometimes has a star on his forehead, or in his halo, because he was said to glow with sanctity.

5 ST FRANCIS – wears brown, or sometimes grey, the habit of the Order of Friars Minor, or Franciscans. Three knots on the belt represent the vows of chastity, poverty and obedience. Francis has stigmata (wounds corresponding to Christ's).

6 ST ANDREW – the brother of St Peter is often shown with the cross on which he was crucified. The tradition that this was a diagonal one developed during the middle ages, and is not universal. He often wears green and has a long white beard.

7 ST STEPHEN – is often referred to as the protomartyr, or first martyr. His stoning to death is recounted in the Acts of the Apostles. Stephen carries the palm awarded to all martyrs, and has stones resting on his head and shoulders. He is dressed as a deacon.

8 ST THOMAS AQUINAS – a Dominican theologian, Thomas is shown as slightly portly, carrying a book and a church. He is frequently shown with the sun on his chest, a symbol of the light of God that shines from his teachings.

THE MYSTIC MILL WINDOW

C.1455, BERN MINSTER, SWITZERLAND

The artists who made this window are not known, though they may have been followers of Niklaus Glaser, who created other windows in the cathedral. This is the lower half of the composition, arranged into five rows, each with four "lights". In the upper half Moses strikes a rock, providing water for the Israelites in the wilderness, which forms a stream flowing into this section. Elsewhere the Israelites also gather Manna, provided as food by God, which was interpreted as a type for the bread at the Last Supper. The window shows the importance of the four evangelists, as the authors of God's Word, and of the four Doctors of the Church, its prime interpreters.

10 11 At the bottom of the mill a chute delivers communion wafers, the most common form of bread used during the mass: the gospels have been turned into the host. The Christ child, identified by a crossed halo, stands at the end of this chute as an illustration of transubstantiation: the Roman Catholic idea that the consecrated host is the actual body of Christ.

4 A prophet, standing on a bank of the stream flowing from the "Old Testament" part of the window above, foretells the coming of Christ.

15 St Jerome, in his red cardinal's robe and broad–brimmed hat, and a bishop (Augustine or Ambrose) are holding a *ciborium* in which the host from the Mystic Mill is collected. At the base of the *ciborium* the hands of the other two Doctors can also be seen.

1 2 The prophet broadening the edge of the stream with an adze could be interpreted as John the Baptist, who was described as "The voice of one crying in the wilderness, Prepare ye the way of the Lord" (Mark 1.3) – this figure is definitely facilitating the flow of the water.

14 St Gregory, to the left, is identified by his triple tiara: he is the only Doctor of the Church who was a pope. Behind him is either Ambrose or Augustine, wearing a bishop's mitre: without more information it is not possible to distinguish them. They are engaged in distributing the host to the faithful.

5 St Peter, dressed as the first pope and wearing a triple tiara, points to the water flowing in the stream, which he regulates by lifting a sluice gate, directing it to turn the millwheel.

13 A priest or deacon distributes wine. The Mystic Mill window is opposite the *sedilia* in Bern Minster, in which the priest and those assisting him at the mass would have sat (see page 56): the window would remind them of the meaning and purpose of their actions.

6 The angel, winged lion and winged ox – symbols of the evangelists Matthew, Mark and Luke – hold texts from their gospels. Matthew's reads "*hoc est corpus meum*" ("this is my body"), Christ's words at the Last Supper (Matthew 26.26). The words are fed into a funnel leading to the millstone where they will be ground like corn.

9 Gabriel holds a banner with the angelic salutation, "Hail Mary, full of Grace". Here it is the Mystic Mill itself which occupies the position "full of grace" (see pages 8–11) .

7 The eagle of St John may be separate because the evangelists are in gospel order (surprisingly unusual in art). However, it may be because John's gospel starts with an exposition of the idea that Jesus was the Word of God: the Mystic Mill expounds the idea that the Word (represented by the gospels) is made into communion bread.

12 The traditional blue of Mary's cloak appears to be a continuation of the stream, and is the same colour as her book: this alludes to her role as the mother of Jesus, the water of life.

1 2 3 4

5 6 7 8

9 10 11 12

13 14 15 16

17 18 19 20

ANGELS & DEMONS

Angels and demons have a very real presence in the Bible, and their importance was magnified in the popular imagination by widely read books such as Dante's *Divine Comedy*. Existing with God in heaven, the angels are God's agents and messengers, existing in a state of grace – unlike mankind they were not subject to temptation, and have not fallen. Lucifer, said to be the most beautiful of the angels, was the exception: because of his ambition he was thrown out of heaven. A battle raged between the rebel angels and those faithful to God, led by the Archangel Michael, and

the latter inevitably triumphed. Lucifer fell to Earth, and into the "pit", where his distance from the love of God keeps him in a state of frozen desolation (even though elsewhere, as we know from many scriptural sources, the fires of hell are stoked for the torment of the damned). Dante describes nine circles of hell, each one reserved for those guilty of different degrees of sin.

The existence of the devil and of demons is also explicit in the New Testament. After his baptism Jesus went out into the wilderness for forty days and forty nights, where

◗ THE TEMPTATION OF ST ANTHONY

Aragonese School, 15TH CENTURY, FINE ARTS MUSEUM, BILBAO, SPAIN

It was not just Christ who was tempted by the devil: the torments suffered by numerous saints are depicted in religious art to remind us that we, too, will be tempted – and that, like Jesus and the saints, we should resist this temptation. St Anthony of Egypt is hailed as the "father of monasticism" (see pages 120–123 and 144) and the ideals he represented were recorded in an account of his life by Athanasius of Alexandria as early as AD360. It is to Athanasius that we owe accounts of Anthony's temptations, when the devil would appear to him in the form of a woman, afflict him with boredom, beat him until he was unconscious, or menace him as a scorpion, snake or another wild beast. Inevitably this became a favourite subject for artists – the hallucinatory nature of Anthony's torments allowing them to exercise their imaginations to the full.

he withstood the temptations of the devil, and on his return he cast out many demons, the most famous of the possessed being Mary Magdalene.

Dante's description of the nine circles of hell is paralleled by his vision of nine choirs of angels. This belief was widespread in the Church, although the ways in which they are depicted and their precise function can vary. The nine choirs were divided by Thomas Aquinas into three hierarchical groups: the Seraphim, Cherubim and Thrones; Dominions, Virtues and Powers; and Principalities, Archangels and Angels.

Guarding and guiding

It is the Archangels, the prime messengers of God, and the Angels, our helpers and guardians, who are most familiar, even though, of those angels mentioned in the Bible, only three have a definable character. St Michael is depicted vanquishing the devil (see illustration, right), often about to swing his sword, with which, in other images, he chases Adam and Eve from the Garden of Eden. He also has a pair of scales, to weigh souls at the Last Judgment.

Gabriel is God's most important messenger. He is shown with a staff of office, which, in the Annunciation, was transmuted into a lily, a sign of Mary's purity. He was also believed to be the angel who announced to Zacharias, father of John the Baptist, that his wife Elizabeth would give birth.

The third is Raphael, who is associated with healing. In the book of Tobit he accompanies Tobias on a journey to collect a debt for Tobias's blind father, after whom the book is named. He helps to exorcise a young woman who becomes Tobias's wife, and later, to cure Tobit's blindness. Both of these miracles are achieved using organs from a giant fish which had attacked Tobias. Raphael is usually depicted walking alongside Tobias, who is carrying a fish. At the end of the story Raphael, who has been disguised, reveals himself and says that he is one of seven named angels who attend the throne of God. Although mentioned in non-biblical literature the others are rarely represented, although they are included, unnamed, in the San Marco creation dome (see pages 70–73).

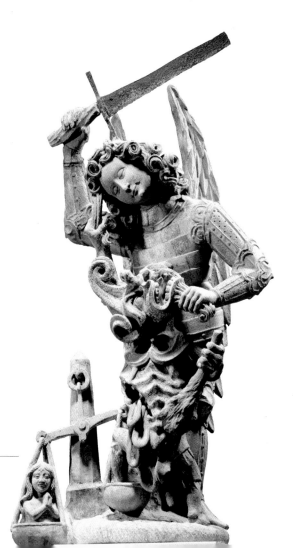

◖ ST MICHAEL
Erhart Küng, 1460–1485, HISTORICAL MUSEUM, BERN

St Michael fights with the devil, and has already cut through the chest and ribs, allowing some of the intestines to fall out. Meanwhile the devil puts his foot in the scales to bias the Last Judgment, a blessed soul waiting patiently in the other pan. This sculpture, fitted with a metal sword, is in a remarkably good condition and still has much of its original colouring. Like other sculptures from the royal portal of Bern Minster, it has been moved to a museum to protect it from atmospheric pollution damage, and its place is now taken by a replica (see also pages 162–163).

VIRTUES & VICES

"And now abideth faith, hope, charity, these three; but the greatest of these is charity."
1 Corinthians 13.13

Saints and angels are represented in churches because of their undeniably virtuous behaviour. The virtues – the precise qualities of character deemed to be good and valuable, both for individual and collective well-being – were also widely depicted as female personifications. Although a range of virtues can be found in churches, seven are more commonly portrayed than the others.

St Paul mentioned three virtues in his first epistle to the Corinthians: Faith, Hope and Charity. The last of these is now regularly translated as "love", although *caritas*, the original Latin word, referred to the pure and unconditional love shown by God, and which is also due to God. Charity can be depicted in a number of ways, including a flaming heart, head or hand, which refers to the fire of love, or with a cornucopia, or "horn of plenty", a symbol of the bounty Charity has at her disposal, although she is most often seen with two or three children. These three virtues are called the theological virtues.

The remaining four constitute the cardinal virtues – those qualities that Plato said an ideal person should possess: Temperance (not doing anything to excess), Prudence (acting wisely), Fortitude (strength) and Justice. Prudence may be shown with three faces, or even with three flames, referring to the past, present and future – the implication is that the present relies on the wisdom gained from past experience to determine future actions. Prudence may be shown with a mirror, because she requires self-knowledge. However, symbols rely on context: those who spend too long looking in a mirror are vain, so a mirror can be a symbol of Vanity.

The most common place to see these personifications is on funeral monuments, where they are supposed to

TOMB OF POPE SIXTUS IV

Antonio del Pollaiuolo, 1484–1493, St Peter's Basilica, Rome, Italy

The three theological virtues are gathered around the pope's head, with the remaining four further down. Pope Sixtus was a member of the Della Rovere family – *rovere* means "oak", the tree that is visible on the shields in the Rovere coat of arms below the virtues on either side. A similar tree is held by Rhetoric at the bottom left, next to Grammar, on the right.

1 **Faith** is depicted with a cross and chalice, referring to faith in the Crucifixion and the mass.

2 **Hope** is shown in the act of prayer. Elsewhere she is depicted with an anchor, as hope keeps you anchored through the storms of life.

3 **Charity** is at the "head" of the monument (largely obscured here) as St Paul cited this as the greatest virtue. She is usually caring for several children.

4 **Prudence** holds a snake – a reference to Jesus' instruction to be "wise as serpents" (Matthew 10.16). This counteracts a possible misidentification with Vanity becase of the mirror she also holds.

5 **Temperance** pours a small amount of liquid from one vessel to another (this can also be interpreted as diluting wine with water).

6 **Fortitude** leans her left elbow on a column, a strong support, and holds a mace. In other images she wears armour and wields a club.

7 **Justice** holds a sword and scales (in more martial images she may hold a severed head).

represent the virtues shown by the deceased during his lifetime (a bold statement of superiority that seems to be predominantly male). Pope Sixtus IV included all seven on his tomb (although it is not possible to see Charity in the illustration on page 101). Many other virtues were recognized and commemorated – for example, the monument of William the Silent includes personifications of Liberty and Religion (see illustration, page 47).

The extraordinary Sixtus is also surrounded by no fewer than ten personifications of the liberal arts. Seven of these were standard subjects that anyone with more than a fundamental education would have studied. Like the Virtues they were divided into three and four, the *trivium* and the *quadrivium*. The *trivium* consisted of Grammar, Rhetoric and Logic, while the *quadrivium* included Arithmetic, Geometry, Music and Astronomy. To these Sixtus added Theology (he was pope), Philosophy (often seen as encompassing all forms of study) and Perspective (he was a great patron of the arts – most notably of the Sistine Chapel and its frescoes, several of which use single vanishing point perspective).

Nevertheless, Sixtus could be accused of Pride – one of the Seven Deadly Sins, which also include Wrath, Envy, Lust, Avarice (or greed), Sloth (or idleness) and Gluttony (see illustration, right). These sins are slightly different from the Seven Vices, which are the opposites of the Seven Virtues listed above: Faith, Hope and Charity are contrasted with Infidelity, Despair, and Envy, while Temperance, Prudence, Fortitude and Justice are contrasted with Wrath (or anger and loss of self-control), Foolishness, Inconstancy and Injustice (Injustice can be seen on page 76).

Although any Christian would be expected to practise the theological and cardinal virtues, an eighth, which is rarely depicted (appropriately), is Humility. A true believer, rather than boasting of their virtues, would be expected to perform good deeds humbly – the basis of this being Christ's own teaching. In a parable Jesus tells of a king who separates the good from the bad, saying that ". . . I was an hungred, and ye gave me meat: I was thirsty, and ye gave me drink: I was a stranger, and you took me in: Naked and ye clothed me: I was sick, and ye visited me: I was in prison, and ye came unto me." (Matthew 25.35–36) To these six "Acts of Mercy", as they became known, was added a seventh: burying the dead. This was derived from the book of Tobit, in which the book's devout namesake carries out burials in accordance with Jewish custom.

◁ **LIBRARY**

Franz Joseph Holzinger and Innocent Anton Warathy, 1722–1726, BENEDICTINE ABBEY, METTEN, GERMANY

The decorations of this library – with stuccoes by Holzinger, and frescoes by Warathy – were devised along scholarly principles. The entrance is flanked by allegories of Faith and Science crowning a bust of Christ, with an inscription explaining that the library is a temple of divine wisdom. The ceiling frescoes relate thematically to the categories of books housed here (at around 200,000 volumes it is the largest monastic library in Bavaria). The earnest message is the primacy of religion over science, or faith over reason. The art includes depictions of the seven deadly sins, and the theological and cardinal virtues – all achieved with a light touch and wonderful *joie de vivre*.

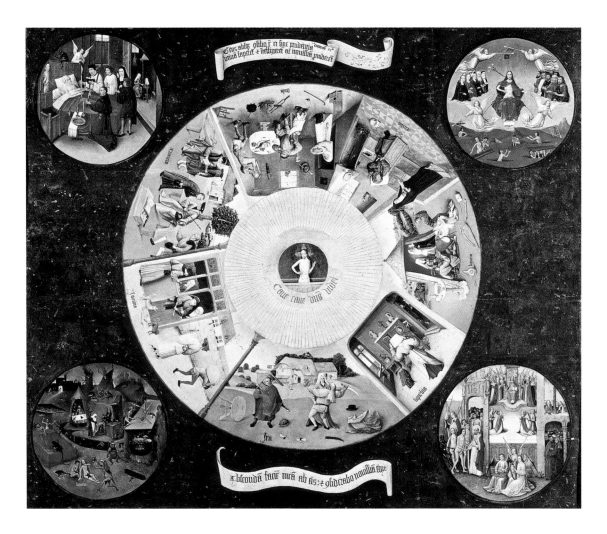

⬥ THE SEVEN DEADLY SINS
Hieronymus Bosch, 1485, Museo Del Prado, Madrid, Spain

Once owned by King Phillip II of Spain, the original function of this painting is not clear: it may have been a table. The seven sins are depicted around the central circle. At the bottom is Wrath – a scene of fighting. Moving clockwise this is followed by Envy, which illustrates the Flemish proverb "two dogs fighting over one bone will rarely agree". In Avarice a judge is bribed, and in Gluttony people eat and drink to excess. Sloth contrasts a woman going to church with her husband who will not stir. In Lust two couples are entertained by clowns, and Pride shows the devil handing a mirror to a woman. In the corners, clockwise from the top left, are the "Four Last Things": Death, Judgment, Heaven and Hell, the last of which shows the damned receiving punishment appropriate to their sins. The central section is a huge eye, with Jesus in the pupil above the motto "Beware, beware, God sees". The message is clear: God can see our faults, and we will reap the rewards of our actions when we die. Nevertheless, this stern moral is conveyed with considerable humour.

SACRED GEOMETRY

"When he prepared the heavens, I was there: when he set a compass upon the face of the depth."
Proverbs 8.27

God was seen as a divine geometer, an idea supported by a verse from the book of Proverbs, which implies that God created heaven and Earth with the aid of a compass. Creation was perfect, and models of the cosmos showed the Earth at the centre, with the sun, moon and stars revolving around it in perfect circles. But it was only perfect until the Fall, when Adam and Eve introduced sin into the world. One of the aims of artists and architects was to re-create the perfection that God intended, and one way of doing this was through the perfection of geometry and the power of mathematics.

Well before the Christian era, thinkers such as Pythagoras (c.570–c.495BC) had realized that a harmony is created by a certain combination of numbers. He realized that if a string on a musical instrument plays one note, a string of half the length will play the same note, but an octave higher. Indeed all the notes of a musical scale can be created from simple

◉ CHURCH OF ST GEORGE
EARLY 13TH CENTURY, LALIBELA, ETHIOPIA

This is the last of eleven similar churches built by carving the buildings out of the solid rock. King Lalibela, after whom the town was named, had the first ten built. His devotion eventually led him to abdicate and live as a hermit. His wife had this last, and most remarkable, church built c.1220 as a memorial to him after his death. King Lalibela is now considered an important saint in the venerable Ethiopian Orthodox Tewahedo Church.

⊙ DOME OF SAN LORENZO
Guarino Guarini, 1668–1680, Turin, Italy

A circular dome on a square church is not especially remarkable, although Guarini, a monk, mathematician and playwright, makes it extraordinary. The eight ribs springing from the base of the dome support the lantern, and allow the dome itself to be pierced by eight pentagonal windows and eight which are oval (they read as circular from below). The ribs divide the windows into groups of three and five, the numbers of the Trinity and of the wounds of Christ: this church has regularly hosted the famed Turin shroud, which illustrates Christ's wounds with a visceral bluntness.

number ratios: 1:2 being the octave, 2:3 being a fifth (five notes in the scale, from A to E, for example) and 5:6 being a major third. Architects such as Filippo Brunelleschi and Andrea Palladio deliberately used these ratios to create a sense of harmony in their churches (see page 176).

Holiness of number and shape

It seemed significant that these simple number ratios result in a scale of seven notes. The ancient Greeks also knew seven heavenly bodies – the sun, the moon and five of the planets – whose movements, they believed, created the "harmony of the spheres". Christian theologians noted that God had created the world in seven days and that the repeating sequence of seven-day weeks is like the apparently endless sequence of musical notes in a scale. For the theologians this was not a coincidence, but evidence of a divine masterplan.

The number seven can be broken into three and four, which correspond to the Holy Trinity and to the four gospels. Seven is similarly divided between the three theological and the four cardinal virtues, and the *trivium* and *quadrivium*. If three added to four makes seven, three multiplied by four gives twelve, and we move from the number of days in a week to the number of months in a year. Twelve was also the number of the tribes of Israel and of the apostles, while the New Jerusalem, which will symbolically replace the world after the end of time, will have twelve city gates. There are many examples of church architecture which

play on significant numbers: for example, the South Rose Window in Notre Dame Cathedral (see illustration, page 37) makes repeated use of the numbers three and four, with four rings of windows around the central quatrefoil. The twelve apostles are in the first ring, with the whole resting on windows which show the sixteen prophets.

We often think of churches as being cruciform in shape, as a sign of faith and in remembrance of Christ's crucifixion, but this outline came about almost by accident. Many early churches took the form of a Roman basilica: a long hall with an altar toward the east end. The basilica built in the early fourth century by Constantine on the site of St Peter's tomb was visited by so many pilgrims that transepts were added on either side of the altar-cum-tomb to ease the flow of human traffic. Only later was it observed that the amendments gave the building the shape of the cross, which

✚ UNA FIDES NATIS EX HIS TRIBVS ET DEITATIS

ECCLE SIA SEM CHAV IAPH ET

✚PARTE NOS DOMINATV MUNDUS NA TIMICO VISO

VERITAS CVM PRESTO DE ABEL OE SH BORAT

subsequently became the governing principle behind a lot of ecclesiastical architecture and the ground plan of many a church was designed to resemble a cross – some of the most explicit examples being the remarkable monolithic churches of Lalibela in Ethiopia (see illustration, page 104).

The next most common shape was the circle. Because the outline continues without a break or angle, the circle was considered to be perfect, and therefore was a symbol of eternity, and of heaven. The circle could also be used to represent Mary's purity and unbroken virginity.

◖ THE THREE SONS OF NOAH

c. 1180, PANEL FROM THE SECOND TYPOLOGICAL WINDOW, CANTERBURY CATHEDRAL, ENGLAND

Japheth, Shem and Ham, the three sons of Noah, stand around a disc labelled "*MUNDUS*" ("the world"). Another inscription explains, "From these three sons is one faith in the Godhead" – the threefold division of the Earth is explicitly related to the Trinity, and its importance to the Church is emphasized by the allegorical presence of Ecclesia, a personification of the Church. The three sons of Noah are seen as types of the Three Wise Men, or Magi, whose story is told in detail at the top of the window.

Specific types of church were built as circles: *mausolea* are circular because death is endless, and because an eternity in heaven is hoped for. A good example is the mausoleum of Constantia, known as Santa Costanza (see the ground plan below). Some churches were circular in imitation of the Holy Sepulchre, in which Christ was buried, although occasionally the imitations seem to be have been of the Dome of the Rock (erroneously mimicking an Islamic building).

A *martirium* – a church dedicated to a martyr – might also be circular, partly because the martyr's soul went instantly to heaven (represented by the circle), and partly to designate clearly the site of the martyrdom: Bramante's Tempietto is an example of this, marking the site where St Peter was once believed to have been executed (see page 175). Finally, several baptisteries are circular (for example, Pisa, page 154), because baptism cleanses original sin, thus allowing the individual an everlasting future in paradise. Another common shape, either for baptisteries or for the baptismal font itself, is the octagon. Again the reference is to eternity, as the *octavo dies* or "eighth day", the first day after the repeating cycle of seven, is the day that will go on forever, and preferably in heaven: baptism opens up this possibility.

The octagon is also, in some ways, a transitional form between a square and a circle: if a circle represents heaven, then the square represents Earth, and the many circular domes on square bases can be seen as images of heaven on Earth. Another commonly used shape is the triangle, symbolic of the Holy Trinity: the triangle is seen often in paintings and in devices such as the trinity shield (see page 78) – it has also occasionally been used in a church ground plan, as it was by Carlo Borromini for Sant'Ivo in Rome.

In the Renaissance many architects aimed for a "centrally planned" church, the ideal being a circle because it was symmetrical, and therefore more perfect and closer to the original harmony of God's universe. However, circular buildings did not suit the liturgy: the priest needed to face the congregation, which led to a linear sense of worship. The requirement to house more people supported a long nave, as did a continued interest in processions. However, with changes in worship in the twentieth century, and technology which allows the priest to be heard even if he doesn't face the congregation, circular churches have become more common, a notable example being Oscar Niemeyer's innovative cathedral in Brasília (see page 209).

THE MEANINGS OF NUMBERS

1 God.
2 The natures of Christ: human and divine.
3 The Holy Trinity; the threefold division of the Earth (Europe, Africa and Asia); the Magi; the theological virtues; the *trivium*.
4 Evangelists; elements (earth, air, fire and water); seasons; cardinal virtues; cardinal points (north, south, east and west); Doctors of the Church. The four largest niches in Santa Costanza create a cruciform structure within the circle.
5 The wounds of Christ (one in each hand and foot, and one in the chest); and the number of the Joyful, Sorrowful and Glorious mysteries (see page 87).
6 Rarely used, although it was the number of days in which God created the world before he rested.
7 Days of the week; heavenly bodies (sun, moon and five known planets); notes of the scale; virtues; liberal arts; deadly sins; Acts of Mercy; Gifts of the Holy Spirit; and many other symbolic associations.
8 The *octavo dies* or "eighth day" – the last, everlasting day in heaven.
9 Choirs of angels, and circles of hell.
10 The Commandments.
11 The number of apostles after the Resurrection.
12 Apostles; tribes of Israel; months of the year; signs of the zodiac; gates of the New Jerusalem. The dome of Santa Costanza is supported by a circular arcade of twelve pairs of columns.

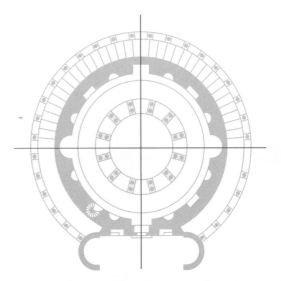

GROUND PLAN OF SANTA COSTANZA, c.350, ROME, ITALY (see 4 and 12, left)

LIGHT & COLOUR

"I am the light of the world: he that followeth me shall not walk in darkness, but shall have the light of life." John 8.12

Both light and colour play a fundamental part in the art and architecture of Christianity, but there is no doubt that it is light which is the more important – a result of Jesus' own claim to be the "light of the world". Depictions of the Annunciation, when Gabriel announces that Jesus will come into the world, as often as not show a beam of light coming down to Mary from heaven. In Palermo, a mosaic illustrating the Annunciation depicts the beam of light coming from a blue semicircle, representing the sky (see illustration, right: Mary can be seen in the spandrel in the bottom corner of the dome). The beam is picked out in silver tesserae to distinguish the light of God from the light reflected from the gold background. The image is located below a window, allowing real light to stream in: the story is part of the structure of the church. The fact that the light coming into the church is real, and is interpreted as the light of God, is such a powerful idea that it remains in use to this day, and is made explicit in the name of Tadao Ando's Church of the Light in Japan (see illustration, left).

One reason for the inclusion of gold leaf on icons and altarpieces was to reflect the light from the candles with which churches were (and often still are) illuminated. Not only did this have a practical function – to make the churches brighter – but it also plays on the layers of symbolism, as if heaven is aglow, and the light of God is shining out of the paintings to enlighten the congregation. In much the same way, the light streaming through stained glass windows helps us to be enlightened by the messages the windows contain. When Renaissance architects and Protestant theologians decided to use plain glass, it was done for similar reasons: that the pure light would awake the reasoning of our mind

◄ CHURCH OF THE LIGHT

Tadao Ando, 1988, IBARAKI, OSAKA, JAPAN

The simplicity of Ando's church is part of its beauty, and of its message: built on a low budget, the concrete walls were cast on-site, and the wood used to form the moulds for that process were then recycled to make the pews. The church has no decoration, and the only windows are the slits in the shape of a cross, as important for this particular church as it is for the foundation of Christianity itself: the Cross here is the Light.

▶ "LA MARTORANA"

1143, PALERMO, SICILY

This tiny church was built in 1143 for George of Antioch, admiral to King Roger II of Sicily, and so it is known as Santa Maria dell'Ammiraglio. However, in 1433 it was annexed to a convent founded by Eloisa Martorana, from whom it takes its more common name, "La Martorana". The extraordinarily rich mosaic decoration appears to have been executed almost immediately afterward.

to logic, either of the structure of the church, or of God's truth, or both – the former was, after all, designed to illustrate the latter.

Splendour and symbolism

Another reason for using gold was to express the splendour of heaven – for many thinkers the Church was *the* symbol of heaven on Earth, and as such its buildings should be glorious and far beyond our mundane existence. It can come as something of a surprise to learn that early churches would all have been richly coloured, a tradition which continued through the Romanesque and Gothic periods. However, over time the original colour wore away and was not renewed, or was systematically stripped down to create starker interiors.

With the increased awareness in the nineteenth century of historical styles, there came a renewed interest in decorating churches in rich colours, with many old churches being repainted in what was seen as a period style, or new churches being built and decorated in a pastiche of period styles. However, even before this revivalism, Baroque architects had flouted the starker choices of the Counter Reformation by glorying in the splendour of coloured marbles, the lavish application of gold leaf and brilliant illumination to excite

both body and soul with a visual exuberance designed to raise the spirits and inspire confidence in the truth the Church was expounding.

Colour can also be used for specific reasons, though the symbolism is notoriously flexible. For example, violet was associated with penitence and tended to be used in church during periods of preparation and reflection, such as Advent (the period leading up to the birth of Christ) and Lent (the forty days before Easter). However, purple was also the colour of royalty and imperial power – it is worn as such by Justinian in San Vitale, Ravenna (see page 138) – and the deep reddish-purple stone porphyry was also used for imperial tombs (for example, the sarcophagus of Constantia, page 113). In many Byzantine icons Mary also wears purple (as she does in "La Martorana"), giving her the status of an empress.

At "La Martorana" Mary is also seen spinning a red thread. The combination of two elements to create one thread symbolizes the union of Christ's two natures, human and divine. Additionally, this red refers to Christ's incarnation (his becoming body and blood) and to his royalty. Traditional tales state that Mary grew up in the temple with other virgins who were occupied weaving the veil of the temple. When they drew lots to see who would

COLOUR & THE ECCLESIASTICAL CALENDAR

In the 13th century Pope Innocent III introduced a sequence of liturgical colours appropriate to the different periods in the ecclesiastical calendar, affecting the altar decorations and priests' vestments. A more thorough system was devised by Pope Pius V in 1570, using white, red, green, violet and black. The last of these is no longer used (although it is the only colour worn by most Protestant preachers), and there are a number of regional alternatives: for example, blue in parts of Spain for the Mass of the Immaculate Conception, and in the USA for feasts of the Virgin Mary. The Church of England uses the same principal four colours, with some variations. In the Greek Orthodox Church maroon is common for solemn feasts, and white and gold at other times. The Russian Orthodox and Slavic churches use up to eight liturgical colours.

WHITE
Occasions: Christmastide, Easter Sunday, Trinity Sunday, Corpus Christi, Epiphany, Transfiguration, Ascension, feasts of virgins and confessors, weddings, baptism.
Symbolism: faith, purity, innocence, virginity, celebration, glory, holiness.

GREEN
Occasions: Ordinary Sundays (after Pentecost) and weekdays throughout the year.
Symbolism: hope, life eternal.

RED
Occasions: Palm Sunday, Good Friday, feasts of Christ's Passion, Pentecost, Thanksgiving, feasts of apostles and martyrs and evangelists, confirmation.
Symbolism: charity, love, incarnation, suffering, martyrdom.

VIOLET
Occasions: Advent, Septuagesima, Quinquagesima, Lent, Ash Wednesday, Holy Week, Maundy Thursday.
Symbolism: penitence, humility.

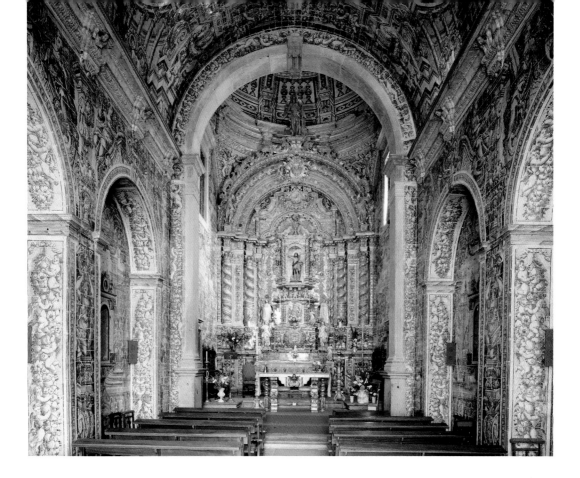

spin which thread, Mary was chosen to spin the red: the most expensive. The use of red fabrics was restricted in many countries to members of the royal court. In northern European paintings Mary often wears red, whereas in Italy she usually wears blue. Roman Catholics see Mary as the Queen of Heaven, but she was also likened to the star by which sailors navigate: the medieval canticle *Ave Maris Stella* means "Hail, star of the Sea", and *maris* ("of the sea", which we see as blue) was a pun on Mary. Blue was also the most expensive pigment, whether it was lapis lazuli (ultramarine) or azurite: spending more money on a depiction of the Virgin was another way of showing the respect and reverence due to her.

Other saints could be identified by colour. In Italy St Peter almost always wears yellow and blue, and Mary Magdalene wears red, although in the north of Europe she tends to wear green. Colour can indicate places and patrons through the use of heraldic colours (the wind vane on the steeple of St Peter's in Zurich is in the blue and white of the city's shield). It can also denote specific qualities: white, green and red have traditionally been used for the three theological virtues, Faith, Hope and Charity, but because these hues have also been used as the heraldic colours of several notable families – leading to their use as the Italian flag – the context is incredibly important. White can also symbolize purity and chastity, while red often refers to Christ's Passion and to the sufferings of martyrs.

FLORA & FAUNA

In the same way that theologians interpreted every aspect of the Old Testament in the light of its meaning for the New, everything in God's creation was believed to be there for a purpose, and that was to remind us of His message. Plants were created on the third day, birds and fish on the fifth and animals on the sixth, and many among them were given a symbolic value by theologians and laymen. The flora and fauna "used" in this way were often the most common or important species in those cultures which adopted them. This reflects Christ's own ministry, during which his teaching was couched in the language of his audience – the fishermen and farmers who were among his first disciples.

John the Baptist recognized Jesus with the words, "Behold the Lamb of God which taketh away the sin of the world" (John 1.29) – the lamb represents Jesus, sacrificed for our redemption. Jesus later asked Peter to care for his flock, and the sheep became a model for the Christian soul in need of guidance and protection: the earliest representations of Christ show him as the "good shepherd". The language of husbandry continues in Jesus' statement, "I am the vine; ye are the branches" (John 15.5), suggesting that he was the originator of the message, but was relying on others to spread it. At the Last Supper Jesus took wine and gave it to the apostles saying, "this is my blood of the new testament, which is shed for many for the remission of sin" (Matthew 26.28). From this arose the idea that the vine is like the Cross, with Jesus, the fruit of the vine, hanging from it. Thus, from the earliest days, the vine has been a common Christian symbol.

The vine appears alongside sheep on the sarcophagus of Constantia (see illustration, right), which also depicts peacocks, another early symbol, its popularity stemming from the belief that when peacocks died their bodies would not rot. As a result, the birds were associated with the incorruptible flesh, or life everlasting. Very often peacocks are shown eating grapes, implying that if we wish to spend eternity in paradise, we can only find this through communion with Christ (symbolized by the grapes).

These symbols emerged partly because Christianity was illegal for the first three centuries of its history, and believers worshipped in secret. One of the earliest symbols was the

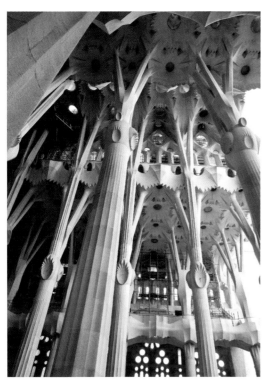

◐ SAGRADA FAMILIA
Antoni Gaudí, STARTED 1882, BARCELONA, SPAIN

Columns have been compared to trees from the earliest times. Initially buildings were supported using the wood itself, and later, in ancient Egypt, Greece and Rome, stone columns were carved with details imitating different types of plant. Gaudí's innovative approach to architecture and engineering led him to emphasize plant forms as part of God's creation, and the results of his creativity include these branching, tree-like structures inside Sagrada Familia (see also page 207).

fish. Not only were the first two apostles – Peter and Andrew – fishermen, but more specifically the first letters of the Greek words "Jesus Christ, Son of God, Saviour" spell out *ichthus*, the Greek word for "fish".

Animals symbolize three of the four evangelists (see page 92). St Mark is the patron saint of Venice and his winged lion is seen throughout that city. However, the lion is also used as a symbol of strength, and can also be seen alongside St Jerome, a reference to a story in which he removed a thorn from a lion's paw – an example that emphasizes how important context is to discovering the intended meaning of any particular symbol. This is especially true of personal symbolism, used as a sign of patronage: after more than 500 years the relevance of a white hart (or deer) is not obvious, but contemporaries of King Richard II would have recognized it as one of his personal emblems (see pages 164–167).

St John's eagle and the dove of the Holy Spirit are two of the most frequently used bird symbols. Goldfinches were believed to eat thorns, and the red colouring on their heads was said to come from a drop of Jesus' blood that had fallen onto a goldfinch trying to eat from the crown of thorns: the goldfinch therefore became a symbol of the Passion. Swallows disappear in the winter, only to return in the spring. As migration was not then understood this behaviour made the bird a symbol of the death and resurrection of Christ. Another almost mythical interpretation of bird behaviour is known as the "pelican in her piety" (see page 118). The pelican was believed to peck at her breast to feed her young from her own body. Even though this probably derived from a misunderstanding of the process of regurgitation, the connection with the idea of Christ's sacrifice, and with the mass, is easy to see.

◉ SARCOPHAGUS OF CONSTANTIA
C.350, VATICAN MUSEUMS, ROME

Constantia, daughter of Constantine the Great, commissioned a circular mausoleum close to the catacombs that housed the tomb of St Agnes (see page 107). She was buried there in a porphyry sarcophagus, the expensive material and its rich purple colouring referring to her imperial status. The symbolism of sheep, peacocks and vines is repeated in the decoration of the building itself (see page 135). The church now contains a replica: the original sarcophagus is exhibited in the Vatican Museums, standing on two marble lionesses carved much later.

VIRGIN & CHILD WITH SAINTS & DONOR

Gerard David, 1510, THE NATIONAL GALLERY, LONDON, ENGLAND

David has depicted a vision of St Catherine of Alexandria in which she saw the Christ child placing a ring on her finger. The mystic marriage is the model for all nuns who dedicate their lives to Jesus. On the right, St Barbara and Mary Magdalene are silent witnesses of this act, which is contemplated, if not seen, by the kneeling donor, Richard de Visch van der Capelle, whose coat of arms adorns the dog's collar.

The white lily is a symbol of Mary's purity and innocence, and is often presented to her at the Annunciation. Lilies are also used as a symbol of chastity, and are held by both St Dominic and St Anthony, who both led chaste lives. Because of its blood-like colour, the red lily (just below this detail) is a reference to the incarnation and suffering of Christ.

An old name for the iris is the sword lily, a name that was also used in Germany. The iris is a symbol of the suffering of Mary, which derives from the prophecy of Simeon when Christ was presented to the temple, "Yea, a sword shall pierce through thy own soul also" (Luke 2.35). However, the plant is the same colour as St Catherine's sash, and may refer to her beheading: the wheel and sword of her martyrdom are just in front of the iris.

A vine grows along the wall, a rich symbol of Christ: the Cross was seen as the vine and Jesus the fruit. In this detail, taken from the far left of the painting, an angel is picking grapes. More centrally, just behind St Catherine's left hand and above the iris, the trellis supporting the vine can be seen in the shape of the Cross.

The fig was sometimes identified as the forbidden fruit – Adam and Eve used its leaves for their first clothes. Because here it is growing in the garden, behind St Catherine's right shoulder, this association is unlikely. The fig was sometimes seen as representing the Cross, and Jesus the fruit hanging on it, and because of its presumed healing properties, it was associated with salvation.

The apple tree has been excluded, outside the wall at the top of the painting on the far left. As the word *malum* means both "evil" and "apple", the apple was the fruit most often associated with the forbidden tree of knowledge. The wall itself is a reference to the *hortus conclusus* or "enclosed garden", a symbol of Mary's virginity.

The columbine has flowers that look like four doves, which gives it both its name and its significance: it symbolizes the Holy Spirit, although it can also stand for the innocence of the Virgin Mary. Behind the columbine are wild strawberries, whose three leaves represent the Trinity. The stoneless strawberry was seen as a heavenly fruit, without the imperfections introduced after the Fall.

Among plants, the vine is one of the most common, and the pure white lily is a frequent attribute of the Virgin Mary, symbolizing her purity, chastity and innocence. The lily is also used to identify saints, such as Dominic and Anthony of Padua, who were known to have led chaste lives, and it is just one of the many flowers depicted by Gerard David in the altarpiece he painted for the church of St Donatian in Bruges (see illustration, pages 114–115).

Grotesque forms

Christianity historically has often assimilated pagan signs, symbols, practices and holy places. Dragons are mentioned in the Bible – they are used as a description of the devil – and therefore the killing of dragons by knights, as exemplified by St George, became a metaphor of the triumph of good over evil. Other mythical beasts were also adopted by Christians because of their potential meaning within the Church. For example, it was thought that unicorns could purify poison by dipping their horns into it and that the creatures could only be caught by a virgin. Thus the unicorn became a symbol of Christ, who cleanses us of sin, and who was born to a virgin. In other cases the presence of inhuman and diabolic forms is simply a reminder that the devil is everywhere, waiting to trip us up and tempt us to sin: vivid sculptures of grotesque and unnatural beings help us to keep on our guard and to avoid temptation.

One of the most widespread fantastical images, which is particularly common in English churches and cathedrals, is the Green Man. This character, usually represented as a face sprouting leaves, may derive from the Celtic nature god, who in one Latin inscription is referred to as Viridios (derived from the word for "green"), as well as Sylvanus, a Roman spirit of the woods. However, similar ideas occur across many different cultures, and all are associated with the coming of spring and the renewal of life and growth. As such, the Christian relevance becomes apparent: the turn of the seasons from fallow winter to fertile spring is associated with the death and resurrection of Christ. Like other symbols, the Green Man was adopted by the Church to remove it from its original context and replace its pagan value with a Christian one, thus undermining its potentially subversive nature.

◐ GREEN MAN

EARLY 14TH CENTURY, NORWICH CATHEDRAL, ENGLAND

This is the finest of a number of carvings of the Green Man in the east wing of the cloisters, which were rebuilt in 1297 after the original structure was destroyed as the result of rioting in 1272.

"CREATURES OF BEAUTIFUL DEFORMITY"

MID-19TH CENTURY, NOTRE DAME CATHEDRAL, PARIS, FRANCE

These words were written in 1125 by the Cistercian Bernard of Clairvaux, in his *Apologia*, a defence of his order and a criticism of the excesses of the Cluniacs. He was appalled by the use of expensive materials and elaborate adornment in churches, and thought that the inclusion of ungodly creatures in buildings served only to distract the mind from God, as well as costing money better spent on the poor. The famous grotesques from Notre Dame (see left and right), which seem so archetypally medieval, were in fact carved as part of the 19th-century restoration programme of architects Jean-Baptiste-Antoine Lassus and Eugène Viollet-le-Duc, many sculptures having been damaged or destroyed by the Huguenots in 1548, and in 1793 during The Terror in the French Revolution.

LETTERS & THE LAW

Although the use of imagery was justified by the need to communicate with the illiterate, letters and words were, of course, still used widely – and they remained at least as important after the Reformation, when Protestants removed and destroyed paintings, sculptures and stained glass. It became standard practice in the Church of England, for example, to replace the painted altarpiece with a list of the Ten Commandments given by God to Moses.

Churches also used biblical texts as part of their decoration, and this included the *tetragrammaton*, the four Hebrew symbols which make up the name of God (see illustration, page 199). Jews were reluctant to use the word itself for fear of profaning the very name of God, and therefore wrote down the consonants without the verbs: the Christian readings "Jehovah" and "Yahweh" are not accurate renderings, but they are nevertheless widely accepted.

Other words, or letters, were also used to represent God. For example, the Greek letters *IC XC* are commonly used as abbreviations of *Iesous Christos*, the apparently Latin "C" being a form of the Greek letter *sigma*, pronunciation of which sounds like an "S". These four letters can be combined with the word *Nika* to mean "Jesus Christ Conquers". The first three letters of *Iesous* are *IHC*, the "H" or "*eta*" being pronounced like the "e" in "bed". A more common form is *IHS*, which was given an alternative interpretation in Latin of *Iesus Hominum Salvator*, meaning "Jesus Saviour of Mankind". Abbreviations in medieval texts were noted by adding a short, horizontal line above the word, and in this case the line above the "H" was turned into a cross by the addition of a vertical. It was in this form, surrounded by rays of light, that St Bernardino of Siena promoted the "Name of Jesus" in the fifteenth century, and the same configuration was later favoured by the Jesuits (see pages 190–191).

The first two letters of *Christos*, *chi* and *rho* (which look like "X" and "P" respectively) were combined in one of the earliest Christian symbols. The cross was not used prior to the legalization of Christianity in 313, partly because it

◖ REREDOS

Grinling Gibbons, 1686, St Mary Abchurch, London, England

Gibbons, although Dutch by birth, was the greatest decorative carver of 17th-century England. He worked regularly for Christopher Wren, but this is the only reredos in London that is securely documented: his bill for an "olter pees" was found in the Guildhall Library in 1946.

was too overt a symbol, but also because crucifixion was shameful, being reserved for the worst criminals. When Christianity was finally legalized the cross soon became more widely accepted, and it has flourished: it now exists in a multitude of forms (see box, right).

Images of the Crucifixion frequently use another abbreviation: *INRI*. It was Roman tradition to announce the crime of the victim on a *titulus* at the head of the cross, and according to the gospel of John it was Pontius Pilate who wrote the words "Jesus of Nazareth King of the Jews" in Latin, Greek and Hebrew. Although a few paintings do include all three languages, it is more common to see only the Latin version, *Iesus Nazarenus Rex Iudaeorum*, or its abbreviation, *INRI*.

The last set of letters in widespread use is derived from the book of Revelation, in which it is stated three times, "I am Alpha and Omega, the beginning and the end" (Revelation 1.8, 21.6 and 22.13). As a result the first and last letters of the Greek alphabet, Alpha (A) and Omega (Ω or ω), are often included as symbols of God's continued presence from the act of creation to the end of time.

◑ *ARCOSOLIUM* OF BISHOP SIRACOSIO
5TH CENTURY, CATACOMBS OF SAN GIOVANNI, SYRACUSE, SICILY

An *arcosolium* is one of three types of catacomb tomb, consisting of a sarcophagus topped by an arch, and was used for important or wealthy members of the community. In addition to the Chi Rho (upright here, to look explicitly like a cross) and the Alpha and Omega, the *sgraffito* (or carving) on this tomb combines two other symbols: the fish-like ship represents the Church, carrying souls on their pilgrimage through life, and the small ship tied to the larger implies that this Christian community owes allegiance to another – Syracuse is subordinate to Rome.

DIFFERENT CROSSES

Although the Cross is the central image of Christianity, it has no unique form. Instead, the many cross shapes have evolved from disguised symbols to increasingly elaborate configurations. The following are just some of the most common.

CHI RHO – the first two letters of the Greek word for Christ are combined, the *chi* appears as an X (although sometimes it is stood vertically to look more like a Latin Cross – see illustration, left) and the *rho* as a P.

TAU CROSS – widely known in Egypt, and possibly derived from the ancient Egyptian *ankh*, the symbol of life, this form is associated with St Anthony of Egypt.

LATIN CROSS – the form of cross St Augustine believed was used to crucify Christ.

GREEK CROSS – both parts are the same length. This cross is used in the Orthodox Church, and was common in early Christianity.

EASTERN CROSS – also used in the Orthodox Church, the top horizontal represents the *titulus*, the headboard with the inscription "INRI" and the lower, slanting bar, the section to which the feet were nailed. It slopes upward to our left as a sign of salvation, in the way that, in images of the Last Judgment, the blessed are on Christ's right.

ST ANDREW'S CROSS – or saltire. According to the *Golden Legend*, a collection of stories of the lives of the saints gathered in the late 13th century, St Andrew was martyred by being tied to a diagonal cross. It is used as the attribute of St Andrew (although in many Italian paintings he carries a Latin Cross), and therefore also for the national flag of Scotland, where he is the patron saint.

CROSS OF JERUSALEM – was used by the Crusader Kingdom of Jerusalem, and by the Order of the Holy Sepulchre. The four smaller crosses represent the four gospels, and also the spread of Christianity in the four cardinal directions.

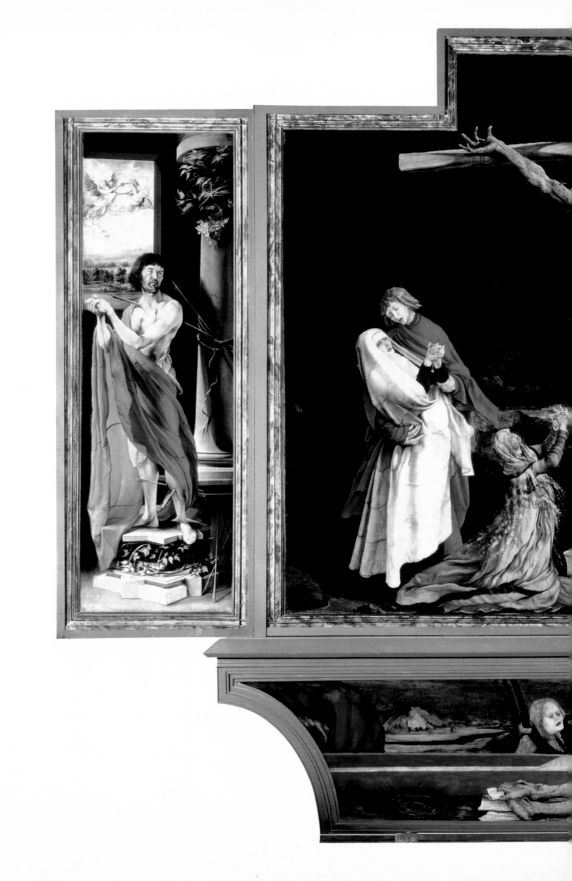

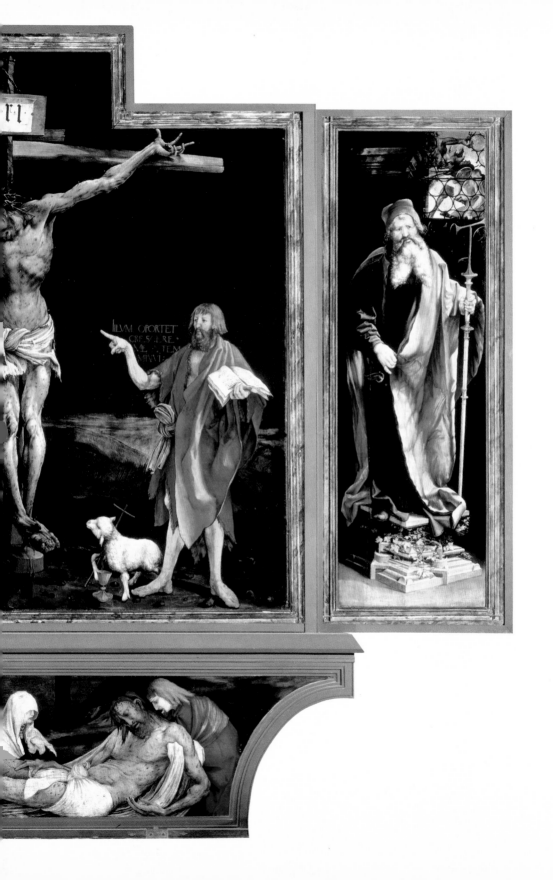

ILLVM OPORTET
CRESCERE
ME . TEM
MIAVI

THE ISENHEIM ALTARPIECE

Matthias Grünewald, 1515, Musée d'Unterlinden, Colmar, France

This uncompromising version of the Crucifixion was painted for a hospital attached to an Antonite monastery which specialized in the treatment of patients suffering from ergotism, or "St Anthony's Fire", a disease caused by a fungus which can grow on damp grain, especially rye. The symptoms can be extreme, ranging from itching and bad headaches to spasms, painful seizures, hallucinations and gangrene. These concerns are reflected in the altarpiece. The death of Christ is made explicit by the presence of his body in the predella, just above the altar, where the mass would take place and transubstantiation occur, but resurrection also follows. The painting can be opened twice, and after the first opening the Resurrection can be seen on the right hand side. When it is opened again, three sculptures by Nikolaus Hagenauer are revealed in the centre, with the Temptation of St Anthony painted on the right wing. The panels of the predella can also be taken off to reveal a sculpture of the Last Supper.

❶ The brutally rendered treatment of Christ's skin, showing the marks of the flagellation, also relate to the appearance of patients at the hospital, whose skin could break out in similar lesions.

❷ In contrast to most images of the Crucifixion, in which the Cross has been made from evenly shaped planks, Grünewald paints a rough-hewn branch, the crude construction of the Cross adding to the abject portrayal of Christ himself. The extreme contortion of his fingers may relate to the spasms experienced by those suffering from "St Anthony's Fire".

❸ The *titulus*, in its abbreviated form, appears to have been written in a fine hand with pen and ink on a piece of paper which has been pinned to a board at the top of the Cross. It is possible that some unsigned paintings originally had signatures attached in this way: several artists painted their names on *trompe l'oeil* labels like this.

❹ St Sebastian – whose martyrdom included being shot with arrows – was often invoked in times of plague. (Apollo's arrows were said to cause plague in the classical age.) Sebastian's arrow wounds were reminiscent of plague sores. Here the wounds remind us of the lacerations on Christ's body, referring equally to the patients in the hospital. Sebastian was not killed by the arrows, and thus was associated with healing.

❺ Angels fly down from the sky with a crown of martyrdom, symbolizing Sebastian's triumph over death and immediate entry into heaven. Wounded by the arrows, St Sebastian was later stoned to death.

12 The devil breaking through the window refers to St Anthony's temptation, which is depicted on the second opening of the altarpiece: Anthony is attacked by a multitude of demons, a manifestation of his spiritual torment. His association with ergotism stems from this, as hallucinations were associated with "St Anthony's Fire".

11 The Tau Cross identifies this figure as St Anthony, the patron saint of the hospital. Another of his attributes is a pig (not included here) – the Antonite monks kept them: an improved diet, including pork, was responsible for the high recovery rate among the monks' patients.

10 John the Baptist greeted Jesus with the words, "Behold the Lamb of God, which taketh away the sin of the world". The Lamb of God is shown holding a cross with its chest bleeding into the chalice, "as a lamb to the slaughter" (Isaiah 53.7), the Old Testament prophecy to which John was referring.

9 Although held by the Baptist, this Bible may be a reference to John the Evangelist, whose gospel opens with the phrase "In the beginning was the Word, and the Word was with God, and the Word was God" (John 1.1): Jesus is identified as the Word, and John the Baptist recognizes him as such. It may also refer to the Old Testament prophecies which are fulfilled in Jesus.

6 John the Evangelist supports the Virgin Mary at the foot of the Cross: Christ spoke to them both, instructing them to care for one another after his death (John 19.26–27).

7 The New Testament records that Mary Magdalene was, like St John and the Virgin, present at the Crucifixion. The jar, her most common attribute, contains ointment with which she is said to have washed Christ's feet, and which she would later take to his tomb to anoint his body.

8 John the Baptist recognizes Christ as the Messiah. The words painted here, "He must increase, but I must decrease" (John 3.30) are part of the Baptist's explanation that he himself is not the saviour, but rejoices that Jesus is among them.

PATRONAGE

The patron, or "donor", is the person who pays for the construction or decoration of a church, and as a result they frequently decide the way in which the work is carried out. There are many reasons why someone would want to be a donor or patron. Monks and priests might need a church in which to worship and/or preach. Others would give money for the greater glory of God, and while it is easy to be cynical about this motive it was a genuine one more often than not. Others became patrons to atone for sins – the building and decoration of the Scrovegni Chapel in Padua being a notable example (see pages 74–77).

The identity of the patron could be advertised in a variety of ways: from coats of arms (see the reliquary cover on page 79) to other, more emblematic references, such as Richard II's white hart (see pages 164–167) or the gold well on some of the roof bosses in Norwich Cathedral (see illustrations, below and opposite). The patrons may want to be identified as an appreciation of their own personal devotion, but alongside

this is a display of their own particular munificence. Not only does patronage draw attention to their wealth and status during life, but after their deaths it would also encourage worshippers to pray for the patrons in the hope that their souls reached heaven as quickly as possible.

There was also the practical need to secure a place in which to be buried. The sponsorship of private chapels for use as family vaults was of prime importance for the decoration of churches. Tombs could be commissioned by someone while they were still alive, or provision for one could be included in a will. Very often, in addition to the construction of a tomb and the decoration of the chapel, the endowments might include funds for the priests' vestments and for church plate – the silverware used during services – so that masses could be said for the deceased on specified days. Although some patrons remain all but anonymous in these bequests, others make themselves known. Richard de Visch van der Capelle commissioned an altarpiece from Gerard

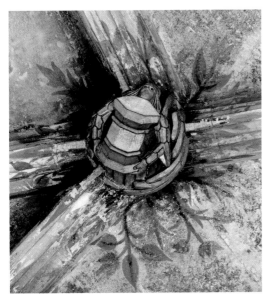

● ROOF BOSS WITH A GOLD WELL
1460S, NORWICH CATHEDRAL, ENGLAND

In addition to coats of arms and personal emblems, the patron can be represented by a rebus, a pictogrammatic representation of their name. For Bishop James Goldwell, who commissioned the vaulting of the presbytery in Norwich Cathedral (see right), this rebus was, quite simply, a gold well, which is held by an angel in as many as ninety-four of the ceiling bosses

● PRESBYTERY, WITH THE GOLDWELL CHANTRY
12TH–15TH CENTURIES, NORWICH CATHEDRAL, ENGLAND

After a fire in Norwich Cathedral in 1463, Bishop James Goldwell paid for a new stone vault for the presbytery, which harmonizes remarkably well with the Norman apse. He also installed a chantry – a small chapel within the body of the building which serves as a place of burial, and in which prayers can be said (or chanted, hence the name) in memory of the deceased. The chantry is the red, green and gold structure at the bottom right of the photograph.

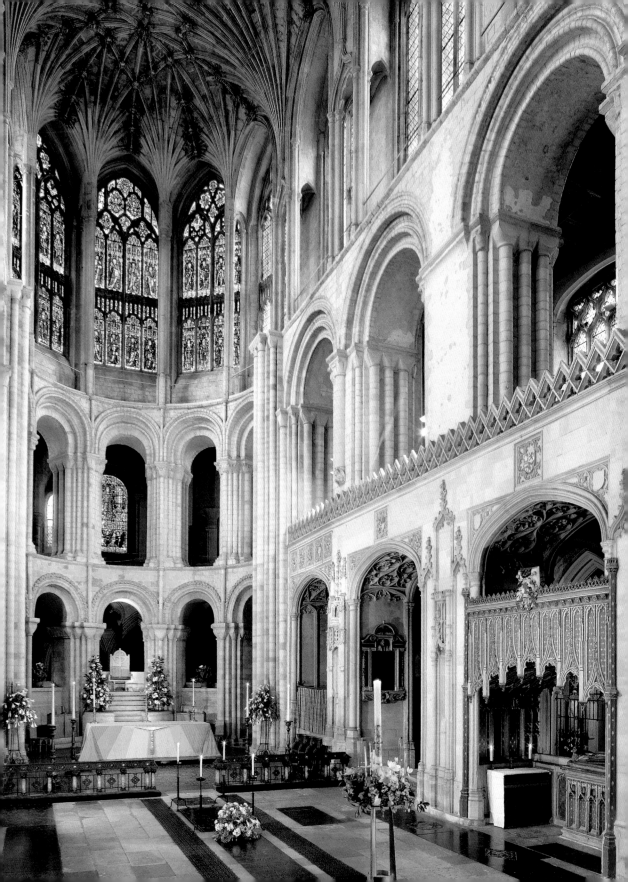

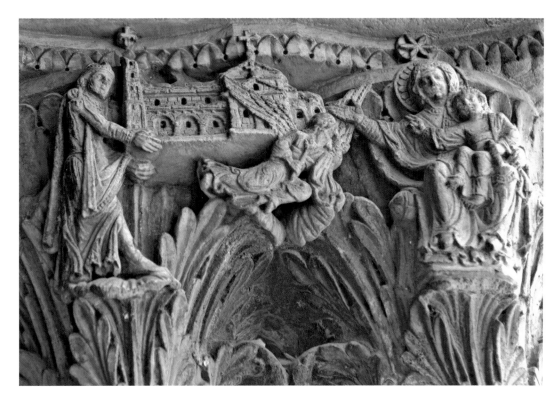

⬤ WILLIAM II DEDICATING MONREALE CATHEDRAL TO THE VIRGIN

Late 12th century, Cloisters, Monreale Cathedral, Sicily

This capital is set on two thin columns on the west side of the cloister, and is positioned so that the cathedral can be seen from the same point of view. Constructed more than 800 years ago, the building still looks the same as this carved version.

David (see pages 114–115), which included a portrait of the donor kneeling in front of the Virgin and Child, a common practice. Sometimes the donors were shown as if giving the object of their patronage to God himself, or to the Virgin (see illustration, above). '

Because patrons chose the artists or builders who would carry out their commissions they were enormously influential and effectively determined the style and contents of the work. In altarpieces, for example, patrons would often specify precisely what should be depicted and which saints should be included. This could be dictated by the church for which an altarpiece was painted, as it is in the Isenheim Altarpiece (see pages 120–123), or by a particular devotion of the patron: for example, the Wilton Diptych includes Richard II's patron, St John the Baptist, as well as two saints who were the king's royal predecessors (see pages 164–167).

The Church and the state

According to Richard II, in Shakespeare's play of the same name: "Not all the water in the rough rude sea / Can wash the balm off from an anointed king." This assertion illustrates a

continuing belief in the Divine Right of Kings, a doctrine that implied monarchs owe their earthly power to God himself, and are anointed by his representative on Earth. In England, this remains the Archbishop of Canterbury, who, in Richard II's time (though not in Shakespeare's own), would have been representing papal authority. That God blesses his chosen ruler is reflected in numerous images: it is a major theme of the Wilton Diptych, and a mosaic in Monreale Cathedral shows how William II's status as king of Sicily is similarly affirmed by the blessing bestowed on him by Christ (see illustration, below).

However peaceable this relationship may appear, Church and state have rarely collaborated without tension. In its early days Christianity was illegal (and has been since across the world in different centuries under different regimes). Christianity was legalized in 313, and in 380 became the official religion of the Roman Empire. However, complications arose from the division of the empire between East and West when Constantine left Rome to set up a new capital in what was consecrated as Constantinople in 330. A document, known as the "Donation of Constantine", suggested that, around this time, the pope had been given authority over Rome and the whole of the Western Empire by none other than Constantine himself. This was used to strengthen the pope's claim as an earthly ruler (over the centuries the papacy ruled over much of the Italian peninsula).

The "Donation" proved to have been a forgery (as long ago as 1440 the scholar Lorenzo Valla pointed to its anachronistic use of language) and it is now thought that the document was written in the middle of the eighth century, at a time when debates about the balance of earthly and

spiritual authority were coming to the fore. Not long after it is thought to have been produced, in the year 800 Pope Leo III crowned the Frankish ruler Charlemagne "Emperor of the Romans". Charlemagne had been summoned to Rome to defend the pope from his enemies, and by crowning Charlemagne emperor Leo was not only rewarding him for his services, but also distancing himself from Byzantium, the still powerful eastern remnant of the Roman Empire.

The act also helped to define which power was responsible for the governance of Europe, even though in later centuries disputes between the pope and the Holy Roman Emperor were commonplace: each insisted that they should have precedence. While the pope had spiritual authority over all Christians (or at least, in later years, over all Roman

◉ CHRIST AND WILLIAM II
1180S, MONREALE CATHEDRAL, SICILY

This mosaic is on the north wall of the presbytery, directly opposite another in which William II presents the cathedral to the Virgin and Child, the same subject as the capital shown on page 126. William's gift of a cathedral is rewarded by this confirmation of his right to rule.

Catholics), he also ruled over the Papal States until 1870, when, with the Unification of Italy, Pope Pius IX retreated to the Vatican.

The Byzantine Empire survived until 1453, when it was defeated by the Ottomans. Until that time the Byzantine emperor was also head of the Orthodox Church. Elsewhere in Europe the head of state had to be sanctioned by the Church: it was the pope, or his appointed deputy (a bishop or archbishop), who would be responsible for the coronation of a king or queen. This changed in England in 1534, when the Acts of Supremacy made King Henry VIII the "supreme head" of the Church of England, the culmination of several years of struggle with Rome. To this day Britain has an

○ THE DONATION OF CONSTANTINE

C.1247, SANTI QUATTRO CORONATI, ROME, ITALY

The precise date of this fresco is not clear, although it is likely to be roughly the same age as the chapel, which was consecrated in 1247. Pope Sylvester, who in an earlier scene has cured Constantine of leprosy, is enthroned, wearing a bishop's mitre. Constantine hands him the tiara, symbolic of his rule of Rome, and reaches for the reins of his horse, which is coming out of the city gates. In the next painting the pope rides into Rome on the horse, which is led by Constantine humbly walking.

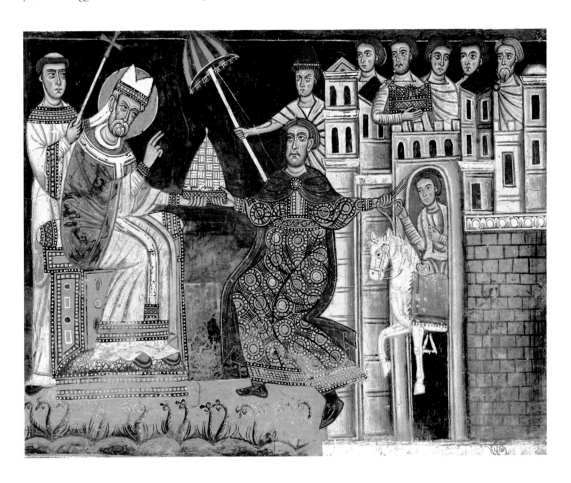

⊙ STEEPLE OF ST GEORGE'S, BLOOMSBURY
Nicholas Hawksmoor, 1716–1731 (LIONS AND
UNICORNS CARVED BY TIM CRAWLEY, 2005–
2006), LONDON, ENGLAND

In his search to renew ancient forms, Hawksmoor
attempted a recreation of the Mausoleum at
Halicarnassus, one of the seven wonders of the
world, following the description of Pliny the Elder.
However, rather than a statue of Mausolus, after
whom the structure was named, Hawksmoor
placed King George I on top of his idiosyncratic
structure. Although Hawksmoor included the lion
and the unicorn, the heraldic beasts of England
and Scotland respectively, these were removed
during a "restoration" in the 1870s, as the Victorians
found them frivolous, but they have recently been
recreated and replaced. The bizarre placing of the
king was only too evident at the time of the church's
completion, as becomes clear from an anonymous
verse quoted by architect John Soane in his *Lectures
in Architecture*:

*"When Harry the Eighth left the pope in the lurch
His parliament made him the head of the church.
But George's good subjects, the Bloomsbury people,
Instead of the church, made him head of the steeple."*

Established Church – meaning that the head of state is
also the head of the Church – whereas in other countries
the Church and the state are separate by law. In the United
States, for example, this principle is contained within the
First Amendment of the constitution.

The relationship between Church and state is reflected in
the appearance of churches in a number of ways. Patronage
could promote the power of the Church, or the power of
the state. For example, the Venetians built and decorated
much of St Mark's Basilica with material they had looted
from Constantinople, thus showing their superiority to the
Byzantine Empire. But the Venetians also promoted the
basilica as being far more important than the cathedral,
which was dedicated to St Peter and located on an outlying
island. In this way the city proclaimed its independence

from the pope and his appointed bishops. One of the reasons
why King William II supported the building of Monreale
Cathedral, some way outside Palermo, was to gain a degree
of independence from the power of the Church. When King
Henry VIII was made head of the Church of England, all
churches were required to display his coat of arms instead
of those of the pope. The worries about the growth of
Nonconformism in the late seventeenth and early eighteenth
centuries in Britain meant that new Anglican churches
displayed their allegiance to the Crown – and therefore the
head of the Church – more prominently. James Gibbs made
sure that the royal coat of arms could be seen clearly in the
pediment of St Martin-in-the-Fields (see page 7), whereas in
Bloomsbury Hawksmoor went one step further by topping
the steeple of St George's with a statue of the king himself.

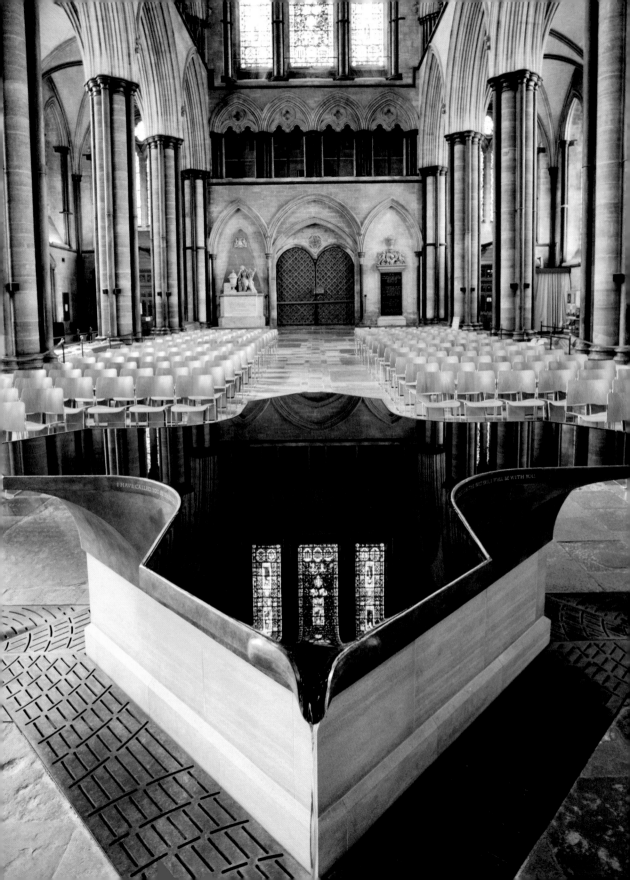

THE HISTORICAL
DECODER

PART THREE

○

The art and architecture of Christian churches have evolved gradually, with changes in the forms of worship often resulting in changes of style, or in the structure of churches. For example, Salisbury Cathedral was built almost in its entirety between 1220 and 1258, and is a remarkably coherent structure architecturally (see left). The pointed arches of the arcade tell us it is Gothic in style, and the contrast between the light walls and the dark Purbeck marble of the columns is typical of Gothic's Early English phase. Built originally as a Catholic place of worship, it was converted to the requirements of Protestantism after the Reformation. The medieval pulpitum was removed during restoration work in the eighteenth century, and nearly 100 years later Giles Gilbert Scott installed a new, neo-Gothic one. There have been constant additions, including the eighteenth-century neo-classical monument, which can be seen to the left of the west door. In 2008 William Pye's font was installed in the centre of the nave, just inside the north porch: the font's position, function and symbolism are entirely traditional, while its form is entirely new. These changes are explored in this last section of the book, which surveys the evolution of church structure and layout, and the artistic styles these represent, making reference to alterations in the liturgy, and to the development of Christianity itself.

○ **SALISBURY CATHEDRAL, WITH THE FONT**
William Pye, 2008, SALISBURY, ENGLAND

Suitable for infant baptism and large enough for the complete immersion of adults, William Pye's font is modern but replete with traditional symbolism. It is cruciform and the four arms point to the cardinal directions, each of which issues a constant stream of water. The effect is to evoke the four rivers in the Garden of Eden, the flow of the river Jordan, the evangelists and the spread of Christianity across the world, as well as the continuing grace of God.

THE EARLY CHURCH

It is difficult to determine the nature of the earliest Christian art and architecture, given that most of what little there was has not survived. For roughly the first three centuries of its existence, Christianity was illegal and worship had to take place in secret, believers gathering in the houses of prominent members of their community. Although one or two of these "house churches" have survived, these do not provide enough evidence to suggest that the others would have been structured in the same way, or had similar decoration. When Christianity was legalized churches were often built repeatedly on the same sites: Christianity's success therefore led to the destruction of much evidence about its origins.

What do survive are the places of entombment. In ancient Rome burial was only allowed outside the city walls and took place in tombs or sarcophaguses above ground,

or in the few places where the stone was sufficiently soft to excavate, burial was below ground, in the catacombs. Initially Christians may have been interred alongside people of other religions, but gradually segregation occurred. The catacombs were not places of worship (with the exception of the *refrigerium*, a commemorative meal for the dead), nor did the early Christians hide out there (as used to be believed). Nevertheless, as secluded spots which would rarely if ever be visited by the authorities, the catacombs were among the first places to be decorated with Christian imagery – especially popular were scenes from the Jewish scriptures, such as Daniel in the lions' den, which showed God's protection of his chosen people. The earliest images of Jesus show him as the Good Shepherd, with one of the sheep on his shoulders: again, God is caring for His people.

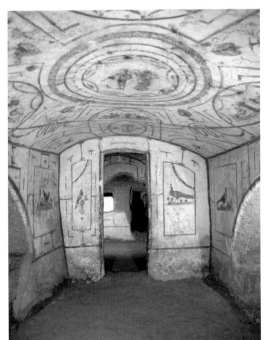

◐ THE CRYPTS OF LUCINA

MID–LATE 3RD CENTURY, CATACOMBS OF SAN CALLISTO, ROME, ITALY

The Crypts of Lucina were constructed in the late 2nd century. These rich decorations date from the 3rd century, and they include images of the Good Shepherd (see below), Daniel in the lions' den, and the early appearance of symbols such as the peacock (see page 112). This room is a *cubiculum*, a small room constructed for private or family burial: the word was also used to refer to a bedroom, thus emphasizing the idea that death was only a form of sleep before the resurrection of the body at the end of time.

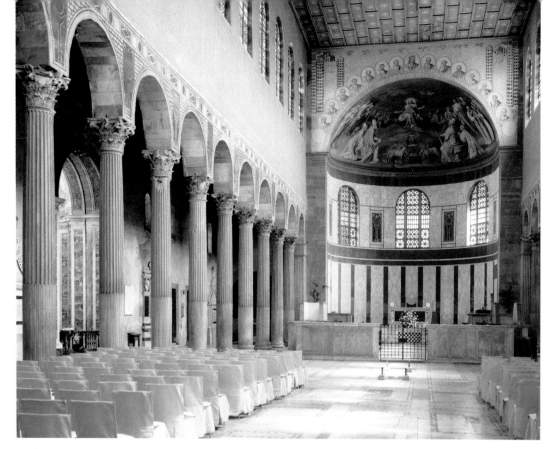

Basilicas and temples

With the legalization of Christianity, it became possible to build public places of worship. No one had ever built a church, but there were several models on which they could be based. Most important among these was the basilica (from the Greek word *basileus*, meaning "king"), a rectangular meeting hall or audience chamber for legal, financial or other matters. The leading official – a magistrate, or even the emperor himself – would sit at one end, on a raised platform in a form of recess (or apse) in which there was sometimes a giant statue, or colossus, of the emperor, who was seen in ancient Rome as a living god. The roof was often supported by two rows of columns, creating a central hall with further space on either side. The transition from basilica to church is easy to understand: replacing the colossus with an altar on which the living God is present in the mass, enabled the priest and other celebrants to sit around the apse more or less as the magistrates would have done in a court of law. The central hall became the nave, with the two side sections

◐ **SANTA SABINA**
425–432, ROME, ITALY

Although this church was remodelled at the end of the 16th century, at the beginning of the 20th century it was restored, as far as was possible, to its original appearance in the early 5th century. Santa Sabina is considered to be one of the best early churches in Rome. It was built on the site of a temple to Juno, and reused twenty-four marble columns from that temple for the arcades of the nave. The Romans did not usually have arches springing from columns; although this is a regular stylistic feature of Romanesque and some later architecture, the arcades of Santa Sabina show that this idea was a late Roman innovation. The plaster latticework in the windows frames very thin slices of translucent mica.

the aisles. There is no fundamental architectural difference, but a profound contrast in function.

Another model was the classical temple, orientated so that the rising sun would enter through a door at the east and illuminate a giant gold statue of the god within. Although early churches were not necessarily orientated, when they

were the altar was at the east so that the congregation faced the rising sun, which became a symbol of the Resurrection and of the light of God. A few temples were even reused as churches – notably the Pantheon in Rome, and the cathedral of Syracuse in Sicily, both of which retain much of their original structure. Some early Christian worship took place in synagogues, and those Jews who converted to Christianity inevitably brought ideas with them – a raised platform from which the scriptures could be read, for example.

The decoration of churches was likewise influenced by the existing examples. Unlike temples, early Christian churches were relatively plain on the outside. Jews did not use representational imagery. It may well have been Roman converts, so used to seeing depictions of the pagan gods, who brought imagery into churches – and it seems likely that the same craftsmen were employed. The idea of the Good Shepherd was already common in classical culture, but in a Christian context it was interpreted differently. The same is true of the mosaic decorations of Santa Costanza

⬥ SARCOPHAGUS OF JUNIUS BASSUS
359, TREASURY OF ST PETER'S, ROME, ITALY

This sarcophagus is structured like a clasical building on two levels, with columns supporting an entablature. The different scenes from the Old Testament and New Testament are in no particular order, as the idea of biblical sequences and comparisons had not yet developed. At the top are, from left to right: the Sacrifice of Isaac, the Arrest of St Peter, the *Traditio Legis* (a symbolic image, with Christ enthroned between saints Peter and Paul), and Christ brought before Pontius Pilate, which is spread over two scenes. At the bottom are, from left to right: Job, Adam and Eve, the Entry into Jerusalem, Daniel in the Lions' Den, and the Arrest of St Paul.

(see illustration, right), which in both style and content would elsewhere have been seen as pagan. There was no specific "Christian" style of painting or sculpture – it had not had time to evolve. Although the scenes portrayed on the sarcophagus of Junius Bassus (see illustration, above) are all taken from the Old and New Testaments, the architectural framework and style is undeniably that of imperial Rome.

Most early churches were built where earlier house churches had stood (Santa Sabina may take its name from the home of a woman called Sabina), or at what were notable holy sites. For example, St Peter's Basilica was built for the Emperor Constantine on top of the apostle's tomb, and Junius Bassus was buried beneath its floor, to be close to the saint. Another Constantinian basilica was built above the catacombs where St Agnes was buried, and it was adjoining this that Constantia, the emperor's daughter, had her mausoleum constructed (see pages 107 and 113). There was also a cluster of early churches built in the Holy Land to mark the sites of the Nativity, the Crucifixion and the Holy Sepulchre (among others).

So why did Christianity seem to emerge from Rome? There are two main reasons. When the Romans – led by Titus, who later became the emperor – sacked the Temple of Jerusalem in the year 70 there was a general exodus of believers, both Jewish and Christian, which meant that the focus of Christianity moved elsewhere. Later, when Constantine legalized Christianity in 313 and when Theodosius made it the official state religion in 380, it was the Romans who had the money to build the churches. But by this time, Roman power was centred in the East at Byzantium.

○ MOSAIC OF THE HARVESTING AND TREADING OF GRAPES
C.350, SANTA COSTANZA, ROME, ITALY

At first glance this may appear to be a typically pagan scene of the harvesting and treading of grapes, the energy of some of the figures suggesting an almost Bacchic frenzy. However, their context in a church – one originally built as a mausoleum – reminds us of the Eucharistic significance of wine and the Christian symbolism of the grape.

BYZANTIUM & THE EAST

The nature and timing of Constantine's conversion to Christianity have long been the subject of debate. Although Church tradition suggests that Constantine became a Christian after his victory over Maxentius at the Battle of the Milvian Bridge in 312, which was attributed to the use of the Chi Rho symbol he had seen in a vision the night before, he was only baptized on his deathbed in 337. This was not unusual at the time: the newly baptized was left with little time before death in which to sin, and so leaving baptism until the last moment may have seemed the safest thing to do to guarantee entry into heaven. During his life Constantine had been responsible for the building of numerous basilicas in Rome and the Holy Land, and he had presided over the Council of Nicaea in 325, called in order to settle some of the

more important disputes within the Church. But when he moved the centre of the Roman Empire to Constantinople (Byzantium), the city he built was more imperial than Christian. The precise reasons for this move are still not clear. Although the "Donation of Constantine" (an eighth-century forgery, see page 127) suggested that Constantine thought he should not rule in the same place as the pope, we know this was not the case. The emperor certainly wanted a new start and in a location that was strategically important, given the way in which the empire had grown eastward, and which could be far from the decadence of Rome.

It was not until 360, during the reign of his son, Constantius II, that the Church of Holy Wisdom, or Hagia Sophia (pronounced "aya sofya") was completed: it was

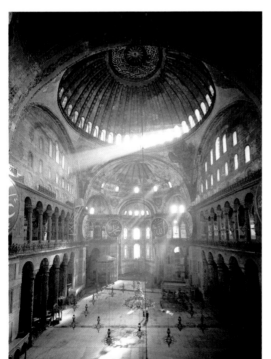

◖ HAGIA SOPHIA
Isodoros of Miletos and Anthemios of Tralles, 532–537, ISTANBUL, TURKEY

Hagia Sophia has had a chequered history. The dome collapsed in 548, and was rebuilt four years later, but has subsequently been rebuilt twice more. Much of the decoration was whitewashed or altered during the Iconoclast Controversy, and after the fall of Constantinople in 1453 the church became a mosque. Today it is a museum, retaining its original majesty, if not its full splendour.

◗ ST MARK'S BASILICA
12TH–16TH CENTURIES, VENICE, ITALY

Venice's Basilica of San Marco was inspired by the Church of the Holy Apostles in Constantinople, which was destroyed in 1461 to make way for a mosque. Byzantine craftsmen were employed in St Mark's to create the mosaics on every surface of the building's upper parts, giving us some idea of the original richness of Hagia Sophia. This church would once have been equally brilliantly illuminated, although many windows were filled in and covered with more mosaic in the 14th–16th centuries. The central dome (at the top, here) depicts the Ascension – Christ is seated in a blue circle supported by angels, representing the heavens, and the apostles are gathered around with their hands shielding their eyes from the sun as they look up into the sky.

destroyed by fire as a result of riots in 404. The replacement, completed in 415 was burned down in 532, and Emperor Justinian started again. At the dedication of the church five years later he supposedly exclaimed "Solomon, I have outdone thee" – suggesting that the new church was grander than the Temple of Jerusalem. Although the central dome visible today is not the original, the effect must have been much the same. That dome was compared to the vault of heaven floating above the Earth. In part this was a result of a multitude of windows, letting in shafts of sunlight to glisten off the mosaics. So great was the impact of a central dome that almost all Eastern churches were modelled on it thereafter.

This idea of heaven floating above Earth was continued in the decoration, with the more heavenly subjects appearing higher up. For example, the dome frequently included a depiction of the Pantocrator ("all powerful": this refers to images of Christ as ruler). Below this, in the apse, are the *Theotokos* ("Mother of God") and Child, with the higher status saints below them, and yet more saints further down.

continued on page 142

EMPEROR JUSTINIAN WITH HIS COURTIERS

c.547, SAN VITALE, RAVENNA, ITALY

Emperor Justinian stands in the centre, wearing the imperial purple. Next to him is Maximian (his name is inlaid above his head), the bishop responsible for the completion of the church, whose throne, a gift from Justinian himself, would have been placed in the apse immediately to the right of this mosaic (see page 58). The soldier on the far left has a shield decorated with the Chi Rho, one of the earliest Christian symbols (see page 119).

⊙ THE THEODORE PSALTER

Theodore, 1066, British Library, London, England

The scribe of this book, Theodore, was a monk at the monastery of St
John Stoudios in Constantinople and he has included his patron, St
Theodore, with the patriarch Nikephoros, holding an icon of Christ
in the left margin. Both are also seen at the bottom arguing with
the iconoclast emperor Theophilus, whose death in 842 led to the
accession of the infant emperor Michael III, and thus just preceded the
"Triumph of Orthodoxy". Three iconoclasts whitewash an icon at the
bottom right. Their inclusion here identifies them as the "evildoers"
mentioned in the text they illustrate: "I have not sat with vain persons,
neither will I go in with dissemblers. I have hated the congregation of
evildoers; and will not sit with the wicked" (Psalm 26.4–5).

⊙ ICON WITH THE TRIUMPH OF ORTHODOXY

Second half of the 14th century, British Museum,
London, England

The "Triumph of Orthodoxy" was celebrated annually on the first
Sunday of Lent from 843 onward. This icon, painted some five centuries
later, includes an illustration of a famous *hodegetria*, a type of icon in
which the *Theotokos* ("Mother of God") holds the child and points
toward him as the source of our salvation. This particular *hodegetria*
was believed to have been painted by St Luke himself. Empress
Theodora and her young son Michael III, who were responsible for
the Triumph of Orthodoxy, stand (dressed in red) to the left.

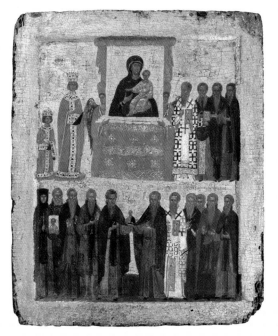

THE ICONOCLAST CONTROVERSY

The word "iconoclasm" comes from Greek words which mean the
destruction of images. The Church had justified the use of pictures to tell
stories which people should know and to show those who should be revered
– indeed, St Basil the Great (c.329–379) claimed that people should respect
icons because, "The honour given to the image passes over to the Prototype".
Nevertheless, there has always been a fine line between respecting an image
because it represents God, who should be worshipped, and worshipping
the image itself, which would be classed as idolatry. It was thought that this
distinction might not be appreciated by the masses, a concern which was
compounded by a growing awareness of other misuses of imagery. Dishes
were decorated with pictures of saints, which may have been intended to
bless the food, and images of saints were being worn as talismans. There was
even one reported instance of the plaster on which saints had been painted
being eaten as a medicine. In addition to this, after the death of Mohammed
in 632, the rapid growth of Islam was interpreted as God's punishment of the
Byzantines. As the Muslims stuck to the Second Commandment and did not
use visual imagery, its use by Christians was felt to be the reason for God's
displeasure and Emperor Leo III declared that icons and images should be
removed. Many were then destroyed, whitewashed or simply replaced with
symbols such as the Cross. Strong support for the use of icons still existed,
but between 726 and 843 the Iconoclast Controversy led to the loss of much
of the early art of Byzantium. Empress Theodora, acting as regent for her
young son Michael III, finally re-established the use of icons, and in 843 they
were declared to be essential to the true faith.

SANT'APOLLINARE IN CLASSE

c.549, Apse mosaic, and 670s, Triumphal Arch mosaic, Ravenna, Italy

The Transfiguration occurred when Jesus took his disciples Peter, James and John to the top of a mountain, then suddenly they saw him shining, his clothes a brilliant white, and in conversation with Moses and Elijah. The basilica housing these mosaics of the Transfiguration was built at Classe, the original maritime port of Ravenna, but the basilica became less important over time after the relics of the patron saint were translated to a church in the city to protect them from pirates.

1 The two figures in the sky are labelled "Moses" and "Elijah" – the key to the interpretation of this mosaic as a stylized Transfiguration.

2 Rather than showing Jesus dressed in brilliant white, his appearance has been "transfigured" into a cross. The blue circle covered in stars would be interpreted as the vault of heaven, and therefore the whole of creation, on which Jesus can be seen enthroned in other mosaics.

3 The three sheep at the foot of the cross stand for Peter, James and John, the apostles who accompanied Jesus and witnessed the Transfiguration.

4 During the Transfiguration a voice declares: "This is my beloved Son, in whom I am well pleased." At the top God's hand appears in blessing.

5 Sant'Apollinare, bishop and patron of this church and of Ravenna, is directly below the cross, his hands raised as an orant (praying figure). The image was directly above the throne of the presiding bishop, and, from the congregation's point of view, above the relics of the saint.

6 The six sheep on each side of Apollinare make him look like Jesus with the twelve apostles, and remind us that the bishop is God's chosen representative on Earth, standing in for Jesus and caring for his flock.

7 Below Apollinare are four bishops: Apollinare's work in Ravenna is continued by that of his successors, with the living incumbent seated below. This is known as the apostolic succession: the authority of the bishops on Earth derives from that of the original apostles.

8 The figure of Christ the Pantocrator (ruler over all), flanked by the symbols of the Evangelists, was added in the late 7th century.

9 More sheep, again representing the twelve apostles, flock toward Christ from stylized buildings representing Bethlehem and Jerusalem. This part of the mosaic is contemporary with the figure of the Pantocrator above.

10 Although the altar is modern compared to the mosaics, the apse floor was raised and the steps leading up to it installed in the late 7th century to allow the relics of Sant'Apollinare to be visited in the crypt below.

11 Of the four mythical beasts mentioned in the book of Revelation, the eagle was allocated to St John because it was considered to be the one most capable of flying close to heaven to hear the word of God, which is discussed in the first verse of the gospel of John.

12 The winged man, or angel, was deemed most appropriate as the symbol for St Matthew because his gospel opens with an account of the ancestors of Christ – all the men who came before him.

13 The gospel of Mark opens with St John the Baptist, a "voice crying in the wilderness". As lions roar, the winged lion became Mark's symbol.

14 The gospel of Luke starts in the temple, where oxen might be sacrificed. The winged ox was therefore deemed the appropriate symbol for St Luke.

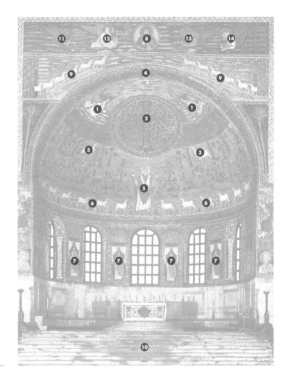

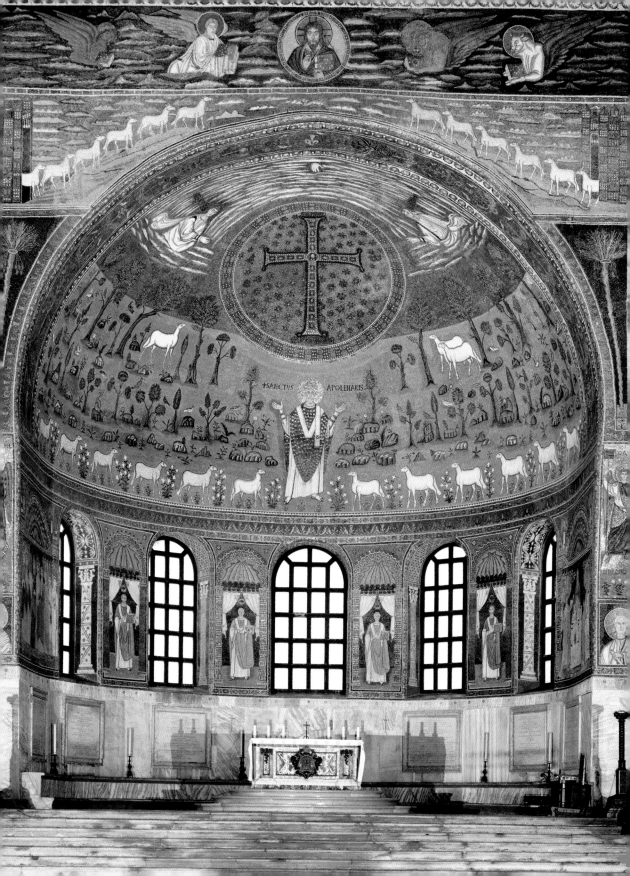

Versions of this arrangement can be seen in the apse mosaics of both Sant'Apollinare in Classe (see pages 140–141) and the cathedral of Monreale (see pages 152–153).

The revitalization of the Western Empire

By the beginning of Justinian's reign in 527 the western branch of the Roman Empire had fallen. Rome was sacked by the Visigoth Alaric in 410, and in 476 the last western emperor, Romulus Augustulus, had been deposed. Justinian set out to recapture much of what had been lost, and substantial gains were made around the Mediterranean coast thanks to his successful general Belisarius. Not least among the regained territories was Ravenna, on the east coast of the Italian peninsula, where a period of wealth and relative stability led to a flourishing of the arts. The emperor's status was affirmed by the construction of new buildings, including the churches of San Vitale and Sant'Apollinare in Classe (the original sea port), both of which were richly decorated in mosaic. On either side of the sanctuary in San Vitale, mosaics include portraits of Justinian and his wife Theodora bringing gifts to the altar, even though neither

◉ THE HARBAVILLE TRIPTYCH

10TH CENTURY, MUSÉE DU LOUVRE, PARIS, FRANCE

The Harbaville Triptych is a particularly fine example of the delicacy which could be achieved by carving ivory. At the top of the central panel is the *Deisis*, an image of Christ enthroned, flanked by the *Theotokos* and *Prodromos* (the precursor of Christ: John the Baptist) who intercede on behalf of the people.

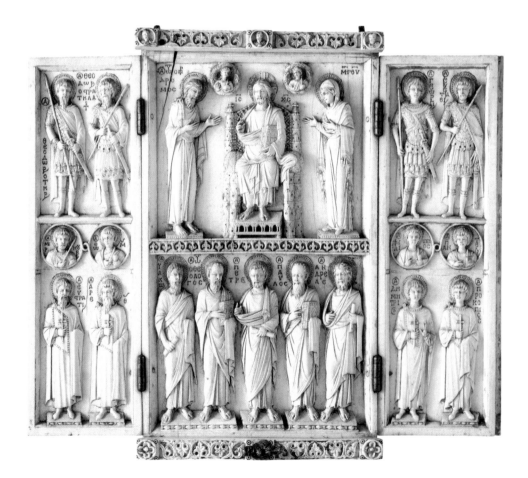

◑ ICONOSTASIS

1537, Moldovita Monastery, Suceava, Romania

In the early days of the Byzantine Church the *naos* (or nave) was separated from the *bema* (sanctuary) by a low barrier, so that the lay members of the congregation could participate fully in the liturgy. This was replaced by a *templon*, a higher, open, screen made up of columns supporting an architrave, or beam. Gradually the spaces between the columns were filled in with icons, and more images were placed on and above the architrave, this *iconostasis* reaching its full height in the 13th century. This evolution meant the gradual enclosure of the priesthood, and an increasing sense that the *bema* represents the "holy of holies" to which the laity have little or no access, and which they can only see when the central "beautiful gates" are opened at specific moments of the liturgy. These doors may only be used by the priesthood. The doors to the north and south are called the deacons' or angelic doors, with the one at the north generally being used as an entrance, and the one at the south as an exit. Although it may seem like a division, the *iconostasis* is often interpreted as a connection between the nave and the sanctuary, and therefore between Earth and heaven, with the icons leading us from one to the other.

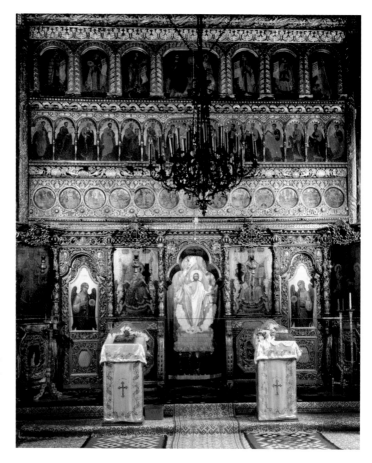

one had ever set foot in Ravenna. The differences between these mosaics and the early Christian ones are immediately apparent. The Ravenna mosaics are far less naturalistic, making use of bolder, more simplified colours and elongated proportions. The figures are more schematic, and the limbs less fully articulated – note, for example, how the feet of Justinian and his entourage do not seem to rest on the ground (see illustration, page 138). The reasons for the stylization are not immediately apparent, but it makes them easier to read from afar, and it also serves to distance us from their reality. This was important, as there were still qualms about the use of imagery in churches, an ongoing debate

which eventually broke out in the Iconoclast Controversy of the eighth and ninth centuries (see box, page 139). This may be the reason why the apse mosaics of Sant'Apollinare are not just stylized, but abstracted: what at first glance may appear to be a landscape in which sheep look up at the Cross can be seen, by comparison with more overt depictions, to be an illustration of the Transfiguration.

The ravages of iconoclasm

When the mosaics of Sant'Apollinare were created in the middle of the sixth century, the first outburst of iconoclasm was still more than a century and a half in the future: the

⬠ MONASTERY OF ST ANTHONY
4TH CENTURY, RED SEA MOUNTAINS, EGYPT

The word "monk" is, like so much of Christian vocabulary, derived from a Greek word *monachos*, meaning "single" or "solitary". As early as the third century Christians were retiring from the hurly burly of the world to live a life of solitary prayer and contemplation. Among the earliest of these was St Anthony, who is believed to have lived in the desert in Egypt from around 285, where he struggled alone with the temptations of the flesh (see pages 98 and 120–123). But there were many such hermits, most of whom may well have left "civilization" to avoid the oppressive nature of the Roman Empire, within which Christianity was still illegal. St Anthony went on to devise a Rule by which such hermits should live, bringing them together for mutual assistance in life, and for their mutual defence against threatening outsiders. The Monastery of St Anthony, pictured above, was founded in 356, shortly after Anthony's death, and is the world's oldest inhabited monastery, though much of the current building and its decoration is later in date.

basilica's distance from Constantinople meant that it was not harmed. Throughout the second half of the eighth century and the beginning of the ninth, frescoes and mosaics were destroyed, altered or covered over (see box, page 139), with the result that the surviving works in Ravenna have become, by default, the best representations of the splendour of the Byzantine court. Although many new works were created as a result of the triumph of Orthodoxy, there were huge losses when Constantinople fell to the Ottomans in 1453, and churches were destroyed or converted into mosques.

East–West schism

By this time the Orthodox Church was separate from the Western Church. The division had been a long time coming: by crowning Charlemagne Emperor of the Romans in 800, Pope Leo III had distanced himself from the authority of the East, and the eventual split was as much about political power as theological difference. Nevertheless, different rites evolved and the Church councils became less and less ecumenical.

The Great Schism occurred in 1054, and was in part the result of a disagreement about the Holy Spirit. The Nicene Creed stated that the origins of the Holy Spirit were within God the Father (he was – and is – said to proceed from the Father), which was sanctioned by Jesus' own words. In 1014 the Western Church introduced one word to the creed, *filioque*, which means "and the Son". So whereas the Eastern Church believed (and believes) that the Holy Spirit proceeds from the Father, the Western Church believed (and believes) that the Holy Spirit proceeds from the Father and the Son. Although this may seem like a minor detail, it provoked huge passions – it is after all fundamental to belief, as it strikes at the very nature of God – and was a convenient disagreement on which to hang a separation which had been looming for a couple of centuries. The final straw was a dispute about papal authority, when, in 1054, a papal legate was sent to the patriarch in Constantinople and the two ended up excommunicating one another. A century and a half later, the sack of Constantinople by the Venetians reopened a wound which otherwise could possibly have been healed.

Although the Orthodox Church continued to evolve, in many ways it has done so less than the Western Church, which experienced humanism during the Renaissance and then went through the Reformation and Counter Reformation, splitting into numerous denominations. In recent years the Orthodox Church has, in some ways, modernized, though icons are as relevant now as they were in 843, and most churches have the *iconostasis*, which has changed little since it reached its current form in the thirteenth century.

◑ SUCEVITA MONASTERY
1581–1596, BUKOVINA, ROMANIA

The monastic tradition initiated by St Anthony has a long and significant history. Sucevita Monastery was started in 1581 and dedicated to the *Koimesis* (the Orthodox term for the Dormition of the Virgin) in 1584. It is the last, and generally considered to be the greatest, of a remarkable group of painted monasteries in Bukovina. The building, decorated both outside and in between 1595 and 1596, was not only richly painted, but also strongly fortified: the defensive walls can be seen at the bottom left and right of the photograph, and these are one of the main reasons why the paintings have survived intact. Monasticism is, of course, not only an Eastern tradition: in the 6th century Benedict of Nursia wrote a Rule, which became the basis of all Western monasticism.

ROMANESQUE

The term "Romanesque" was introduced in France in the nineteenth century to describe European architecture from the sixth to the thirteenth centuries which appeared, in some stylistic respect, to be Roman, but was not. The name is deceptive because the sources for the art and architecture of this period were not, on the whole, directly classical, but it is nevertheless a convenient term. The most obviously "Roman" feature is the use of semicircular arches, resting either on columns (perhaps with bases and capitals) or on piers (blocks of masonry separating different "bays", or units, of architecture) made up of pilasters and half columns. Again, the origins of these are not directly from the classical past. The period encompassed by the Romanesque style is today considered to date from the tenth century, although earlier (pre-Romanesque) forms are not essentially dissimilar.

Carolingian and Ottonian influences

The "Pre-Romanesque" period is divided into "Carolingian" (the Frankish dynasty to which Charlemagne, reigned 768–814, belonged) and "Ottonian" (named after Otto, reigned 962–973, the most powerful in a line of Germanic kings). Although Charlemagne had been crowned "Emperor of Rome" it was Otto who established the nature and power of the Holy Roman Empire after he was crowned by the pope in 962. The fact that these rulers and military leaders were also sanctioned by the Church plays a large part in the development of the architecture of the time. Not only did they build many substantial fortifications, their churches were also designed to display the benefactor's power and strength. Hence these structures tend to be large and solid, favouring prominent towers and thick walls. The latter were

◖ SOUTH DOOR

EARLY 12TH CENTURY, PARISH CHURCH OF ST MARY AND ST DAVID, KILPECK, ENGLAND

The structural forms of this doorway are typically Romanesque, with combined columns and a richly carved, broad arch, but the decorative details are not the simple, geometric forms seen in Durham (right). Instead there is a heavy Viking and Celtic influence: the outer columns are carved with snakes, each one biting the tail of the next to symbolize the continuing cycle of life and death – a theme echoed by the "green man" on the capital of the inner right column (see also pages 116–117), the foliage of the column itself, and the tree of life in the tympanum. The inner of the two arches is carved with mythical beasts.

◗ DURHAM CATHEDRAL

FROM 1093, DURHAM, ENGLAND

The main structure of Durham Cathedral was completed within forty years, and it remains the best preserved Romanesque cathedral in England. The massive circular piers, with bold geometric decoration and solid capitals, alternate with composite piers formed by the clustering of half columns, typical of the period. The rose window seen here is part of a Gothic chapel added in the 13th century to accommodate the pilgrims visiting the shrine of St Cuthbert.

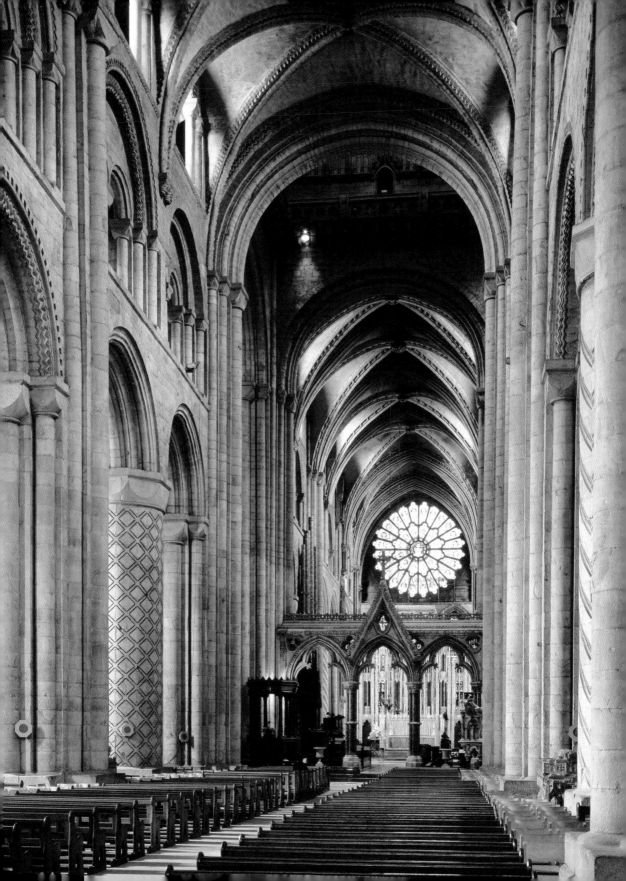

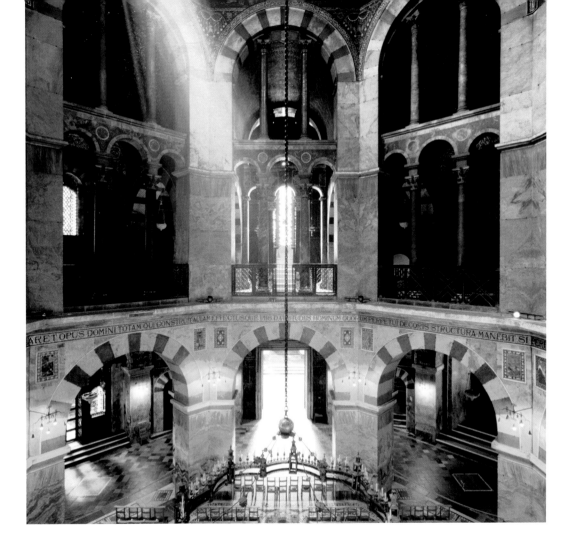

◯ PALATINE CHAPEL

Odo of Metz, 792–805, AACHEN CATHEDRAL, AACHEN, GERMANY

Charlemagne conceived this chapel for his palace in Aachen as part of a self-conscious "classical revival" even before he was crowned emperor. In 787 he made the first of three visits to Ravenna, the probable source of much of the building material (including the columns), and the inspiration for this chapel. The octagonal central space with large, round-topped arches supported by eight massive piers and sub-divided by columns is based on San Vitale, completed under the Byzantine Emperor Justinian (see page 138). The geometry of the original was simplified, and a large, fortified entrance known as a "westwork" was added. This was perhaps the most important innovation of Carolingian architecture: it is the origin, among other examples, of the impressive screen at the west end of Lincoln Cathedral (see illustration, page 14), and ultimately, even the west façade of St Paul's in London (see illustration, page 197).

also a safeguard: building on a large scale, the masons tended to be cautious, which means the columns and piers are often far more substantial than they need to be, the walls are thicker than necessary, and – so as not to weaken the walls – the windows are relatively small. Given that glass was in short supply, and rarely used for windows, the small openings also helped to shelter the interior from the elements.

The Romanesque style grew in part from these Carolingian and Ottonian origins, which had in turn been inspired by the art and architecture of Byzantium – for example, Charlemagne's inspiration for his Palatine Chapel in Aachen had been San Vitale in Ravenna. However, Romanesque also relied on other, local, traditions – and as the style developed,

it flourished. This was the result of the increased wealth of Europe, occurring in parallel with a growing sense of piety, triggered in part by the growth of Islam, which led to the declaration of the First Crusade in 1095.

Monks, saints and pilgrims

Monasteries and abbeys were increasingly powerful (their power deriving from their wealth), and the establishment of numerous monastic houses across the continent was one of the major reasons for the diffusion of the Romanesque style. The cult of saints, and the subsequent growth in pilgrimage was also a hugely important factor. Every altar had to contain the relic of a saint, and the more important he or she was the greater the number of pilgrims would be and the larger the church's revenue as a result. As well as providing the means to build large and magnificent structures, these developments affected the way in which the buildings were constructed. As early as the 670s the floor of the apse in Sant'Apollinare in Classe (see pages 140–141) was raised to allow pilgrims to

visit the relics, which were placed in the crypt below, and many churches were built with a raised presbytery, allowing easy access to a shrine below the altar. This was the case in Canterbury Cathedral, although the relics of St Thomas Becket were later moved, and this would also have been the original function of the crypt in St Procopius, Trebic (see page 54). In other churches an ambulatory was constructed: a semi-circular walkway going around the back of the apse, which allowed pilgrims closer access to the sanctuary. (Ambulatories can be seen around the apse of Chartres Cathedral, at the base of the flying buttresses, on page 19, and behind the *cathedra* of Norwich Cathedral – the only one in northern Europe still in its original location: see page 125).

⊙ STAVE CHURCH
LATE 12TH CENTURY, BORGUND, NORWAY

The rhythmic structure of this wooden church starts at ground level, with an open loggia whose sloping roof is interrupted by porches, each of which has a steeply pitched roof.

LOCAL CHURCH-BUILDING TRADITIONS

Although there have been general changes in style throughout Europe, different cultures have also been influenced by more local traditions. In England, Anglo-Saxon architecture before the Norman invasion is one example; a second is the variety of influences on the south door of the church in Kilpeck (see illustration, page 146). The cathedral of Monreale, in which an early Christian basilica structure in the nave is combined with an east end with three apsidal endings – a typically Eastern Orthodox structure – is yet another example (for the central apse, see pages 148–149). However, some of the most striking examples are the stave churches of Scandinavia, built entirely out of wood, though resting on a stone foundation. The basic construction is relatively simple: a framework of beams rests on posts (the structure known as "post and lintel", common to early buildings including Stonehenge and Greek temples). It is the posts, or *stafr* in Norwegian (related to the English "staff"), which give the churches their name. The framework is then filled in with vertical planks, and the roofs covered with wooden tiles. The basic structure is a rectangular nave with a square choir, although some of the churches, such as Borgund (right), have a double-height ceiling, with the central section surrounded by a form of ambulatory, each unit being expressed in the different sections of the roof. Decorative features are often derived from pre-Christian examples – such as the Viking finials at the top – and Borgund church also has runic inscriptions. Most of the surviving stave churches are in Norway, and date from the 12th century. Although only twenty-eight remain, there may once have been as many as 2,000 – inevitably their fabrication from wood has led to loss from both fire and damp.

Typical features of Romanesque architecture can be seen in Pisa, where all three buildings – the baptistery, cathedral and campanile (bell tower) – have small windows, arcades of rounded arches and blind arcades (a series of arches attached to the wall). The structures themselves are also typical, with bold, simple forms, and a baptistery that is separate from the church (an inheritance from the earliest days of Christianity, when converts were not allowed into the church until they had been baptized – many churches were therefore built with baptisteries which were adjacent, or even completely separate). A concern that this sacrament might be carried out unofficially led to it being restricted in some cities so that only the bishop could perform baptisms: the substantial size of the building in Pisa reflects the fact that everyone in the city would have been baptized there.

The breadth and grandeur of Romanesque architecture is repeated in the sculpture, in which figures frequently appear massive, with bold, rounded forms, and have a deceptive simplicity which can mask the sophistication of the narrative techniques (see, for example, page 24). Whereas early Christian churches had been relatively plain on the outside, over time decoration was added, a common element of which is the Last Judgment over the main west door, such as at Conques (see illustration, right). In Ferrara, where St George is depicted in the tympanum because the cathedral was built to honour his relics, sculptures depicting the Last Judgment were installed later, higher up on the façade.

Romanesque churches frequently have a profusion of massy architectural decoration, with piers being constructed from composite columns, or decorated with bold geometric carving. These would originally have been richly coloured, often using the same geometrical patterns. Colour was also introduced with the production of stained glass, although relatively little Romanesque glass survives. Remarkably, some murals and ceiling paintings have lasted the centuries (see pages 30–31 and 35), although a continued interest in

THE DECORATION OF CAPITALS

As the masons of Romanesque churches moved further away from the forms inherited from the classical past, and took on board the influence of other traditions, they started to relish the possibilities provided by the different stone elements of their buildings. One of their chief innovations was the use of capitals – the top part of a column – to tell stories, to warn or to amuse. Subjects varied from biblical narratives to parables, and aesthetically from the grotesque to the majestic – the last particularly well illustrated by the capital on page 126: a miniature masterpiece showing King William II, ably aided by a flying angel, dedicating Monreale Cathedral to the Virgin and Child.

◎ THE DREAM OF THE MAGI AND THE SUICIDE OF JUDAS

Gisilbertus, c.1130–1146, St Lazarus' Cathedral, Autun, France

The cathedral of Autun was built as a pilgrimage church to house the body of Lazarus, who, according to legend, was martyred there, having sailed across the Mediterranean with his sisters Mary and Martha. Gisilbertus, who signed a tympanum of the Last Judgment above the west door, was also responsible for a remarkable array of capitals, including this charming depiction of the three Magi asleep in one bed being told in a dream to follow the star, and, as a contrast, a harrowing depiction of the suicide of Judas, assisted by two sniggering demons.

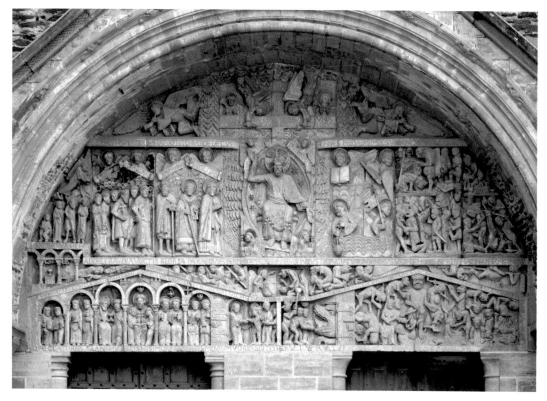

◔ THE LAST JUDGMENT

12TH CENTURY, ABBEY CHURCH OF ST FOY, CONQUES, FRANCE

Christ sits in judgment at the end of time, his right hand raised to welcome the blessed to heaven, his left hand lowered to condemn the sinful to hell. The tympanum is clearly structured, with flat stringcourses (each one bearing relevant inscriptions) separating the relief into three horizontal bands. At the bottom left the blessed in heaven sit calmly in a Romanesque arcade, while to the right the depiction of hell is agonized and chaotic.

mosaic has led to some better survivals, particularly in those centres, such as Venice and Sicily, which had strong links with the East (see pages 137 and 153).

The development of the Romanesque style in the north of Europe was in part due to the power of the Church, but also owed much to the power of one particular dynasty – the Normans. With the invasion of England in 1066, William, Duke of Normandy ("the Conqueror"), brought with him Romanesque architecture. As well as defensive

structures, such as the Tower of London, he was responsible for a considerable number of churches. Many of Britain's cathedrals have their origins in this period, with Norwich, Ely, Peterborough, Hereford, Gloucester, and, most notably, Durham all having substantial Romanesque naves: in Britain the style has traditionally been called "Norman". However, the same dynasty also helped to spread the style southward, because the Normans, under the brothers Robert and Roger d'Hauteville, took control of Sicily from its Muslim rulers between 1061 and 1091, whereupon the richness of Islamic decoration fed into the Sicilian form of Romanesque. One of their successors, King William II, founded Monreale Cathedral in 1174, and three years later he married Joan, the daughter of England's first Plantagenet king, Henry II. As such, she was also related to William the Conqueror, and thus two branches of the Norman dynasty were united.

Both in Durham and Monreale we see the beginnings of a new style. In 1133 the builders at Durham made a technical

continued on page 154

MONREALE CATHEDRAL

C.1180, MONREALE, SICILY

King William II of Sicily founded the cathedral before 1174, and it was dedicated as a cathedral to the Virgin Mary in 1182. William married Joan, daughter of the English king Henry II, in 1177, seven years after the murder of Thomas Becket, in which Henry was considered to have played a major part. The depiction of the saint so soon after his martyrdom, and in clear view of William from his throne, would have prompted William to pray for forgiveness for the actions of his father-in-law, and served as a reminder of the responsibilities of a monarch.

1 No longer the beardless Good Shepherd, the image is labelled "*IC XC*" – Jesus Christ – on left and right, with the words "the Pantocrator" running from one side to the other.

2 The text "I am the light of the world" is written in both Latin and Greek, reflecting the dual nature of the culture in Sicily at the time.

3 The Virgin and Child are enthroned between the archangels Michael and Gabriel, and below the Pantocrator, the incarnation bringing Jesus closer to us on Earth. Mary wears the imperial purple.

4 St Peter wears yellow and blue, and he has short grey hair and a beard: this became the standard representation of the saint in Italy.

5 St Paul is shown with the standard iconography of a long dark beard and a receding hairline.

6 Below the apostles are deacons, bishops and monastic saints. This figure is labelled "St Thomas Becket", and is one of the earliest known depictions of the English martyr: the mosaic of Thomas would have been set little more than a decade after his death, and it is on the side of the apse that would be more visible to the king.

7 King William II's throne. Above this is the mosaic illustrated on page 127, which shows Christ blessing William, and therefore confirming his right to rule.

8 The bishop's throne. This is a relatively recent structure, replacing a pulpit. Originally the bishop would have sat in the apse. The bishop's status as "vicar of God" is therefore different from the king's status as ruler: although Church and state are interlinked, the king and the bishop each has his proper domain.

9 King William II gives the cathedral to the Virgin – the same subject as the capital illustrated on page 126.

10 The chancel arch is sanctified by the Annunciation.

11 The throne of God, empty but for the instruments of the Passion, is surrounded by cherubim and seraphim.

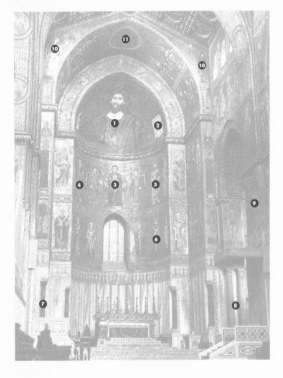

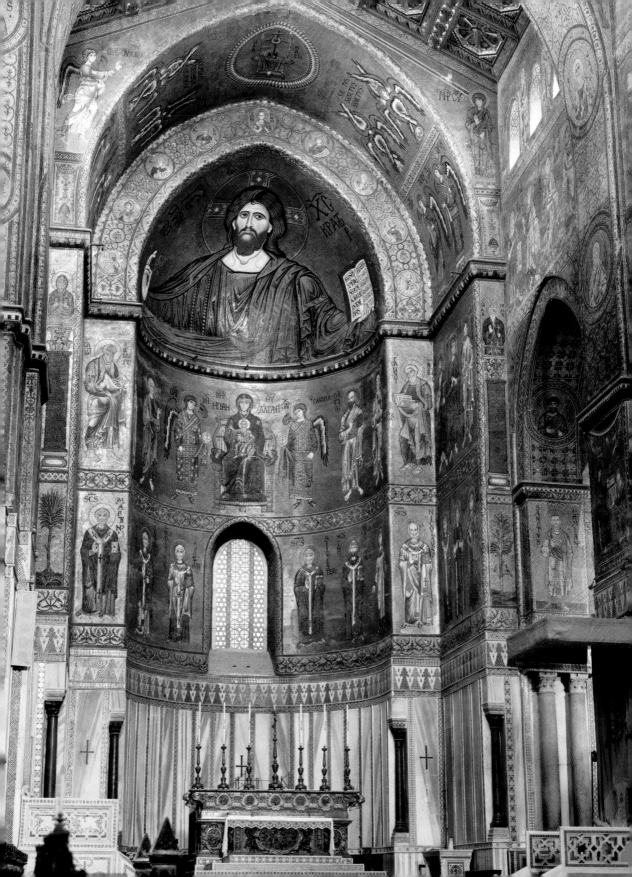

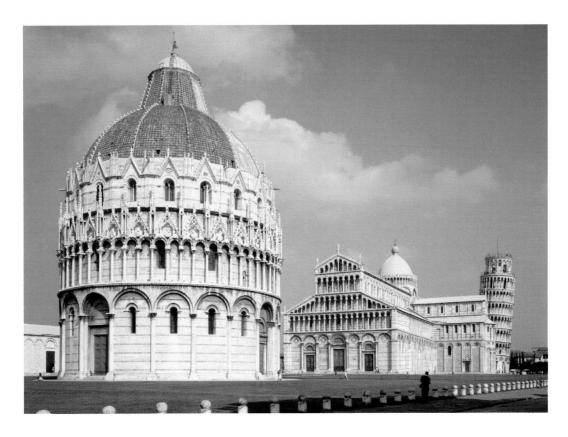

○ BAPTISTERY, CATHEDRAL AND BELL TOWER
STARTED 1063, PISA, ITALY

The famous "Leaning Tower" of Pisa is in fact the bell tower, or campanile, of the cathedral, built separately, as they often were, to minimize damage if it were to collapse. The precaution here was wise, because the boggy ground led to subsidence soon after construction had started in 1173. Later excavations uncovered boats: this area was originally part of a Roman port, and classical remains were incorporated into the structure. Several Latin inscriptions can be seen reused in the walls of the cathedral, and the columns of the nave vary in height because they come from different buildings. Both the campanile and the cathedral have elaborately tiered arcades, and all three buildings have blind arcades at ground level. The separate baptistery – circular as an expression of the eternity in heaven that baptism permits – was typical of early cathedrals, although Pisa's, designed by Diotisalvi and started in 1153, is one of the latest: it was not completed until 1363, and the decoration of the upper half is notably Gothic in style.

advance when they successfully vaulted the nave with stone – rather than wood – and in the later part of the vaulting the ribs rise to a point. The apse mosaic in Monreale is also pointed, rather than having the rounded profile that might be expected in a Romanesque building (see illustration, page 152). The pointed arch was a feature of Islamic architecture, and its adoption in Sicily was a sign of the eastern influence felt there. However, it can also be found in a common form of Romanesque wall decoration. In an elaboration of the blind arcade (seen on the Pisa baptistery and cathedral), overlapping arcades were introduced, and the intersection of the round-topped arches created the pointed arch. Whatever the origins, it was the adoption of the pointed arch which would allow Gothic builders to create their greatest masterpieces.

JOURNEYS OF SPIRITUAL SIGNIFICANCE

The idea of making a journey as a sign of religious devotion is common in many cultures. In Christianity it can be dated as early as the 3rd century, although it received an official sanction when the empress Helena, mother of Constantine the Great, made a pilgrimage to the Holy Land in the late 320s. She founded basilicas at Bethlehem and on the Mount of Olives, and further Constantinian basilicas were built at locations such as the Holy Sepulchre, where Christ was buried. Although these sites have been subject to war, damage and decay, they have always been rebuilt and redecorated – a sign of the continued devotion they attract.

But however strong a believer's faith, pilgrimage to the Holy Land was not within the scope of all. The gradual development of the Stations of the Cross allowed a form of virtual, miniature pilgrimage within a single church (see pages 48–49), while the cult of saints also led to the growth of more localized pilgrimage: praying in the presence of a saint's bodily remains was considered the same as speaking to them in person. Rome – the cradle if not the birthplace of Christianity – was also favoured, particularly after the institution of the first Jubilee, or Holy Year, in 1300, as were (and are) miracle-performing images such as Our Lady of the Gate of Dawn, in Lithuania (see page 86).

One of the most significant sites in Europe was Santiago de Compostela, in northern Spain, the burial place of St James the Great, one of the apostles. The Romanesque building, with its richly carved portals (see page 23), was enhanced with an impressive Baroque façade, built by Fernando Casas y Nóvoa between 1738 and 1750, and topped with a sculpture of St James dressed in a pilgrim's hat and cloak, and carrying a staff, cast in bronze (see illustration, below). A cockleshell is attached to the hat, and there is one on each shoulder: this is the attribute of James, and is to this day the badge awarded to pilgrims arriving in the city. The devout would travel in groups (for company and mutual safety), visiting other holy sites along the way.

The vast income from pilgrims went into the construction and decoration of churches, shrines and reliquaries: St Foy, in southern France, was one of the major beneficiaries (see pages 92 and 151). England's most popular pilgrim route was the one which led to the shrine of Thomas Becket, and the frequently irreligious exploits of the pilgrims inspired Chaucer's *Canterbury Tales*. After King Henry VIII's destruction of Becket's shrine, along with many others, in 1538, the only one in Britain still to contain its relics was that of Edward the Confessor, a king and a saint. Westminster Abbey had been rebuilt in the 1240s to honour the abbey's founder and provide a fitting home for the shrine.

GOTHIC

Between the eleventh and thirteenth centuries, neither the forms of worship nor the subjects used for the decoration of the buildings changed substantially. The Abbey Church of St Foy chose to put the Last Judgment above its main portal in the twelfth century, but so too did the Münster of Bern as late as 1460: it is not the themes which change, but the way in which they are represented. There was a move from the solid and majestic feel of the Romanesque to the light, soaring and gloriously aspirational forms of the Gothic, beautifully exemplified by the Octagon of Ely Cathedral (see illustration, right).

The most characteristic feature of Gothic architecture is the pointed arch, which solved major structural problems and allowed lighter, taller structures to be constructed: it was this which led to the remarkable success of the style. The pointed arch is more stable than the round arch. In the latter, the keystone at the top of the arch has nothing to support the downward pull of gravity, and if the arch is too wide, it will simply collapse. Conversely, the two sides of a pointed arch lean against each other, and so support each other, and the keystone is held up by both sides – in fact, it increases the stability of the arch by weighing it down. As a result, pointed arches – and therefore Gothic churches – can be built larger and higher, reaching toward God and reflecting the splendour of heaven.

It was also structural issues that led to the development of flying buttresses (see pages 18–19). Like half of a pointed arch, a buttress can support the roof: this not only allowed the evolution of stone vaulting of remarkable complexity

◖ THE PILLAR OF ANGELS

c.1295, Strasbourg Cathedral, France

The slim, sinuous figure on the left is St Matthew: the head of his angel can just be seen on the capital below his feet. Above the evangelists (all four are depicted) are four angels blowing the final trumpets, and at the top is Jesus, at the Last Judgement, accompanied by three angels.

◗ THE OCTAGON

William Hurley, 1322–1340 (repainted in 1859), Ely Cathedral, England

The Octagon was built in wood after the Norman tower had collapsed as an accidental result of digging the foundations for the Lady chapel. One of the true glories of the Gothic, the Octagon could not be built in the same way today because Britain no longer has trees big enough to provide the supporting structure. Heaven was created in sound as well as sight: in addition to the figure of Christ in a boss carved from a single piece of oak, and the surrounding paintings of the Heavenly Host, the panels at the bottom of the lantern can be opened, enabling the monks, like a choir of angels, to sing from on high.

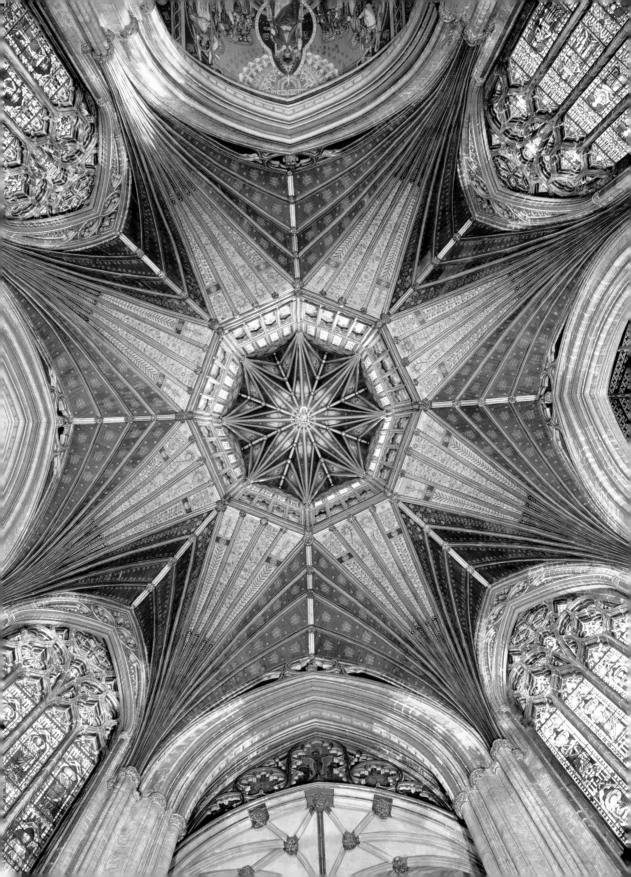

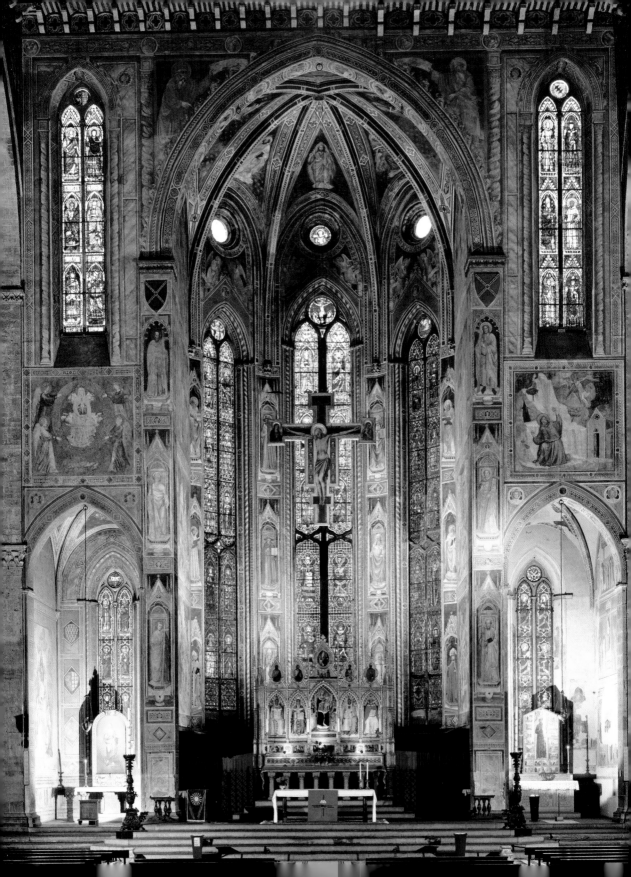

and beauty, but also meant that walls did not need to bear the entire weight of the roof and could therefore be pierced with larger windows. The splendour of Gothic architecture comes not just from its soaring height, but also the brilliantly coloured illumination from the windows: stunning examples include Notre Dame (page 37) and Chartres (pages 38–39).

The first truly Gothic church is said to have been Abbot Suger's rebuild of the west end of the Abbey of St Denis, near Paris, between 1137 and 1140, followed by a new choir, which was finished in 1144. The new abbey was consecrated in the presence of the king of France, five archbishops and thirteen bishops: with such powerful support, it is hardly surprising the new style became successful. When a fire in Canterbury Cathedral destroyed the east end of the building in 1174 – just four years after the murder of Thomas Becket – it was a Frenchman, William of Sens, whom the monks appointed to rebuild it, thus introducing the Gothic to England. (Elsewhere in England building in the Romanesque style continued well into the thirteenth century.) Anglo-French influences were not surprising: through the Angevin Empire the Plantagenet kings of England ruled about half of medieval France down to the Pyrenees – King Henry II was already Duke of Normandy and of Aquitaine when he came to the throne in 1154. The attempt to display status was one of the things that led to the spread of the Gothic across Europe, as the different nation states, increasingly familiar with each other through a growth in trade, attempted to demonstrate their wealth through the beauty of their cities.

○ **SANTA CROCE**
1294–1385, FLORENCE, ITALY

Although using the pointed arch allows great height, Italian builders never adopted the flying buttress (the exception is Milan Cathedral, which was constructed by workmen from north of the Alps). Either Italian builders were not convinced that flying buttresses would work, or their love of fresco meant that broader wall surfaces were preferable to large windows. Notice how the pointed panels of the main altarpiece echo the size and proportions of the chapels. In the same way that each panel shows a different saint, each chapel has a separate dedication, and in both cases those closer to the centre have higher status.

Preaching and pilgrimage

Another important factor in the diffusion of Gothic was the establishment of two new religious orders. Inspired by Jesus' words to his apostles, the members of the orders trusted God to provide. Both St Dominic and St Francis thought that their followers – who lived on charity, and became known as mendicants, or beggars – should not retire from society, but become an active part of it, preaching to the people and living among them. The pair founded what were to become the two most important orders in the west: the Order of Preachers and the Friars Minor, although they are better known as the Dominicans and the Franciscans.

Both are orders of friars whose active ministries seek to serve the larger community, which differentiates them from monks, who live a life of seclusion and contemplation. The success of the mendicant orders in the thirteenth century promoted Gothic architecture simply because their desire to reach as many people as possible led to the construction of many substantial buildings, including the Franciscan church of Santa Croce in Florence (see illustration, left).

The ever-growing popularity of pilgrimage also helped to spread Gothic art and architecture – and the contingent reliance on relics continued to have an effect on church structure. Although altars had for centuries contained relics of saints, the growth of pilgrimage meant that these relics needed to be accessible. Some Romanesque churches had placed shrines in the crypt, while others created ambulatories around the presbytery. Catering to this need was a consideration when rebuilding Canterbury, not least because of the number of processions which took place. Increasingly the shrines were placed behind the high altar, often behind a screen, with access from the ambulatory. Inevitably this meant the bishop's *cathedra* could no longer be in the apse and it was moved to the side of the altar, alongside the choir (a tall, modern *cathedra* can be seen close to the altar on the left of the choir in Coventry Cathedral – see illustration, page 208). Similarly, in smaller churches, the priests sat alongside the altar in a *sedilia* (see page 56).

◐ KING'S COLLEGE CHAPEL

John Wastell (FAN VAULTING), 1512–1515, CAMBRIDGE, ENGLAND

King's College was founded by King Henry VI in 1441, but the chapel was only gradually completed under kings Richard III and Henry VII. John Wastell, who also designed Bell Harry Tower in Canterbury Cathedral (see page 2), was the mason responsible for finishing the stonework of the chapel, including the largest fan vault in the world. The bosses alternate between the Tudor rose (King Henry VII was the first Tudor monarch) and the portcullis, an emblem of the Beaufort family, which Henry inherited from his mother Margaret (the portcullis is a reference to the "handsome fort" of the family name).

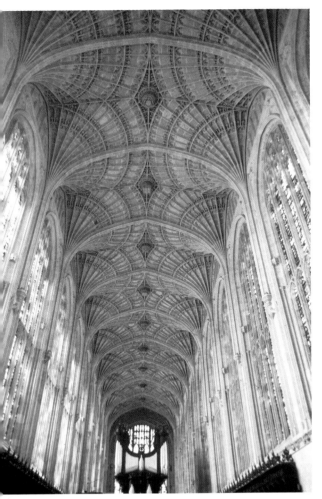

By this stage it was also rare for baptisteries to be constructed outside the church – more commonly a baptismal font was located inside, usually near the door at the west end because it still functioned as a welcome to the church. However, new converts were no longer excluded, partly because conversion was becoming rare. From the ninth century infant baptism had become increasingly popular, and by the time that someone was old enough to choose whether or not to enter a church, they had already been baptized.

Altarpieces, or retables, were widespread and becoming more elaborate – another reason for moving the bishop from behind the altar. Polyptychs (multi-panelled altarpieces) could convey a rich variety of meaning, and frequently took the same form as the churches themselves, as in Santa Croce in Florence (see page 158). While Florentine art was strongly influenced by the forms of Giotto (his workshop frescoed the two chapels to the right of the High Altar of Santa Croce between 1315 and 1330), elsewhere Gothic painting developed a greater sense of fluidity. The "s-shaped curve" became common – visible in the sculptures from the pillar of angels in Strasbourg and in the Virgin of the Wilton Diptych (see illustrations, pages 156 and 164–167) – and flowing, sinuous forms were favoured. Draperies were elaborated more for the sake of decorative line and patterning than for a realistic description of their materials. Gradually, however, more naturalistic observations began to be included: an interest in recording the appearance of the world around us, which was to be an essential feature of the Renaissance.

◐ NOTRE DAME

1163–1345, PARIS, FRANCE

The cathedral of Paris, Notre Dame, was one of the first churches to be influenced by Abbot Suger's rebuilding of St Denis in the 1130s and 1140s. Originally the transepts would not have projected, but they were extended in the 1240s and 1250s when the South Rose Window was created (see illustration, page 37). The flying buttresses became necessary when the windows of the choir were enlarged during the initial construction, whereas the slim spire – known as a *flèche*, or "arrow" – was added as part of Viollet-le-Duc's 19th-century restorations.

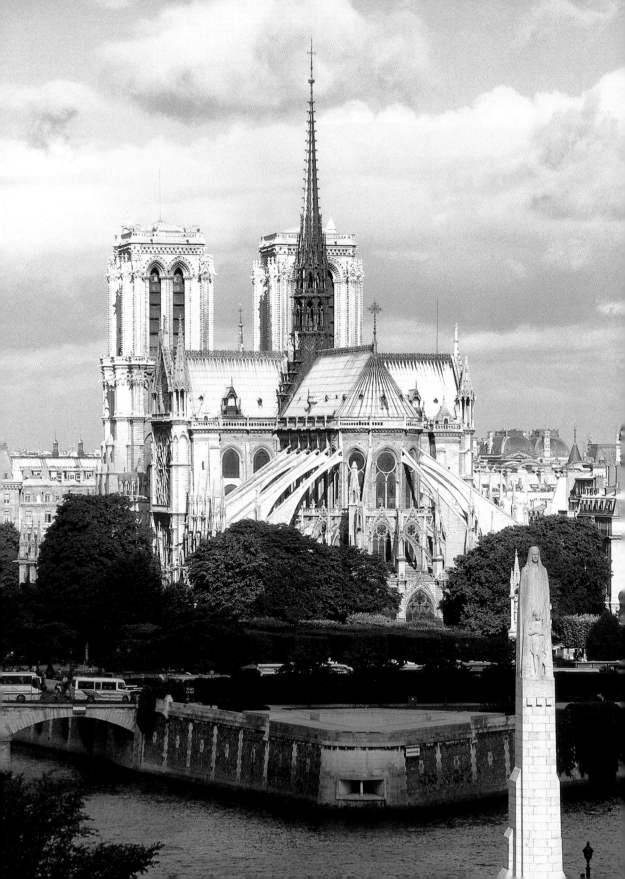

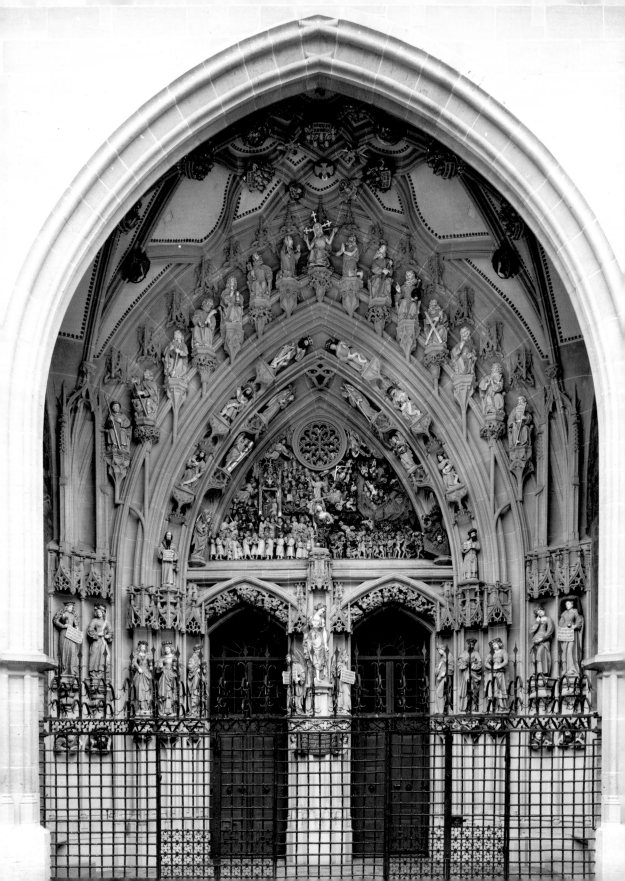

BERN MÜNSTER PORTAL

Erhart Küng and workshop, 1460–1485, BERN MINSTER (MÜNSTER), SWITZERLAND

The main portal of the Münster in Bern is the last and most complete of the medieval Judgment portals, and includes an encyclopedic digest of contemporary theology. As well as the Last Judgment, which is paired with the Parable of the Wise and Foolish Virgins, the sculptures around the tympanum include the twelve apostles, eight of the prophets, and five angels holding the instruments of the Passion, while the nine choirs of angels, seven heavenly bodies, four evangelists and the Holy Spirit are all carved on the bosses of the vault. In 1501 an anonymous artist painted the Annunciation and the Fall on the left and right walls of the portal, which link with the Redemption and Damnation seen in the centre. The complex underwent a thorough restoration between 1964 and 1991 when all of the sculptures, with the exception of the reliefs in the tympanum and vault, were transferred to the Bern Historical Museum and replaced with replicas.

1 Christ sits in judgment, with the Virgin on his right (our left) and John the Baptist on his left, interceding on our behalf: the idea of the Byzantine *Deisis* was still current in the 15th century (see page 142).

2 On either side, arranged along the archivolt, are the twelve apostles. From the bottom left are saints Thomas, Matthew, Thaddeus, Bartholomew, John and Peter; then Paul, James the Great, Andrew, Phillip, Simon and James the Less.

3 The Archangel Michael defeats the devil and weighs the souls at the Last Judgment. (This is a copy of the sculpture on page 99.)

4 The blessed, dressed in white – who include a pope, cardinals, bishops and secular officials, including, it is said, Bern's mayor – are ushered into the gate of heaven. Saints and prophets, holding their attributes, await within.

5 The damned, naked and wretched, with the same authority figures of Church and state (and, the story goes, the mayor of Zurich), are tortured by demons and thrust into the fires of hell.

6 Despite the iconoclasm that raged through Bern (see illustration, page 178) this portal survived intact. Only the figure of the Virgin on the trumeau was removed, and replaced with the more secular figure of Justice, carved by Daniel Heintz I in 1575.

7 In Jesus' parable (Matthew 25.1–13) the wise and foolish virgins were awaiting the arrival of a bridegroom. The five wise virgins kept their lamps filled with oil, and were ready to meet the bridegroom when he came. They are on the side of the blessed, holding their lit torches.

8 The five foolish virgins had no oil. When they went to buy some, they missed the groom's arrival and were shut out of the marriage. The moral of this tale was succinct: "Watch therefore, for ye know neither the hour nor the day wherein the Son of man cometh." (Matthew 25.13) They are on the side of the damned, looking distressed, their torches unlit.

9 Above the left door the vines grow numerous bunches of grapes, reflecting the harvest to be reaped by the blessed in heaven.

10 On the right the vines are barren, blasted like the souls of the damned.

11 In the archivolt below the apostles are eight prophets: from bottom left they are Ezekiel, Zacharias, Moses, David, Daniel, Haggai, Joel and Ezra.

12 In the archivolt surrounding the tympanum are five angels holding the instruments of the Passion.

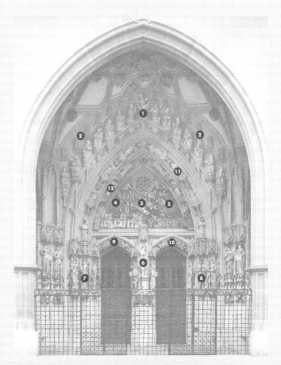

THE WILTON DIPTYCH

C.1395–1399, The National Gallery, London, England

This is a small, portable altarpiece, presumably made for the private devotions of King Richard II. He is shown in the presence of St Edmund and St Edward the Confessor, two English kings who preceded him, and his patron St John the Baptist. The three saints present Richard to Christ and the Virgin Mary. By comparing the positioning of the saints and Mary with the ground plan of Westminster Abbey, it becomes clear that they are standing in the same order and arrangement as the chapels dedicated to them. As Richard was crowned king – like monarchs since – in the abbey next to the shrine of St Edward, this choice and arrangement of saints emphasizes the idea that King Richard II ruled by divine right. The painting could even be seen as a claim toward his future canonization, because he is in the company of two other royal saints. Richard was born on 6 January – feast of the Epiphany, the day on which the Magi paid homage to Jesus: this gives another level of meaning to the image of three kings approaching the Christ child.

1 The arrow, combined with the crown, tells us this is St Edmund (Sebastian, see pages 122–123, would not have worn a crown in his lifetime). Edmund was a king of East Anglia, and died in 869 defending his realm for Christianity from the then pagan Danes, who shot him with arrows.

2 St Edward the Confessor is identified by a ring, which refers to a story of pilgrimage. On the way to the Holy Land a pilgrim was given a ring to take with him as a sign of devotion by an old man who could not make the journey himself. However, on arriving at his destination the pilgrim once more saw the old man, who revealed himself to be St Edward.

3 St John the Baptist holds a lamb: he recognized Jesus as the Saviour with the words: "Behold the Lamb of God, which taketh away the sin of the world." (John 1.29)

4 According to the Bible John the Baptist lived in the wilderness dressed in camelskin. The skin is particularly realistic here, and the head of the camel can be seen resting against the saint's left leg.

5 King Richard II wears a collar made of broom cods, the seed pod of the broom plant. The Latin name for broom is *Planta genista*: the family emblem of the Plantagenet dynasty, to which Richard belonged. He also wears a badge in the shape of a white hart (or deer), a personal emblem taken from his mother, Joan of Kent. The gold patterning of his red robe is also made up of broom cod collars and white harts.

6 Jesus' halo is delicately tooled with the cross of thorns. He points up to the flag, appointing Richard as king of England on his behalf.

7 The flag of Christ Triumphant, showing the red of his suffering in a cross against the white of his purity, is often carried at the Resurrection. It became the flag of England after its association with the Crusades and St George, who became the patron saint of England. The ball at the top of the pole includes a tiny image of an "emerald isle. . . set in the silver sea", Shakespeare's description of England from *Richard II*, written some two centuries after the painting.

8 The angels wear the same heavenly blue as Mary, and they all sport broom cod collars and white hart badges: they have come out in favour of Richard as king. All but one either look or point toward him.

9 Unlike the barren, earthly, setting of the left side, the right, in heaven, is paradise: a rich pasture strewn with roses, violets and daisies. Although they are accurately drawn they are not to scale with each other.

RENAISSANCE

It is traditional to assume that the Renaissance, or "rebirth", started in Florence in the early fifteenth century, although a century earlier Giotto was already painting with a remarkable sense of visual and emotional realism in order to communicate as directly as possible (see pages 74–77). The fourteenth-century writer Boccaccio was aware of Giotto's work and of those classical authors who spoke highly of painters as artists to be respected, rather than simple craftsmen. As the Renaissance drew its inspiration from the classical past, these ancient texts were of prime importance, and there was also an increased awareness of Italy's classical ruins. It was, therefore, artistic and scholarly concerns which drove the Renaissance, rather than developments within the body of the Church. However, the continued success of the mendicant orders cannot be underestimated as a factor, because they used art to communicate their ideas. This inevitably favoured a style which could expound concepts as directly and clearly as possible: the increasing naturalism of painting and sculpture had precisely the quality required.

Clarity was also the aim of Filippo Brunelleschi, the prime mover of Renaissance architecture. He returned to the clear, clean lines of classical architecture, with rounded

continued on page 174

● ANNUNCIATION

Filippo Lippi, c.1440, San Lorenzo, Florence, Italy

This Annunciation, painted for San Lorenzo, uses perspective to draw us in, and also involves us by the realistic appearance of the objects depicted. It is also in the exact format that Brunelleschi specified for the altarpieces in this church: this is the only area of colour he wanted in each chapel, the rest being given over to space and light, which he hoped would inspire intellectual and spiritual clarity.

● SAN LORENZO

Filippo Brunelleschi, 1421–1469, Florence, Italy

As well as marking out the proportions of the building, the architectural elements – the entablatures, columns and the divisions of the floor – serve to focus our attention toward the altar. Brunelleschi developed perspective, giving rise to a system that could be used by any artist to create a realistic illusion of depth. The interior would originally have been far brighter, but the Counter Reformation desire for large altarpieces meant that many of the windows were blocked up.

THE GHENT ALTARPIECE

Hubert and Jan van Eyck, 1425–1432, St Bavo, Ghent, Belgium

An inscription on this frame states that work was started by
Hubert van Eyck. After his death in 1426 it was completed by his
brother Jan: as yet it is not clear who painted what, and it may be
that Jan was responsible for most of what we see. The wings of
the altarpiece can be closed – the curved tops of the outer panels
fit over the rounded arches above God, Jesus and Mary. When
closed, as it would have been most of the week, the donors, Joos
Vijd and his wife Elizabeth Borluut, can be seen kneeling on either
side of saints John the Baptist and John the Evangelist, painted
in monochrome to look like sculptures. Above the saints is the
Annunciation, with Mary's words of acceptance, *Ecce ancilla
domini* ("Behold the handmaid of the Lord"), painted upside
down so that they can be read by God in heaven.

❶ The humanity and vulnerability of Adam and Eve, who are painted
life sized, derives from their realistic colouring, and by the fact that
they are seen from below, the point of view of the worshipper at ground
level. The perspective used in the central panels is different, and more
uplifting. Eve's physiognomy, with rounded stomach and small breasts,
was fashionable in the 15th century.

❷ Although Jesus is usually seen between the Virgin and the Baptist,
as in a *Deisis* (see page 142), the presence of the dove and lamb below
implies that the Trinity is shown on the central axis, and that this figure
is God the Father, a conclusion which is confirmed by the papal triple
tiara he is wearing. However, the youthful appearance is more like
Christ: the duality may reflect Jesus' statement that "he that hath seen
me hath seen the Father" (John 14.9).

❸ The four outer panels on the lower tier show, from left to right, the
Just Judges, the Soldiers of Christ (including St George, on the white
horse), the Holy Hermits (including St Anthony Abbot), and the Holy
Pilgrims, led by the giant St Christopher with his staff. These four
groups were used to represent the cardinal virtues of Justice, Fortitude,
Temperance and Prudence.

4 The Lamb of God stands on the altar, a wound in its chest bleeding into a chalice, representing the body and blood of Christ as experienced during the mass. The altar is surrounded by adoring angels, some of whom hold the instruments of the Passion.

5 Four processions approach the altar. Old Testament prophets and patriarchs are prominent at the front left, with apostles and members of the Church opposite them on the right.

6 In the background confessors and martyrs (male saints) approach from the left, and virgin martyrs (female saints) from the right.

7 The Fountain of Life is octagonal, like many fonts, and looks strikingly like monastic *lavatoria* including the one in Poblet (see page 45). The vertical axis, from God the Father and through the dove and the lamb, continues down the column of the fountain, and through a channel in the ground along which the Water of Life flows out of the basin and toward the altar on which the mass will be re-enacted – and therefore toward us.

arches instead of pointed Gothic ones. That this happened in Florence is not surprising: there were a number of important Romanesque structures, including the baptistery, which proved more inspiring than other Gothic buildings. Indeed, for many years it was erroneously believed that the baptistery had been a Roman temple. Brunelleschi's sources were therefore not strictly classical. This is true of his first, great church of San Lorenzo, which used the same basilica plan as Santa Croce (see page 158), with a central nave and two side aisles, although its appearance is strikingly different. Like medieval builders, Brunelleschi based his structures on modules – but he aimed for a simplicity that would allow these repeated units to be seen more clearly. He also deliberately limited the use of colour, favouring whitewashed walls articulated by a cool, grey sandstone called *pietra serena*.

This allowed the geometric forms – squares and semicircles, cubes and hemispheres – to become more obvious, so that the harmonious nature of the building and its proportions could be more easily seen and understood.

Brunelleschi even went as far as specifying the size and format of the altarpieces that should be installed in each side chapel: Filippo Lippi's *Annunciation* (see page 168) is one of the few still in the location for which it was intended.

Northern and Iberian Renaissance

Lippi's painting also shows the influence of northern European art on Florentine painting. North of the Alps the Renaissance took on a substantially different form. While Italians were developing a rational approach to perspective and an almost scientific interest in idealized form, the northern artists were intrigued by the realistic depiction of every different surface: Lippi's meticulous glass vase in the foreground of the *Annunciation* is inspired by northern examples. Although he was using egg tempera – a paint in which the pigment is mixed with water and egg yolk – northern artists such as Jan van Eyck had perfected the use of oils, which allow a greater veracity in the depiction of surfaces. The Ghent altarpiece, for example, includes a wonderfully realized differentiation of textures between wood and metal in the organ at the top right, and between the rich fabrics worn by God and the subtle flesh tones of Adam and Eve.

◖ **CHAPTER HOUSE WINDOW**
Diogo de Arruda, 1510–1513, CONVENT OF CHRIST, TOMAR, PORTUGAL

The Knights of the Order of Christ were formed in the early 14th century in Portugal after the dissolution of the Knights Templar. The Convent of Christ was part of a Templar stronghold, and, like many Templar buildings, a circular church in imitation of the Holy Sepulchre was included. Prince Manuel became Grand Master of the order in 1484, and when he acceded to the Portuguese throne the convent was still a priority. As king he was responsible for the building of the chapter house, replacing an earlier Gothic structure attached to the Romanesque rotunda, in the early 16th century. This window is one of the most exuberant examples of the Manueline style.

The Renaissance was also different in the Iberian peninsula. Portugal's increased wealth, resulting from a growth in trade after Vasco da Gama's discovery of a new route to India around the Cape of Good Hope, led to extensive building. This in its turn drove the development of a distinctive style of architecture named after King Manuel I (ruled 1495–1521), who commissioned over sixty buildings during his lifetime, and had assigned the India expedition to Vasco. The Manueline style picks up the exuberance of late Gothic art and imbues it with some of the realistic observation of the Renaissance. It has a vocabulary drawn from the sea voyages which produced the increased wealth, with motifs inspired by ropes, shells, coral and even seaweed, as well as quoting from Islamic and Indian buildings.

In pursuit of harmony

As the Renaissance progressed, artists and builders (some of whom could now be classed as architects, since they designed buildings without working on their construction) made a closer study of classical remains and texts. The only architectural treatise to survive was the *Ten Books on Architecture*, written by Vitruvius during the first century BC. In it he discusses the need to create harmoniously proportioned buildings in order to provide a suitable environment in which we can live, work or worship. This fed into the Christian interest in harmony and proportion – the more symmetrical a church was, the more perfect it would seem and the more suited to God's message.

In the sixteenth century Andrea Palladio used the clarity and light introduced by Brunelleschi and combined them with a more studied classicism, which he had learnt from close observation of Roman remains. He also solved a problem relating to the Christian application of classical architecture. Architects wanted to give their churches a temple façade, with a triangular pediment supported by columns, but if the façade was high enough to cover the nave, it was not wide enough for the side aisles (or chapels).

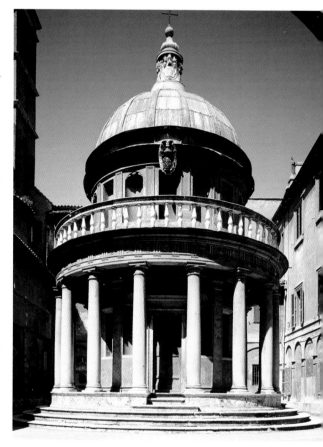

○ TEMPIETTO
Donato Bramante, c.1504, SAN PIETRO IN MONTORIO, ROME, ITALY

Bramante's chapel is circular, a *martyrium* commemorating what was thought – in error – to be the site of the crucifixion of St Peter. As an evocation of classical architecture it was so successful that it soon became known as the Tempietto, or "little temple". It also appears to be the realization of many architects' dreams: a centrally planned church – and if the altar had been in the middle, the building would be perfectly symmetrical. However, the demands of the liturgy meant that this was not acceptable, and even the Tempietto is subtly cruciform, with the altar opposite the main door, and two side doors providing understated transepts.

⬥ IL REDENTORE

Andrea Palladio, 1576–1591, VENICE, ITALY

Il Redentore, or "The Redeemer" is an *ex voto* church, meaning that it was constructed using the donations of the public, given in gratitude to Jesus – the Redeemer – for ridding Venice of the plague which had killed around a third of the population in 1575. As well as relying on the language of classical architecture, the building is harmoniously proportioned. The central, higher façade is two-thirds the width of the wider one, the ratio 2:3 representing a fifth in musical harmony, whereas the wider bay between the two central half columns is twice the width of the bays on either side, between the half columns and the pilasters. The ratio 2:1 is related to an octave. (See also pages 104–105.)

ARCHITECTURAL TERMS

1 **COLUMN** – a round, more-or-less cylindrical structure which acts as a support. It can be freestanding, or attached to a building (an engaged column), or it can exist as a half column (a semicircular structure which is engaged).

2 **PILASTER** – a square column that appears to be embedded in the wall.

3 **ENTABLATURE** – the horizontal "beam" that is supported by columns or pilasters. The three main divisions of the entablature are the architrave, resting on the capitals; the frieze, in the middle; and the cornice, at the top. In the Doric order the frieze is decorated with blocks of three vertical bars, called triglyphs, separated by spaces (which can be decorated) called metopes.

4 **PEDIMENT** – a triangular gable end, defined by the entablature and the roof. In a broken pediment the two roof elements do not meet in a point, and there is a gap (this is a feature of 16th-century and later architecture).

5 **SEGMENTAL PEDIMENT** – a pediment with a curved top, the segment of a circle.

6 **BASE** – the lowest of the three main divisions of a column or pilaster.

7 **SHAFT** – the central section of a column or pilaster.

8 **CAPITAL** – the top section of a column or pilaster. Capitals of the Tuscan and Doric orders are very plain, those of the Ionic order have two scrolls, and those of the Corinthian order have acanthus leaves. Capitals of the Composite order have both scrolls and acanthus leaves (a composite of the Ionic and Corinthian orders).

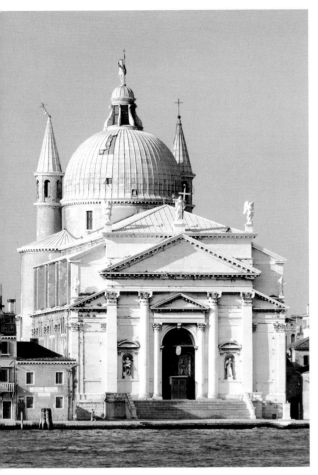

◗ ST PAUL'S, COVENT GARDEN
Inigo Jones, 1631–1633, LONDON, ENGLAND

Exactly how, when – and even if – the
Renaissance reached England is a matter of
dispute, because many builders clung to the
Gothic. Renaissance forms had been used
in the 16th century, although these were
frequently built up with a Gothic profusion.
It was Inigo Jones who was responsible
for introducing the purity of Palladio's
Renaissance style, although not until the 17th
century. Jones deliberately built St Paul's,
Covent Garden, in the most basic of orders
– the Tuscan – and is said to have referred to
it as "the handsomest barn in England". The
structure of the sloping wooden roof with its
supporting beams reveals the origin of the
elements of classical architecture in the wooden
temples of the earliest Greeks. Stone is only
used for the portico – the rest of the structure
is brick (Jones' patron, the Earl of Bedford, was
short of funds). Jones had intended the portico
to frame the entrance to the church, but the
bishop of London, William Laud, insisted that
the entrance be at the west, as was traditional,
thus rendering the portico functionless.

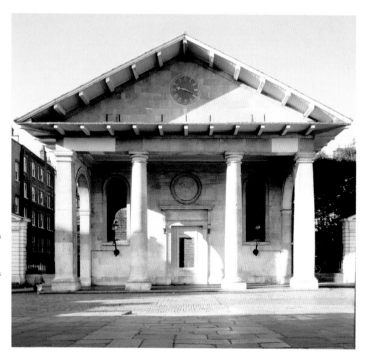

Likewise, if it was wide enough for the side aisles it would
not be high enough for the nave. Palladio's solution was to
combine two façades: a taller, narrow one in front of the nave,
supported by a giant order (one that apparently goes through
more than one level of a building), and a wider, lower order
to cover the side chapels.

Vitruvius had also described the different orders of
architecture – basically the ways in which columns and their
associated entablatures evolved, and how they were designed.
These ideas were elaborated in the sixteenth century, leading
to the definition of five distinct orders, and suggesting a
Christian significance for each. The Doric order, solid and
down to earth, with a plain capital and a frieze decorated with
triglyphs and metopes, was suitable for churches dedicated to
male saints such as St Peter. Indeed, it was used by Bramante
for the Tempietto. The Ionic order, with scrolls (or "volutes")
in the capitals, was suitable for matronly women, or scholarly
men, whereas the Corinthian order, slim and "maidenly",
its capital decorated with acanthus leaves, was ideal for
churches dedicated to virgin martyrs. The Tuscan order was
the plainest and most basic of the five. On the Redentore in
Venice (left) Palladio uses the Composite (combining the
Ionic and Corinthian) for the giant order supporting the
upper pediment, and the Corinthian for the minor order
supporting the lower pediment. The use of the most richly
decorated orders relates to the celebratory nature of the
building, in the same way that Inigo Jones's use of the Tuscan
order fulfils his patron's requirement for a humble building
(see illustration, above).

Palladio also challenged the primacy of Vitruvius by
writing *Four Books on Architecture*, which explained Palladio's
ideas and promoted his own work. The books were hugely
important for the development of architecture, influencing
Christopher Wren and Inigo Jones, among others.

THE AGE OF REFORM

In 1517 Martin Luther, an Augustinian friar, nailed a list of complaints to the door of Wittenberg Cathedral in Germany. His protest about Church practices was intended to instigate reform, but his *Ninety-Five Theses on the Power and Efficacy of Indulgences* proved to be a catalyst for a far-reaching process.

At death, if not condemned to hell, those souls burdened with unresolved sins had to be purified in purgatory. The faithful were encouraged to perform good deeds by saying certain prayers or visiting holy sites, which could lead to an "indulgence" – that is, a reduction of time in purgatory. But if people gave money so that God's work could be done elsewhere, would that not be as good? This sale of indulgences was problematic – and involved much more than whether people could be certain where the money was going. Luther believed that our salvation does not rest in our deeds, but in our faith. Priests cannot forgive us for our sins – that is a gift from God, the grace we receive as a result of Christ's sacrifice. This undermined the status of priests and made Luther highly unpopular with the Church establishment.

◉ SUPPRESSING THE MASS AND IMAGES IN BERN
Heinrich Bullinger, "The History of the Reformation" (a copy from 1605–1606), Central Library, Zurich, Switzerland

Many churches once had a sculpture or painting on every side of every pier, and each one represented a separate altar – all of which were either removed or destroyed during the age of reform. This process was later replicated in some Roman Catholic churches after the Council of Trent.

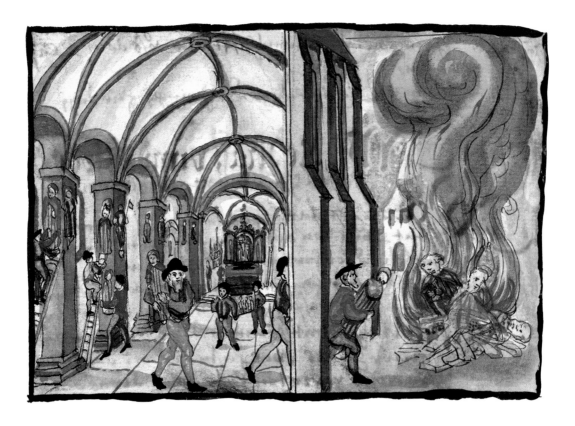

Plainer faith

In Zurich, Pastor Huldrych Zwingli also believed that we are justified through faith rather than deeds, but he went far further than Luther. He rejected the veneration of saints, broke Church laws on fasting and in 1524 he got married at a time when the clergy was supposed to be celibate (the following year Luther also married). Zwingli argued that the Bible should be the only authority on matters of faith, and claimed that none of the traditions he broke was supported by biblical texts. This opinion also led him to uphold the ban on imagery articulated in the Second Commandment. Thus Zwingli was responsible for Christianity's second major outbreak of iconoclasm, during which churches were stripped of anything that could be considered idolatrous.

The Church had come to believe in seven sacraments, perceptible signs made up of words and actions through which the Grace of God is conferred (baptism, Eucharist, confirmation, confession or penance, unction, marriage and ordination). An affirmation of this belief is seen in Jan van der Weyden's triptych painted around seventy years before the Reformation began (see pages 180–181). In 1521 Luther denounced the sacraments as corrupt and little more than papal inventions. Although initially Luther

continued on page 183

⊙ ST BARTHOLOMEW

C.1500, DETAIL OF THE ROOD SCREEN, ST WINIFRED, MANATON, ENGLAND

The meaning of the word "defaced" is made explicit in this image. Identified (by means of the knife with which he was flayed alive) as St Bartholomew, this figure's face – the most human and therefore most sacrilegious part of the image – has been scratched away. This act probably took place in response to a decree issued in 1548 by the Privy Council urging that all superstitious images be taken down or defaced.

STRIPPING THE CHURCHES

A major feature of Reformation theology was that every aspect of the faith should be grounded in scripture. Unsurprisingly, the law of Moses was given particular attention – and particularly the strict wording of the Second Commandment: "Thou shalt not make unto thee any graven image, or any likeness of any thing. . ." (Exodus 20.4). This commandment was clearly contradicted by the decoration of every church then standing. Ideally the "cleansing" of churches would have been conducted in a civilized manner, with the organized removal and destruction of imagery, but it rarely was. In some cases rabble-rousing preachers moved crowds to acts of mindless vandalism, and in others the process became little more than an excuse to pillage the wealth of the Church. After Protestantism was officially accepted by the city of Bern (following a public debate lasting from 6 to 28 January 1528), the first attempts to remove imagery were greeted with hostility by those who adhered to the "Old Faith", which led the reformers to destroy paintings and sculptures in anger. And if it was not as calm as the illustration (left) suggests, it was also not as tidy. Pastor Zwingli (see main text) preached a final sermon before leaving Bern, with what he described as lumps of wood and stone scattered around his feet: pulling the sculptures from their pedestals had revealed that there was nothing holy about them. Whereas the wooden sculptures and altarpieces could be burned, a contemporary poem tells us that anything made of stone was thrown into a hole where it would remain until Judgment Day. Such statements were not taken entirely seriously – then, in February 1986, excavations undertaken to repair the enormous platform built on the side of the valley next to the Münster uncovered around 550 fragments at a depth of 14m (46ft), many of which are now exhibited in the Bern Historical Museum. Despite the displeasure of the reformers, iconoclasm in Bern remained a selective affair and no one is entirely clear why the stained glass of the apse or the sculptures of the portal were not destroyed (see pages 96–97 and 162–163): pragmatism and local pride are the best suggestions.

THE SEVEN SACRAMENTS ALTARPIECE

Rogier van der Weyden, c.1445–1450, Koninklijk Museum voor Schone Kunsten, Antwerp, Belgium

This elaborate and large painting – the central panel is 2m (6.5ft) high – was commissioned by Martin Chevrot, the bishop of Tournai in Belgium (the Walloon city in which Rogier van der Weyden was born) for use in his private chapel. It is thought that Chevrot appears on the left-hand side of the painting as the bishop administering the sacrament of confirmation. At its centre is the Crucifixion, essential for our salvation, which appears to take place larger than life in the nave of a church, and around this revolve the seven sacraments in which the life of the Church and the lives of the faithful are inextricably linked from birth to death.

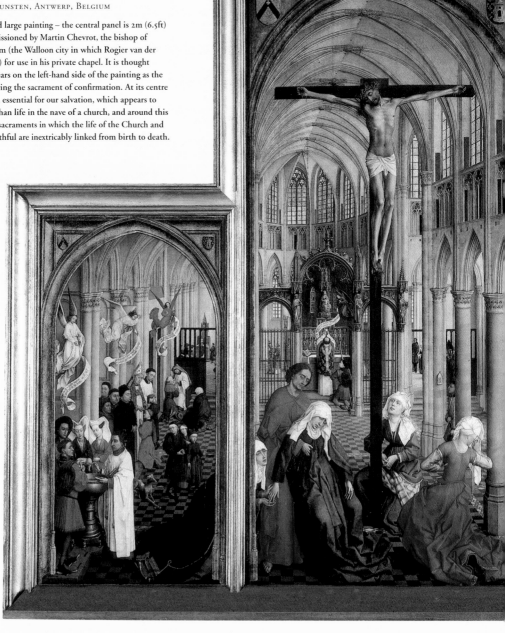

Baptism, signifying the purification of original sin and the beginning of life anew, was derived from Christ's own baptism. This detail is at the front left of the painting: van der Weyden depicts the sacraments across the painting from left to right, following an order that is more or less chronological through the Christian's life.

Confirmation is so called because it confirms and deepens the grace conferred by baptism and so strengthens an individual's bond with the Church. This is achieved through the agency of the Holy Spirit, which appeared at the baptism of Christ and during Pentecost, when the apostles were inspired to go out into the world and evangelize.

Confession, also known as penance and reconciliation. After baptism, wrongdoing would distance the soul from God. Reconciliation is only possible if the person is truly contrite, confesses their sins to a priest, and, after absolution, performs an act of penance.

Eucharist is central to the Christian faith as it embodies the believer's communion with God. In the painting it is also central, taking place on the high altar directly behind the Crucifixion: in the same way that Christ's body is raised on the Cross, the priest is raising the bread. It is during the elevation of the host that Roman Catholics believe transubstantiation occurs.

Ordination, or holy orders, is a sacrament that can be ministered only by a bishop, and is the process by which someone is set aside as a priest, canon or bishop, authorizing them to administer certain of the sacraments.

Christ's presence at the Marriage at Cana (illustrated by Giotto, see illustration pages 75–77) is one of the reasons for the inclusion of marriage as one of the sacraments. It is also interpreted as representing Christ's own marriage to the Church.

Initially extreme unction (also known as "'anointing of the sick") could be ministered whenever illness threatened, but it was gradually restricted until, as its more common name, the "last rites", suggests, it became part of the preparation of the body (and soul) for death.

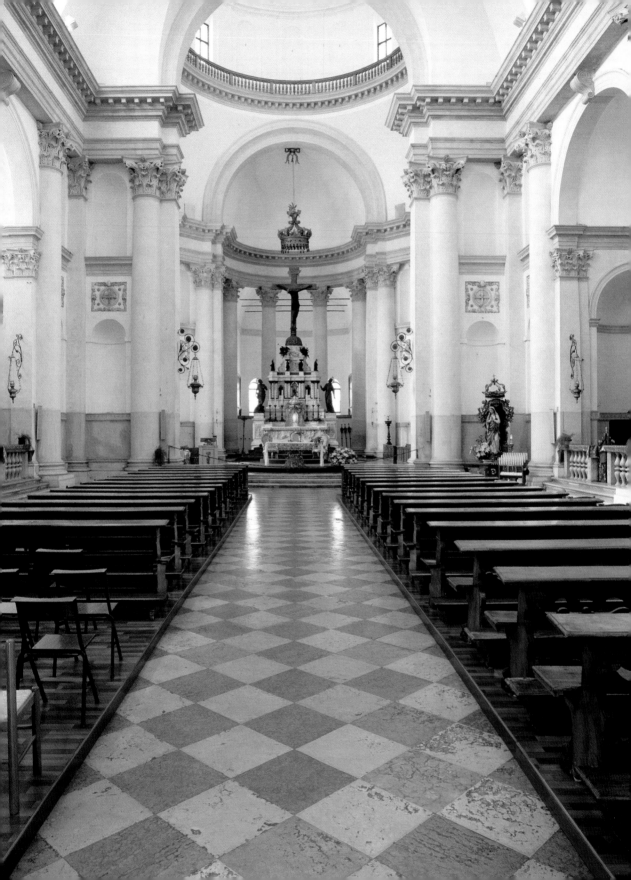

considered penance to be a potential third sacrament, most Protestants have only accepted baptism and the Eucharist – both instituted by the actions of Christ himself. Zwingli considered the Eucharist to be a commemorative meal rather than a true sacrifice. Luther disagreed, arguing in favour of the "real presence of Christ" in the Eucharistic bread, whereas Zwingli insisted that the bread only represented the body of Christ. If the Eucharist is a commemoration, a symbolic act rather than a sacrifice, then a table will suffice and an altar is unnecessary. And if the priest has no power over man's redemption, he can only teach and advise: thus the sermon became the most important part of the service, and the altar, or communion table, ceased to be a major focus.

In England, King Henry VIII had been awarded the title "Defender of the Faith" by Pope Leo X after Henry had written a pamphlet "In defence of the seven sacraments against Martin Luther". Despite that, when Leo's successor, Pope Clement VII, refused to grant the king an annulment of his marriage, Henry broke from Rome to set up the Church of England, with himself at its head. Because the monastic orders would not respect his leadership and continued to look to the pope, Henry went on to dissolve the monasteries, with the substantial added benefit to the monarchy of increased lands and wealth: the ruins of many of the great ecclesiastical houses are still scattered across the British landscape.

It was only with the accession of Henry's son as King Edward VI in 1547 that the Church of England became fully allied with the Protestant cause, and the following year edicts were sent out requiring churches to organize the removal of "idolatrous" material. Although Queen Mary I returned the country briefly to Catholicism, her sister Elizabeth reinstated Protestant practices, while subtly maintaining aspects of both forms of worship. Ever since the Church of England has hovered awkwardly, if not uncomfortably, in between.

The Counter Reformation

All these developments helped to make it clear to the Church in Rome that it had to justify its position. In 1520 a reformed branch of the Franciscans, called the Capuchins, was founded when one of their number realized that his contemporaries were not living in the way that St Francis had wanted. In 1534 Ignatius of Loyola founded the Society of Jesus "to strive especially for the defence and propagation of the faith" in the face of the Reformation movement. As an institution the Church responded to the threat of Protestantism by meeting in a series of twenty-five sessions between 1545 and 1563, which became known as the Council of Trent (most discussions were held in that northern Italian city). The council upheld the validity of the seven sacraments, and even strengthened the act of penance through the invention of the confessional (see page 49). It was decreed that the congregation should have a greater participation in the Eucharist: obstructions, such as screens, should be removed, and any distracting features with which the churches had become cluttered should be cleared. There was to be a greater focus on Christ himself: altarpieces were moved and replaced with tabernacles housing the consecrated host. The veneration of saints was upheld, although the canon was limited to verifiable saints. Images were still encouraged, although they should be large enough to be seen, easily understood and should illustrate Bible stories or the lives of the verifiable saints. Many of these features can be seen in Palladio's church interiors: clear, clean lines which focus our attention on the easily accessible altar, with a choir *behind* it so as not to obstruct our view – the side chapels and their altarpieces are not visible either, having been designed not to detract from the high altar and its prominent tabernacle.

◑ IL REDENTORE,
Andrea Palladio, 1576–1591, VENICE, ITALY

We are prepared for the clarity and simplicity of the interior of Palladio's church by the calm logic of the façade (see illustration, page 176): the entablatures of the giant and minor orders are at the same heights, and there is the same alternation of wide and narrow bays. Compared to earlier churches the most important structural difference is that there is no screen, and the choir is behind the chancel, allowing the congregation an uninterrupted view of the altar, and therefore a greater participation in the act of worship.

BAROQUE

The Counter Reformation was essential for the development of the Baroque. The ideas promoted by the Council of Trent needed to be conveyed in Catholic art and architecture as part of the process of opposing the increasing strength of Protestantism. The art of the Counter Reformation was ideal to instruct the mind, as its simple and uncluttered forms meant that it was easy to understand. However, such directness and simplicity might not move the soul. Simply put, the art was not necessarily exciting. What the Baroque did was to make the impact of religious art more immediate by placing the observers at the centre of the work, turning them from spectators into actors.

The master of the period was undoubtedly Gian Lorenzo Bernini, who marshalled sculpture, painting and architecture to create dramas involving the faithful in the appreciation of God's splendour. He thought that the beauty of something lay in its conception as well as its appearance. The idea, or *concetto*, behind the work was its starting point, and Bernini gradually elaborated this to create a glorious whole. An example was given by Bernini's contemporary Francesco Borromini, who had been his assistant before becoming, effectively, his rival. Borromini suggested that the convex and concave curves on the façade of one of his own churches represented the chest and arms of a man welcoming the faithful. Those arriving at St Peter's in Rome are greeted by Bernini's colonnades (see illustration, page 12), and given the similarity of the *concetto* Borromini may have played some part in its mathematically complex design.

The use of a *concetto* was common internationally, and could be used for any design on any scale. The Augsburg

continued on page 192

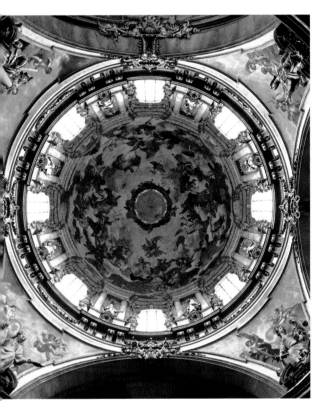

● **ST NICHOLAS CATHEDRAL**
Krystof and Kilián Ignác Dientzenhofer, 1702–1752, LESSER QUARTER, PRAGUE, CZECH REPUBLIC

The cathedral of St Nicholas is typically Baroque, with architecture, painting and sculpture all working together. Sculpted Virtues sit on broken pediments atop the four corner piers (for example, Justice is at the bottom right), and the pendentives behind them are painted with figures complementing the sculpture. The windows illuminate the dome with its heavenly vision of angels flying ever upward.

● **KARLSKIRCHE**
Johann Bernhard Fischer von Erlach, BEGUN 1715, VIENNA, AUSTRIA

The Habsburg Emperor Charles VI decided to dedicate a church to San Carlo Borromeo, one of the prime movers of the Counter Reformation, in the hope that this would avert disaster when plague broke out in 1713. The two triumphal columns, a reference to the Roman Empire, are almost engulfed by the façade of the church. Combined with the strength and power of the design, these columns refer to the continued imperial pretensions of the Habsburg regime.

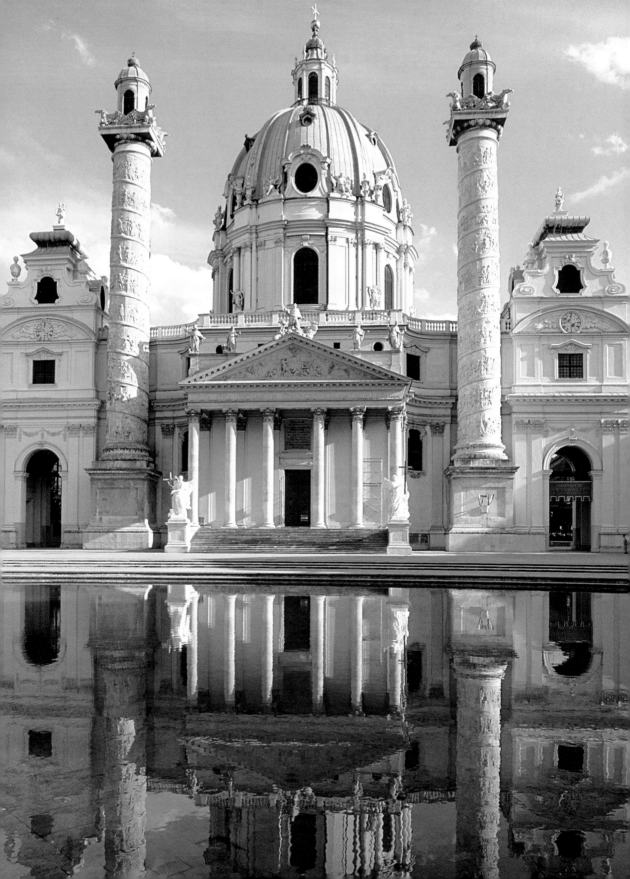

THE AUGSBURG MONSTRANCE

Johannes Zeckel, 1705, Victoria and Albert Museum, London, England

A monstrance, or *ostensorium*, was designed to display (or "demonstrate") the consecrated host, which Catholics believe to be the body of Christ. Introduced with the institution of the Feast of Corpus Domini ("the Body of Our Lord") in 1264, monstrances became more important after the Reformation because they stress the validity of the doctrine of transubstantiation. This example was made in Augsburg, in what is now Bavaria, Germany, at the beginning of the 18th century. Rather than directly involving the viewer in the drama, the monstrance gives the host itself a central role. Christ is not represented as an image, and is only present when the monstrance is in use. The insertion of the host completes not only the depiction of the Last Supper, but also an abstracted representation of the Holy Trinity.

1 The central space contains a crescent-shaped structure, which, with a circular glass element, is called the "luna", the function of which is to keep the host in place. Roman Catholics believe in the doctrine of the "Real Presence". This means that the consecrated host is the body of Christ, even though it still has what are referred to as the "accidents" of the wafer – that is, its appearance, taste and texture. Thus, when the monstrance is in use, Christ is not represented, but he is actually present.

2 In front of the space reserved for Christ is a representation of a chalice, used to hold the wine during the mass.

3 Corn, representing the bread used during the mass, emerges from a cornucopia, or horn of plenty.

4 The grapes, growing on a vine, stand not only for the wine of communion, but they also refer to Christ's statement: "I am the vine; ye are the branches." (John 15.5, see page 112.)

5 Judas sits on our side of the table, and on the other side from Jesus: this placement has been standard since the earliest representations of the Last Supper. All the other apostles are looking at Jesus: Judas is the only one who turns away, the purse containing the thirty pieces of silver held in his right hand.

6 The dove of the Holy Spirit is revealed by two angels, who draw back the curtains around a circular structure similar to the luna.

7 The crown is a reference to God the Father, and to his kingdom. Thus, when the monstrance is in use we have a symbolic representation of God the Father at the apex, the "Real Presence" of God the Son in the centre, and an image of the Holy Spirit as a dove in between: partaking of the bread during the mass involves a true communion with God.

8 The orb is a further reference to God as ruler, its threefold division (a hemisphere at the bottom, and two quarter spheres on top) relating not only to the Trinity, but also to the division of the Earth between the descendants of Japheth, Shem and Ham (see page 106).

9 Another reference to the Trinity can be seen in the way the monstrance is supported: the three theological virtues – Faith, Hope and Charity – are gathered around the stem. Faith is at the front holding a cross and Bible, while one of the points of Hope's anchor is just visible projecting from behind the figure at the bottom right.

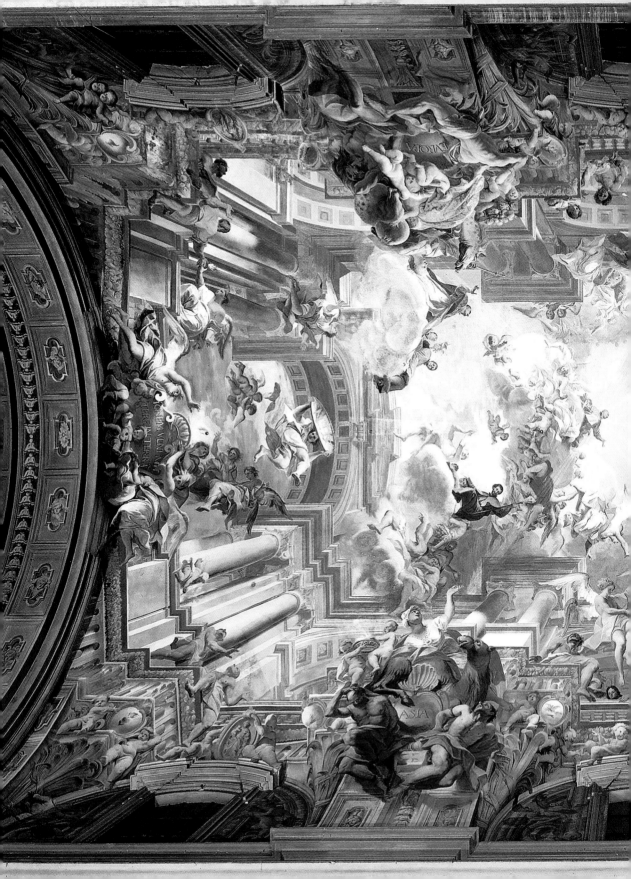

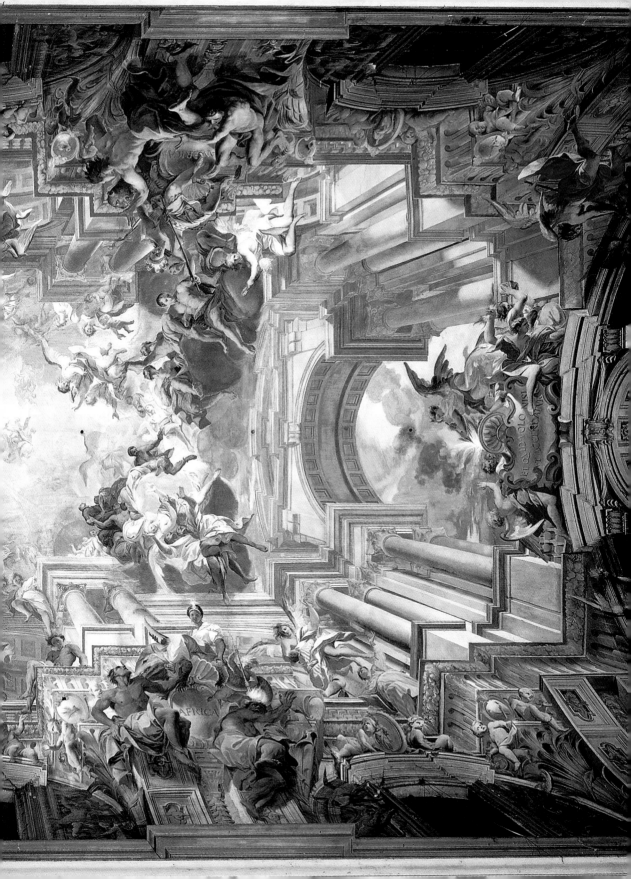

THE APOTHEOSIS OF ST IGNATIUS

Andrea Pozzo, 1691–1694, SANT'IGNAZIO, ROME, ITALY

"I am come to send fire on the earth; and what will I if it be already kindled?"
Luke 12.49

Ignatius of Loyola, who with his companions founded the Society of Jesus (or Jesuits) in 1534, was christened Inigo, but took the now familiar version of his name as he thought it would be better known to the French and Italians than the original. His followers were not slow to recognize its similarity with the Latin word *ignus*, meaning "fire", and made frequent references to his ability to enflame his followers with the love of God, and with enthusiasm for their duties, one of which was to act as God's missionaries across the known world (then the four continents of Europe, Asia, Africa and America). This mission is illustrated by Andrea Pozzo as if heaven were present on – or just above – Earth, and visible through the ceiling of the church, with Ignatius of Loyola depicted as a mirror whose virtue reflects the light of God to the four corners of the Earth.

❶ Christ, carrying his cross, is at the dead centre of the ceiling, and at the vanishing point of the perspective: as humankind's saviour, our attention should be focused on him. Next to Jesus are the other two persons of the Trinity, God the Father and God the Holy Spirit.

❷ St Ignatius of Loyola, the founder of the Jesuits, is carried on a cloud by angels. A beam of light from Christ reflects off Ignatius toward personifications of the four known continents, and toward the name of Jesus.

❸ Europe is represented as a fair-haired, white woman riding a horse. She carries a sceptre and rests her left arm on an orb: the implication is that Europe is the prime continent, and rules the other three – a commonly held belief at the time.

❹ Asia rides a camel. To her left two cherubs carry a blue and white bowl – a reference to Chinese ceramics – with smoke issuing from it. At the time, most spices and incenses were imported into Europe from the "East".

❺ Africa is shown as a black woman riding what is intended to be a crocodile, and she carries an elephant tusk: ivory was highly prized, and was often intricately carved (see page 193) or inlaid in furniture.

❻ America, depicted as a Native American with an elaborate headdress, a spear and a quiver full of arrows, appears to be leaping from a leopard. A macaw, imported into Europe from South America, sits on the base of a nearby column.

❼ An angel carries a plaque bearing the letters *"IHS"*, the "Name of Jesus", in the form popularized by San Bernardino of Siena in the 15th century and favoured by the Jesuits (see pages 118–119). The surface of the plaque is shiny: this is another mirror reflecting the Light of God toward us.

8 A bowl containing fire is tended by angels. Below it is an inscription: "*Ignem veni mittere in terram*" ("I am come to send fire on the earth"), a quotation, from the gospel of St Luke, which was related to Ignatius' name.

9 This architecture is all imaginary: only the window frames, the cornice at the top of the walls and the arches at either end are solid, three-dimensional structures. Pozzo inserted a red stone disk into the floor of the church at the precise point from which the perspective works. This is directly below the vanishing point of the perspective, and so directly below Jesus. In the same way that the fresco only makes sense from the correct viewpoint, so life, the Jesuits would have said, only makes sense if we look to Jesus. And in the same way that this painting is an illusion, so is the life that we lead on Earth: only life with God in heaven after the end of time will be real and everlasting.

goldsmith Johannes Zeckel designed a monstrance which takes its meaning from the physical presence of Jesus in the consecrated host, whereas Austrian architect Fischer von Erlach designed one of the Baroque's grandest churches (see illustration, page 185) with a balance of ancient and modern to show that the continued strength of Habsburg rule had its origins in the ancient Roman Empire. In Poland, the organ of the pilgrimage church of Swieta Lipka (see illustration, page 59) uses rich colours and ebullient forms to add to the inspiring power of music, and as if this were not enough the carved angels can take part in the heavenly drama by revolving and playing their instruments.

Bernini's contribution to St Peter's was extensive. Once inside the basilica you are confronted by the distant spectacle of the *Cathedra Petri* framed by the *baldachino* (see illustration, page 66), the relationship between the different elements changing as you move through the space. Along the north wall, the tomb of Pope Alexander VII also invites our involvement, because what is apparently the door to the tomb is in fact a real door which once led to a sacristy. Elsewhere in Rome the most truly theatrical of all his works is the sculpture of the then recently canonized St Teresa of Ávila (see page 93), whose ecstatic visions became the keynote for the excitation of the soul, in the same way that the Corner Chapel of which it is a part perfectly defines the Baroque ideal. Real light, from a hidden source, shines along rays of gilded stucco to illuminate the figures, while illustrious members of the donor's family, carved in marble, are apparently seated in theatre boxes on either side.

⊙ SANTO DOMINGO
STARTED 1572, OAXACA, MEXICO

Passing through this low-ceilinged vestibule the church opens out into a richly decorated nave, with an elaborate gold altar filling the east end. The church was built by Dominican missionaries. The stuccoed ceiling shows the family tree of St Dominic, who was important to the missionaries as the founder of their order and a fellow Spaniard.

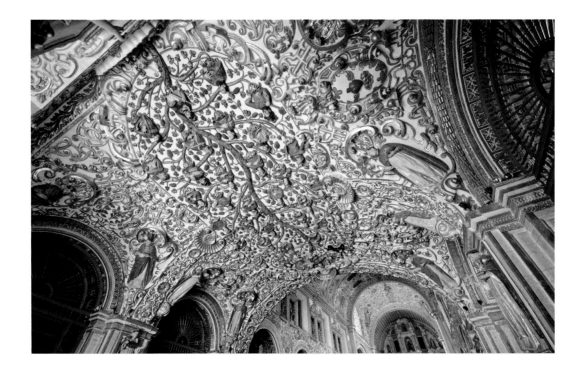

⊙ THE CHILD JESUS AS THE GOOD SHEPHERD

INDO-PORTUGUESE, PROBABLY GOA, 1675–1750, VICTORIA AND
ALBERT MUSEUM, LONDON, ENGLAND

The ivory from which this sculpture was carved was probably
exported from Mozambique, in Africa, to Goa. The imagery,
drawing strongly on pre-existing Indian visual culture, was adapted
for Christian ends. Despite Jesus' noticeably Indian features,
the Christian nature of the ivory is confirmed by the presence of
God the Father just above Jesus, with the dove of the Holy Spirit
hovering at the apex. Below Jesus, Mary and Joseph stand on either
side of a fountain: in the Indian context this would have referred
to the fecundity of nature, but as the water of life it also has strong
Christian connotations.

MISSIONARY ZEAL

*"Go ye therefore and teach all nations, baptizing them in the name of the Father,
and of the Son, and of the Holy Ghost: Teaching them to observe all things
whatsoever I have commanded you."* Matthew 28.19–20

Christ's mission to his apostles was a clear sign to later Christians that it
was their duty to preach throughout the world and to convert its peoples.
In the 13th century St Francis had based his own mendicant order on
Jesus' instructions to take no money, only one coat and no shoes, and
Francis himself travelled as far afield as Egypt and Palestine. A revival of
the Franciscan movement at the end of the 14th century resulted in an
increase in missionary zeal, which became of utmost importance in 1492
with the discovery of the New World. Franciscans accompanied Christopher
Columbus on his second voyage in 1493, and in 1519 more went with Cortés
on his expedition to Mexico. Other Franciscans went to the Antilles, and
began the conversion of Colombia and Venezuela. They were joined by the
Dominicans and Jeronimites, at the request of Pope Clement VII, in 1526.
The Reformation was well underway and it is clear that the Catholic Church
was not only following Christ's teaching in trying to evangelize the world,
but was also replacing those souls lost to the Protestant cause in Europe.

The New World was not the only focus of attention. When the Portuguese
started to colonize India in 1498, King Manuel I claimed that "the main
basis of this enterprise was always the service of God our Lord and our own
profit" – a profit which allowed the development of Manueline architecture
(see illustration, page 174). Although the modern mind emphasizes trade
and colonial domination as principal motivations for worldwide exploration,
the sincerity of the participants' faith should not be doubted. When the
Jesuits were founded in 1534 the order vowed to take up missionary work in
Jerusalem "or to go without questioning wherever the pope might direct",
which before long took them to Canada, Japan, Paraguay and Ethiopia.

Missionary work led to the exportation of European styles of architecture,
and to the introduction of new ideas into European art: the combination
of Christian iconography and Indian tradition seen in this Indo-Portuguese
ivory is just one example of that. The buildings themselves were given an
entirely European appearance, and by the 17th century the churches, so
obviously alien to local tradition, had become a sign not just of the success of
the missionaries, but also of the power and success of the colonizing nations.

The ceiling of the Corner Chapel is painted, with the architecture dissolving away to form the sky: heaven is actually there and within our sight. This was a common Baroque conceit, seen in the dome of St Nicholas Cathedral, Prague, and, perhaps the most brilliant example, the ceiling of Sant'Ignazio in Rome. The latter was the first church dedicated to the founder of the Society of Jesus, who, like St Theresa, was canonized in 1622. Pozzo's ceiling – like Bernini's sculptural works – plays on our sense of sight, and with our awareness of space: the divine vision is not something we are merely witnessing from outside, but it is happening here and now, as the perspective sweeps us up beyond the dissolved ceiling into the physical presence of God.

○ ST MARY'S PILGRIMAGE CHURCH
Peter Thumb, 1747–1750, BIRNAU, GERMANY

The bright, light and uplifting interior is not just the responsibility of architect and builder Peter Thumb: the sculpture and stucco decoration was carried out by Joseph Anton Feuchtmayer, and the frescoes were painted by Gottfried Bernard Göz. Their collaboration turns what is basically a simple rectangular nave with two shallow side chapels into an apparently complex space. The architectural rhythm is established by a series of pilasters which support a cantilevered balcony, and then dematerialized by the stucco elaboration and carried into the imagined heavens by the frescoes on the ceiling. The dedication of the church to Mary is the result of a miraculous image which was transferred here from an earlier church, and this informs the subject matter of the ceiling paintings: even on this scale her celestial blue stands out against the pale background, brilliantly illuminated as it is by the two tiers of windows.

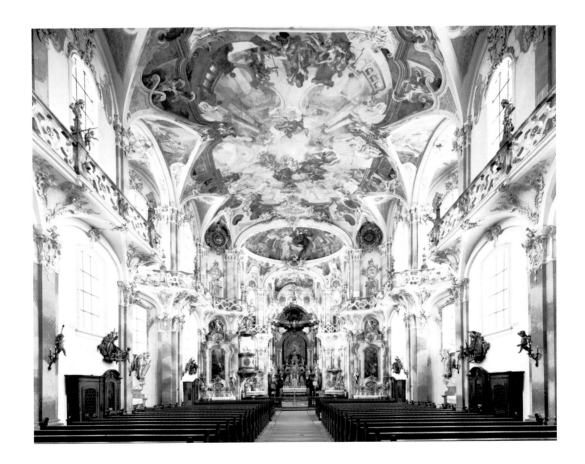

○ **BOM JESUS DO MONTE**
Carlos Amarante, André Soares and others,
1722–1834, BRAGA, PORTUGAL

The sanctuary of "Good Jesus on the
Mountain" was built in 1693 on the site
of a chapel which dated back to at least
1393, although the church seen here is a
replacement of 1784 by Carlos Amarante.
The elegant staircase is not merely decorative:
the first section, started in 1722, includes a
Via Crucis, with chapels housing terracotta
sculptures of the Passion of Christ, followed
by a zig-zag section with five fountains,
each illustrating one of the five senses. The
top section, following a different zig-zag
pattern, is dedicated to the three theological
virtues of Faith, Hope and Charity. The
devotion necessary to climb the stairs while
contemplating these subjects made this one
of the prime pilgrimage sites in Portugal, and
the most committed pilgrims would make the
ascent on their knees.

Baroque or Rococo?

In the eighteenth century the bold and muscular forms
employed by the Baroque developed into a lighter and more
playful style known as Rococo. The precise origin of this
word is unknown. Baroque comes from a Portuguese word
barocco, describing a large, irregular pearl, whereas Rococo
refers more to rocks and shells. The French word *roche*,
means rock, and *rocaille* refers to stone- or shell-work: it is
not unrelated to *coquille*, meaning shell. It is even possible
that the word Rococo was invented as a joke – a Baroque
style that uses rock and shell motifs.

Whether or not it is a separate style, distinct from the
Baroque, is a matter of debate: some suggest it is a form
of decoration rather than a style in its own right, and
opinions vary as to whether it is the culmination of Baroque
or a debased form of it. It tends to be associated with the
frivolity of the eighteenth-century aristocracy, and as such
could be considered entirely worldly, although it enjoyed a
considerable success in churches, particularly in Germany
and Austria.

Whereas the architecture of the Baroque tends to use
strongly coherent elements, the Rococo equivalents are
far more highly decorated, with delicate and intricate
patterning that tends to break up the structural form of
the building. Ornamentation is often asymmetrical, and
uses S- and C-shaped curves amalgamated into complex
forms. Whereas in paintings and sculptures the Baroque
often uses strong diagonals, both across the surface and into
depth, Rococo compositions tend to be built on a series of
overlapping diagonals, of which the staircase at Braga in
Portugal (see illustration, above) could almost be an abstract
representation.

CHURCHES OF THE WORD

For many years after the Reformation there was no need for Protestants to build new churches – the existing ones just needed to be adapted for the new forms of worship. Being based on the authority of the scriptures, and inspired by preaching, these became known as "churches of the Word". In addition to the removal of idolatrous imagery, a greater emphasis was given to the preacher. In England this led to the development of double- and triple-tiered pulpits, with preaching from the upper level, readings from the middle, and announcements by minor church officials, who also led the congregation in communal responses, from the lowest. Seating also became more important, in order to facilitate concentration. The altar was replaced with a simple communion table, which was often brought into the nave in front of the choir screen. The chancel was frequently not used, and in some churches it took on other functions (the choir stalls in St Edmund's, Southwold – see illustration, pages 50–51 – are carved with graffiti because the chancel housed a school). However, in 1634 the archbishop of Canterbury, William Laud, decreed that the communion table should be moved back to the east end of the church, "like an altar". Rather than decorating it with imagery, the retable was dedicated to words – the Ten Commandments, the Lord's Prayer and the Apostle's Creed (see also pages 118 and 201).

It was not until 1666 that the opportunity to build new churches in London came about as a result of necessity,

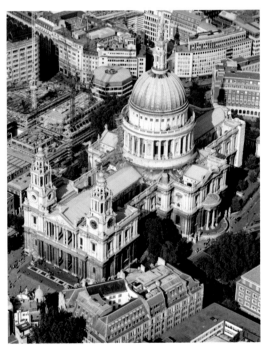

○ **ST PAUL'S CATHEDRAL, AERIAL VIEW**
Christopher Wren, 1675–1710, LONDON, ENGLAND

In common with earlier architects, Wren wanted a centrally planned church, the greater symmetry of which would be more harmonious, but the Church authorities insisted on a standard, longitudinal plan. This aerial view shows how Wren tried to get what he really wanted. From the outside, the addition of chapels at the west end creates a form of screen, not unlike that of Lincoln Cathedral (see illustration, page 14), thus creating a dominant façade, but also apparently limiting the length of the nave proper so that, from the inside, the dome appears to rest approximately halfway along the structure.

○ **ST PAUL'S CATHEDRAL, FAÇADE**
Christopher Wren, 1675–1710, LONDON, ENGLAND

St Paul's was built to replace an older cathedral which was all but destroyed in the Great Fire of London in 1666. Built between 1675 and 1710, the cathedral standing today has been thoroughly cleaned and restored to celebrate the tercentenary of its completion. As well as revealing the fine architectural detailing, the figurative carving can also be seen more clearly. This includes a relief of "The Conversion of St Paul" in the pediment, with a statue of the saint at its apex. To the left, at the corner of the pediment, is St Peter, while at the same level at the bases of the bell towers are the four evangelists with their symbols.

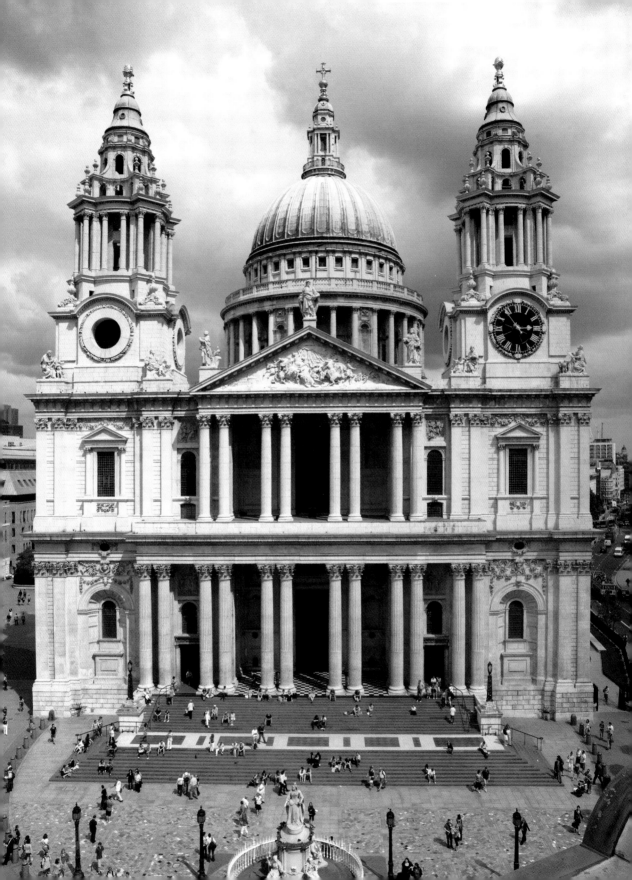

when the Great Fire destroyed more than eighty churches, including St Paul's Cathedral. In order to pay for the new buildings a tax was placed on coal (ironically suggesting that since fire was to blame, fire should pay). Christopher Wren was given overall responsibility for the work. By that time the Church of England had been in existence long enough to have decided what its buildings should look like, but just as the forms of worship introduced in *The Book of Common Prayer* in 1662 were not substantially different from their predecesors, neither was the structure of the Anglican churches. However, Wren was able to introduce the ideas of the Italian Renaissance, known to him from the books of Andrea Palladio, which had only relatively recently arrived in Britain through the work of Inigo Jones. Certain aspects of Wren's work, such as the strong contrasts of light and shade he produces on the façade of St Paul's through the

creation of a deep portico, and the complex stacking of different architectural elements, have led to comparisons with contemporary Baroque architecture, although it is with the following generation of British architects, including James Gibbs (see page 7) and Nicholas Hawksmoor that the influence of the Baroque is more apparent. Nevertheless, given the number of churches for which he was responsible (well over fifty), Wren was able to play numerous variations

○ OUDE KIRK
14TH–16TH CENTURY, AMSTERDAM, THE NETHERLANDS

The "Old Church" in Amsterdam evolved over several centuries, and was a Catholic place of worship until 1578. In 1566 it had been subjected to the fury of the iconoclasts, who looted the church and destroyed much of its artistic heritage. The present, stripped-back appearance of the interior is the result of this destruction, combined with later decoration and the installation of appropriate church furniture (much of it in unpainted wood) in the 17th century.

ST PETER'S CHURCH

Hans Rudolf and Hans Jacob Weber, 1705–1706, ZURICH,
SWITZERLAND

St Peter's is the oldest parish church in Zurich and also became, with
the rebuilding of its nave in the 18th century, the city's first purpose-
built Protestant church (although its original steeple was retained; see
page 15). The stucco decoration would not detract from the preacher,
elevated in the centre of the church so as to be clearly visible to all. In
front of the pulpit is the combined font and communion table.

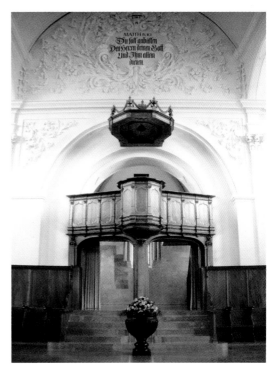

on a series of basic themes, his great masterpieces being St
Paul's Cathedral and, nearby, in miniature, St Stephen
Walbrook (see page 61).

In Switzerland, too, worship took place for many years in
the same, adapted churches. The first "new" church in Zurich
was St Peter's, where the nave was rebuilt to allow for Protestant
worship. St Peter's is designed primarily for preaching, with a
pulpit placed where the *pulpitum* would, traditionally, have
been. The focus is clearly on the centrality of the preacher
and of the Word, rather than on any pictorial signs of faith.
Above the preacher's head, at the top of the wall, is the
tetragrammaton, the Hebrew word for the name of God (see
page 118) and below that a biblical text: "Thou shalt worship
the Lord thy God, and only him shalt thou serve" (Matthew
4.10). In front of the pulpit is a combination of two types of
church furniture, each associated with one of the sacraments
recognized by Protestants. Baptism, the act of welcoming a
new member into the Church, has become central, and rather
than being placed near the door, the font is located at the heart
of the church, in front of the whole congregation. The lid that
closes the font also serves as the communion table: acceptance
into the Church and communion with God are celebrated in
one and the same place.

The Reformation in the Netherlands

In the Netherlands the Reformation was the result of political
change as much as anything else. In the sixteenth century
Spain ruled the Seventeen Provinces of the Netherlands,
and in 1568 the Dutch began a war of independence which
was to last for eighty years. In 1581 seven of the northern

states formed the Dutch Republic, a situation Spain finally
accepted in 1648 with the Treaty of Münster. As well as
freeing themselves, the Dutch went from being officially
Catholic to predominantly Protestant. The new republic's
power to break free and its ability to govern itself were based
on enormous wealth from international trade. Even before
the end of the war with Spain the republic was building new
churches, and in Amsterdam alone the architect Hendrick de
Keyser was responsible for the city's first Protestant church,
the South Church, in 1603, and then two more in the west
and north of the city, begun in 1620.

The shift to Protestantism had an enormous effect on
Dutch art. No longer were artists painting for churches,
which allowed the genres of landscape, portraiture and still
life to come to the fore. This does not mean that there was no
imagery in the churches – as in England, tomb monuments

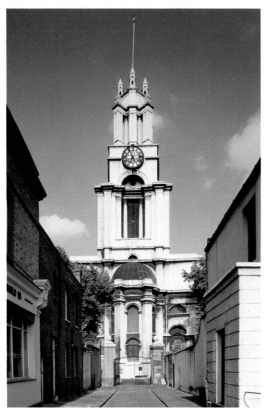

ST ANNE'S, LIMEHOUSE
Nicholas Hawksmoor, 1714–1730, LONDON, ENGLAND

One of the functions of Hawksmoor's elaborate tower is to lift our eyes up to heaven. The apse-like porch has a semicircular roof, which is echoed in the arch above it in the belfry. The effect is of a perspectival progression, leading our eyes upward to the pinnacles atop the angled crown. The pierced forms and agglomeration of smaller units relates the structure to Gothic buildings, although all of the individual elements are derived from classical architecture.

were still constructed to honour the dead. The prime example, and one of the major focuses of civic pride, was the tomb of William the Silent, commemorating a protagonist of the war of independence (see illustration, page 47).

Diversity of faith

By the 1700s the number of different denominations was multiplying, and not all were welcome. Once St Paul's was completed in London, the money available from Coal Tax was set aside to build fifty more churches, not only to provide for the growing congregations, but also to discourage the growth of Nonconformism. Nicholas Hawksmoor was appointed to organize the churches' construction, and although only a dozen or so were completed, he himself designed six of Britain's most original churches in fulfilment of this ideal.

Some ninety years earlier, in 1620, some of the Nonconformists, the Pilgrim Fathers – a group of Puritans facing persecution in England – had set out for the New World, and what they hoped would be a land of religious freedom. They were not the only Christians opposed to the established Church. In the 1650s George Fox became convinced that it was possible to have a direct experience of Jesus without an intermediating clergy. This led him to found the Religious Society of Friends, popularly known as the Quakers, whose belief that there should be no external signs of faith, and no external or internal rites, meant that their meetings were (and are) held in simple rooms with little or no decoration. It would be hard to recognize a Quaker Meeting Room as a church, and strictly speaking it is not. The Quakers, too, suffered persecution, even in America, leading William Penn to found Pennsylvania, giving its capital the name Philadelphia, meaning "brotherly love".

Restrictions on worship were still commonplace in eighteenth-century North America, where the English colonies were expected to adhere to Anglican practices, though the French colonies had no such limitation. This was a contributory factor in the American War of Independence, and when the United States Bill of Rights was drawn up in 1789 the First Amendment guaranteed freedom of religion. The earliest churches in the United States are similar to contemporary British examples, with St Martin-in-the-Fields (see illustration, page 7) being a virtual prototype for many.

● ST MARY WOOLNOTH

Nicholas Hawksmoor, 1716–1724, LONDON, ENGLAND

Hawksmoor's knowledge of the Baroque style from Rome is confirmed by the twisted, or Solomonic, columns and the canopy with winged cherubs that frame the retable, which are clearly based on Bernini's *baldachino* (see page 66). The twisted columns get their name from the assumption that they were used in the Temple of Solomon. The Old Testament reference is intentional: the retable includes no imagery, but has instead a transcription of the Ten Commandments.

ST ANNE'S, LIMEHOUSE ST MARY WOOLNOTH

HAWKSMOOR'S LONDON: GEOMETRY AND MEANING

Hawksmoor's interest in the early Church – in particular the directness and humility of early Christian worship (as it was perceived in his time) – led him to use bold, simple forms. Although not all of Hawksmoor's decisions are revealed in documentary evidence, his fascination with geometry is clear from the buildings themselves. The ground plan shows us that the west stairs of St Anne's in Limehouse are based on an equilateral triangle ❶. This creates a false perspective, increasing the apparent grandeur of the staircase and encouraging us to enter (in effect, we are "funnelled" into the church). However, it is also a symbol of the Holy Trinity, which may be relevant. The stairs lead into the church through a circular porch ❷, which is divided into six by the protruding buttresses. In its position and shape the porch is like the baptisteries of early churches: indeed, Hawksmoor and some of his contemporaries believed that baptism should not take place inside the church. The circle symbolizes perfection and eternity: God can be seen as entering the baptized in the imagined completion of the triangular staircase. Above this rises a square tower ❸, and at the top clustered pilasters are set on a diagonal at each corner (see left), with additional clusters half-way between them: thus there are eight of these. Like the circle, the number eight is frequently used to express the continuity of our spiritual life after the end of time.

St Mary Woolnoth is based on a square, and contains a central, square lantern supported by twelve columns, three at each corner, which can be seen as symbolizing the twelve apostles. These columns also function to divide the space. The central section ❹ – the same size as the square lantern – constitutes the nave. The columns parallel to the west front effectively create a narthex ❺, the introductory area beyond which the catechumen (convert awaiting baptism) of the early Church were not allowed to pass. On the sides the columns define two aisles ❻ (and would originally have supported the galleries, although these have been removed). At the front of the church the columns form a rudimentary screen, separating off the chancel ❼.

Each side of the lantern contains a semicircular window: one of these four windows can be seen in the photograph above. A symbolic interpretation of these windows as a reference to the four evangelists is supported by an idiosyncratic feature of the architecture: the keystones at the top of the windows are carved like Corinthian capitals, which are features one would usually expect to see at the top of columns. Thus the windows, admitting light into the church, also perform a supportive function, in the same way that Christianity is held up by the four gospels, which shed light on the life and work of Jesus.

CHOOSING FROM THE PAST

From the middle of the eighteenth century a reaction against the perceived excesses of Baroque and Rococo led to art and architecture with a greater sense of nobility and restraint. Drawing on classical architecture, as the Renaissance had before it, this movement became known as neo-classicism. Its adoption was sometimes the result of political change, which created a need for buildings expressing order and sobriety: for example, the style was promoted by Napoleon, to inspire comparisons between his rule and the Roman Empire.

Neo-classicism was influenced by the discovery and excavation of Pompeii and Herculaneum, which revealed previously unknown examples of classical sculpture and architecture, and also, for the first time, Roman painting. But the focus was not just on Rome: German archaeologist and art historian Johann Joachim Winckelmann wrote some of the first important studies of Greek art and architecture, in which he saw "a noble simplicity and a calm grandeur in gesture and expression". His observations became the aim of neo-classical artists and architects. They favoured harmony and simplicity over the elaboration of individual details, looking back not just to the originals, but also to their greatest re-statements, notably the work of architects and artists such as Palladio and Raphael. Rather than copying exact appearances, they aimed for an idealization which would show "a more beauteous and more perfect nature". It is not a style in which originality, or bold statements, are valued, but one in which the artist seeks to perfect pre-existing forms. A good example is Carl Ludvig Engel's Lutheran Cathedral in Helsinki (originally dedicated to St Nicholas), which was inspired by Palladio's Villa Rotonda in Vicenza.

Engels designed this building in honour of Tsar Nicholas II, at a time when the Russians were already developing an interest in their own history and culture, rather than that of the Greeks and Romans. This resulted in a style known as Russian Revival. Count Anatole Demidoff (one-time owner

◖ ALEXANDER NEVSKY CATHEDRAL
Mikhail Preobazhensky, 1894–1900, TALLINN, ESTONIA

Alexander Nevsky (1220–1263), recognized as a saint by the Orthodox Church in 1547, was one of the great heroes of medieval Russia. It would therefore seem appropriate that a cathedral dedicated to him should be constructed in the Russian Revival style, which arose in the second quarter of the 19th century as a result of the appreciation of the architecture of the past, and especially of architecture as an expression of national heritage. Estonia had become part of the Russian Empire in 1710, and the semi-independent government of Estonia was abolished in 1889 shortly before the cathedral was built: rather than being "appropriate", the choice of style, and even dedication, can be seen as a form of cultural imperialism.

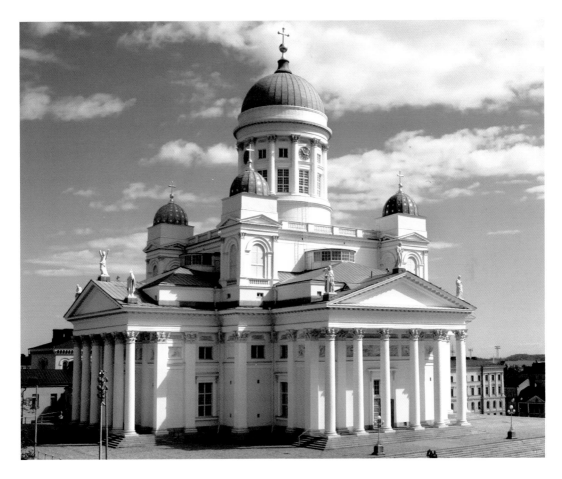

of the eponymous altarpiece, see pages 94–95) published an account of his journeys through Russia in 1839, with illustrations by his travelling companion André Durand. These proved to be important source material, and the results were diverse, including both the Cathedral of the Resurrection in St Petersburg (see illustration, page 8) and the Alexander Nevsky Cathedral in Tallinn.

In western Europe the use of classical forms became problematic. In 1841 the architect and designer Augustus Pugin wrote *The True Principles of Pointed or Christian Architecture*, asserting that Gothic was the only really Christian style. All other styles, based on the classical, round arch, were pagan in origin, and should not be used for churches. Pugin's writings coincided with a revival in the Church of England brought about by the Oxford Movement, which sought to reintroduce

◭ LUTHERAN CATHEDRAL
Carl Ludvig Engel, 1830–1852, HELSINKI, FINLAND

Engel's church relies for its impact on the simplicity of its geometry: a square with a pedimented portico on each side. It would have looked more "classical" before the addition of the four corner domes. These were the responsibility of Engel's successor, Ernst Lohrman, who also added the twelve statues of the apostles, three on each pediment, which constitute the world's largest ensemble of zinc sculptures.

aspects of the liturgy associated with Roman Catholicism. This revival meant that many new churches were constructed, usually in the now-favoured neo-Gothic style. The decoration of older buildings, many of which had fallen into disrepair, was also affected. Much of what we see in churches in Britain today is the result of Victorian restoration, most notably by architect and designer George Gilbert Scott.

An interest in the Gothic past had been promoted by Romantic literature and an interest in historical ruins. In France Victor Hugo's *Notre Dame de Paris* was first published in 1831. Hugo wanted to encourage the preservation of surviving Gothic monuments, many of which had been damaged in the French Revolution. A Commission for Historical Monuments was established, and from 1840 Eugène Viollet-le-Duc set about restoring many important French churches – work which included the creation of the apparently medieval chimeras on Notre Dame (see illustrations, pages 116–117). For Viollet-le-Duc "restoration" involved "completing" the building, aspiring to a stylistic perfection it may never have had. This can be seen as "invention", an accusation which has also been levelled at Gilbert Scott in Britain.

Architects also turned to the Romanesque: the choice of style was often related to denomination. The Oxford Movement had attempted to take the Church of England closer to Rome and association with the Gothic was inevitably a link with the Church before the Reformation. Gothic is therefore a fundamentally Catholic style, and as such was chosen for St Patrick's Cathedral in New York. In the late 1840s one American author suggested that neo-Romanesque architecture was less ostentatious and more republican than neo-Gothic, and so was favoured by Low Church groups. When Henry Hobson Richardson designed Trinity Church for the Episcopalians in Boston he chose the neo-Romanesque: its new association with democratic forms of worship was important.

▶ ST PATRICK'S CATHEDRAL

James Renwick, 1858–1879, Manhattan, New York, USA

Renwick's building, complete with rose window, pinnacles and pointed arches has all the appearance of a neatly constructed gothic original, although it does not have flying buttresses: nineteenth-century engineering meant that they were not necessary. Originally mocked for being too far from the city, by now this is considered "mid-town": the city has grown around it, and what was once the largest building on the island is now dwarfed by its neighbours. Work continued after the church's consecration in 1879, with the spires being completed in 1888.

◀ TRINITY CHURCH

H.H. Richardson, 1873–1877, Boston, Massachusetts, USA

Originally Richardson planned a more conventional, three-aisled church for this site, but changed the internal structure for a Greek cross, with a large, open centre suitable for the preaching of his inspirational friend, the Rector Phillips Brooks, and for the more inclusive and democratic form of worship which was evolving. Although Richardson cited Romanesque sources – the tower, for example, is inspired by the Cathedral of Salamanca, in Spain – he himself said that his work was a "free-rendering" of these ideas, which were themselves taken up by his followers in a style known as the "Richardsonian Romanesque".

ECLECTIC & MODERN

The architects of recent centuries, faced with a choice between the different styles of architecture used throughout the history of the Church, have been able to choose from the European past as well as architecture from around the world. When John Nash adapted the Brighton Pavilion for the Prince Regent (later King George IV) he was famously inspired by the architecture of India, although for All Souls' Church at the top of Regent Street in London (another project for the future king), Nash chose a classical style, with a porch loosely inspired by Bramante's Tempietto (see page 175), boldly elaborated with a circular tower and a spire.

While many architects continued to choose between classical, Gothic and Romanesque as the situation or patron required, others mixed and matched these with international influences. In the nineteenth century the growing interest in local traditions, which arose out of the nationalist movements of the era, alongside the burgeoning Arts and Crafts movement, meant some architects chose to elaborate their buildings with details which would reflect the nature of the congregation. Others sought to develop new styles of architecture that would be a better expression of their particular form of worship. In Glasgow, for example, Alexander "Greek" Thomson designed three remarkable churches for the Scottish United Presbyterians, who had been formed in 1847: sadly only one of these now survives intact. It has been suggested that aspects of his designs were based on descriptions of the Temple of Solomon, an interest which had been shared, coincidentally, by Nicholas Hawksmoor some 150 years before. However, the way in which the separate units of two of Thomson's churches were

◐ CAPITAL FROM ST VINCENT STREET CHURCH
Alexander Thomson, 1857–1859, GLASGOW, SCOTLAND

It has been suggested that Thomson's remarkable churches were an attempt to recreate the Temple of Solomon, and that with his imaginative and richly coloured capitals he was trying to create an alternative Semitic order of architecture.

◑ THE NATIVITY FAÇADE, SAGRADA FAMILIA
Antoni Gaudí, STARTED 1883, BARCELONA, SPAIN

Gaudí took over a year after building of the cathedral began, and he developed the neo-Gothic plan following his own original, and constantly evolving, ideas, working on them until his death in 1926. There are three façades dedicated to different aspects of Jesus' life, each has four towers, which makes one for each apostle. Above the nave and chancel are towers representing Jesus, Mary, and the four evangelists. Because Matthew and John were also apostles, and Judas is excluded, Gaudí included three additional figures, only one of whom (St Paul) regularly joins the twelve. The four towers of the Nativity Façade are dedicated to Barnabas (mentioned as an apostle in Acts 14.14), Simon, Thaddeus (Jude) and Matthias, who was elected to replace Judas in the Acts of the Apostles. Around the door angelic musicians celebrate the birth of Christ in the presence of the three Magi.

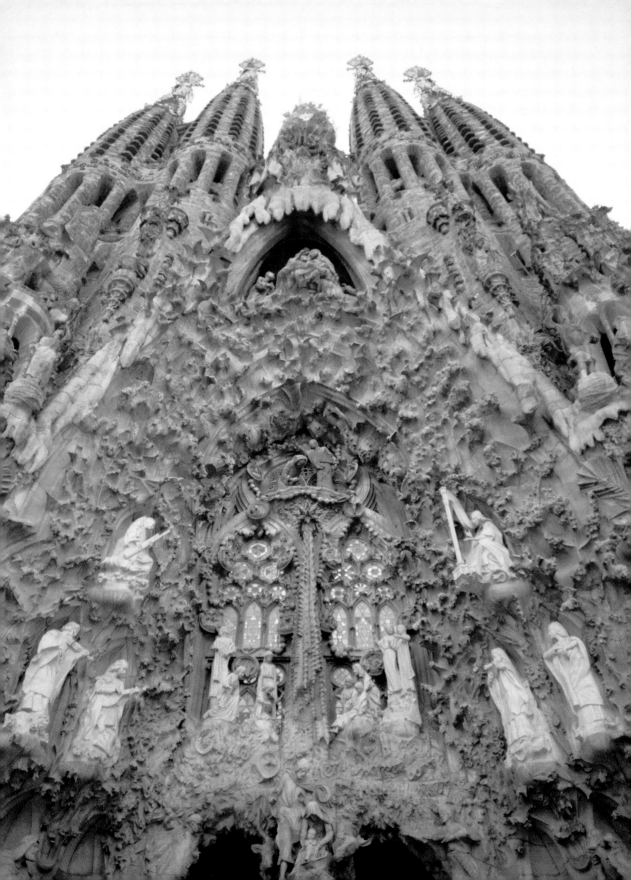

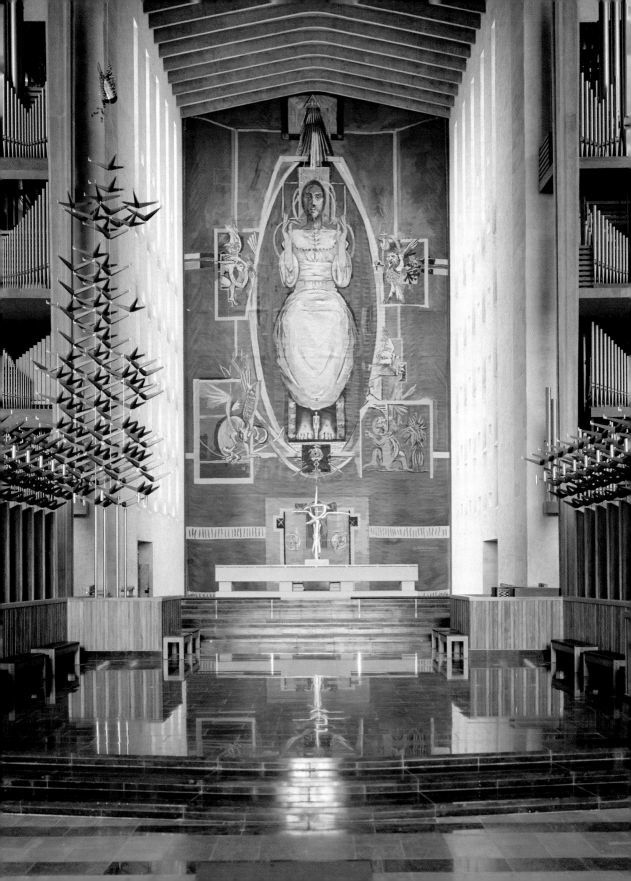

stacked up has also drawn comparison with the Acropolis in Athens, while the tower of his St Vincent Street church contains architectural references from around the world, including Egypt, Assyria and India.

Dramatic new forms

Despite the eclectic sources of Thomson's architecture, the structural form was more or less conventional. Other architects were beginning to develop new techniques, and one of the most remarkable of them was the Catalan Antoni Gaudí. His experiments in engineering led to the introduction of the parabolic arch. When designing Sagrada Familia Gaudí effectively worked upside down, hanging

◗ **COVENTRY CATHEDRAL**
Basil Spence, 1956–1962, COVENTRY, ENGLAND

Despite its apparent modernity, the design of Coventry Cathedral is entirely traditional in its layout – a central nave with two side aisles, headed by a pulpit on the left and a lectern on the right. Behind these are the choir stalls, and then the chancel, where the altar is preceded by a rail. Although the forms are remarkably different, the structure is in fact exactly the same as that of the 15th-century church of St Edmund, Southwold (see pages 41 and 51): a result of the liturgical requirements of the Church of England. The only major difference is the absence of a rood screen.

small bags of lead shot, one-thousandth the weight that the columns would have to support, from loops of string. The shape which the string adopted defined the shape that his arches would have: this is called a parabola. One of the reasons that a pointed arch is stronger than a round one is that it is a closer approximation to this mathematically stable form. Gaudí drew eclectically from both Gothic and classical architecture as he saw fit. He did not like pure Gothic architecture, which he saw as being too precise – "the architecture of the compass". Although many aspects of Gaudí's great, unfinished building are based on Gothic precedents, he intended it to be encrusted with rich and varied decoration, much of which was based on naturally occuring forms: in the same way, the branching of its columns, the result of his load-bearing experiments, make the interior look like a grove of trees (see page 112).

With the development of new building materials and techniques in the twentieth century, church design could change dramatically. Steel-framed buildings allowed firm structural support, meaning that, as with office blocks, walls could be completely released to create larger areas of glass, achieving the results that the Gothic architects had

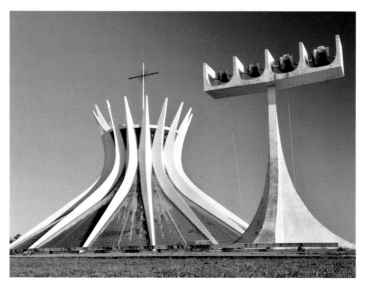

◗ **METROPOLITAN CATHEDRAL**
Oscar Niemeyer, 1958–1970, BRASÍLIA, BRAZIL

Niemeyer was appointed in 1956 as the chief architect for Brasília, Brazil's new capital. Despite his own atheism he designed the cathedral, apparently trying to make it devoid of religious significance in the hope that it could still be used under a communist regime. However, the curved concrete elements have been compared to a crown, or to hands reaching up in prayer. There are sixteen of them, significant as the sum of twelve (the apostles) and four (the gospels). The number was favoured by Bramante, who used sixteen columns for the Tempietto (see page 175). The building is a hyperboloid, one of the forms investigated and employed by Gaudí.

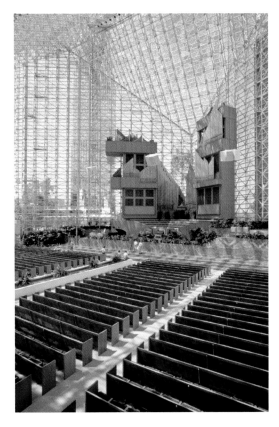

◐ THE CRYSTAL CATHEDRAL

Philip Johnson, 1977–1980, GARDEN GROVE, CALIFORNIA, USA

The "crystal cathedral" was designed not only to house a congregation of more than 2,000 at its weekly services, but also to serve as a photogenic backdrop for television evangelism, with an estimated 20 million viewers watching the "Hour of Power" every week. The Reformed Church in America is governed by elders, so despite its name, this building was not a cathedral – there was no *cathedra*, and no bishop. It was an example of a so-called "megachurch" – they tend to be evangelical or Pentecostal and there are more than 1,000 of them in the United States, although five of the largest are in South Korea. However, this may be a passing phenomenon. The Crystal Cathedral Ministries went bankrupt in 2010. In 2012 the church was sold to the Roman Catholic Diocese of Orange and has been adapted for Catholic worship – a sign of the changing demographic in California.

pioneered, but without the need for flying buttresses. The introduction of cast concrete meant that almost any shape could be created, although few architects adopted the parabolic arch. Nevertheless, for many years design remained conservative, and new techniques were often used to create modern versions of old structures, just as the liturgy was not fundamentally different from that of the preceding three and a half centuries. Even after the destruction wrought by two world wars, and the resulting need to create new buildings, the basic form of churches was little changed – as witnessed by the interior of Coventry Cathedral. Designed by Basil Spence, the decoration of the building was a collaborative effort, with contemporary artists commissioned to create different elements: John Piper designed the windows for the baptistery; Graham Sutherland, the majestic tapestry that hangs behind the High Altar; and Elizabeth Frink, an angular bronze eagle lectern. In the wake of the nineteenth-century Oxford Movement there has been a gradual relaxation in the Anglican attitude to representational imagery, and as well as working on new buildings, artists have also been called on to decorate the old.

Vatican II and Evangelism

Between 1962 and 1965 the Second Ecumenical Council of the Vatican was held in Rome. Better known as Vatican II, one of its most important decisions was that there should be a greater participation in the liturgy by the congregation, which inevitably had implications for new churches: circular, inclusive forms became far more important. However, it is worth noting that Oscar Niemeyer had designed the apparently weightless cathedral in Brasília in 1958, and this was followed by Frederick Gibberd's Cathedral of Christ the King, designed as the result of a competition in 1960 for a Catholic cathedral in Liverpool, which was similarly topped with a crown. Although these new ideas may appear prescient, the issues had been under discussion in the Church throughout the 1950s, and Pope John XXIII had announced his decision to hold the council as early as 1959.

Quite apart from being able to build more remarkable structures from a wider variety of materials, technology has removed the need to build at all. With the advent of "TV evangelism" the concept of the Church as the body of people who worship, as opposed to the physical building in which worship takes place, has once more become operative. Although the Vatican maintains radio and television outlets, the Catholic insistence on participation in the sacraments means that the possibility of worship without attending church is of greater relevance to Protestant, and specifically Evangelical, denominations. One product is the Crystal Cathedral in Garden Grove, California, designed by Philip Johnson for the Reformed Church in America. Around 10,000 panes of glass are attached to the supporting structure with silicone-based glue to enable the building to withstand earthquakes. Johnson goes beyond the modernist ethos "form follows function": the church is designed in the shape of a star. Whatever the reference, Johnson took a step toward postmodernism, in which ideas from the past, from high art to popular culture, are combined together, often to witty or ironic effect.

The third millennium

One of the most obvious, though perhaps least noted ways in which Christianity has affected the way we live is that it has defined the date. Whether we describe the year according to the abbreviation "AD" (Anno Domini, "the year of our lord"), or the increasingly common "CE" ("Common Era"), the measurement is from the supposed date of Jesus' birth. We have therefore entered the third millennium, and the way in which Christians worship continues to evolve. While the birth of TV evangelism means that for some of the faithful attendance at church may not appear to be necessary, across the world new churches continue to be built, and old ones to be decorated.

In an era with more than 30,000 different denominations of Christianity, there is no set of rules on how a church should be built and decorated, and more than ever before,

⊙ THE LAST JUDGMENT

Marc Mulders, 2007, SINT-JANSKATHEDRAAL, 's-HERTOGENBOSCH, THE NETHERLANDS

Installed in a Gothic cathedral in the 21st century, Mulders' window draws on traditional ideas, while being entirely modern. In the cinquefoil at the top of the tracery Christ sits in Judgment, "a rainbow round about the throne" (Revelation 4.3), the image similar to the figure at the top of the Bern Münster Portal (see pages 162–163). A yellow stream pours from his side, becoming red, like the rivers of fire in early Judgment imagery. All around are abstracted forms representing heaven and hell, with peacocks, monsters and frogs. In the bottom left panel, intended to resonate powerfully with today's viewer, is an image of the second plane flying into the World Trade Center.

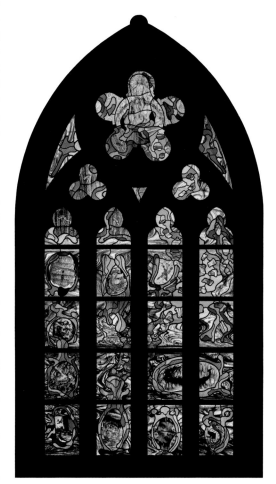

given the developments of modernism and postmodernism, any materials can be used, and in any style. But many of the recent developments have one thing in common: an interest in some of the earliest and most basic themes of Christian worship. Mark Mulders' window, called "The Last Judgment", was unveiled in 2007. He was commissioned "to make a stained glass window that was related to the spirit of this time". The window was designed for an original Gothic tracery, and it includes an image of Christ based on medieval prototypes, as well as using innovative techniques, including a photographic image of the destruction in 2001 of the "twin towers" in Manhattan, which Mulders himself described as "hell on Earth". In California, USA, the Cathedral of Our Lady of the Angels, was completed in 2002 – its monumental doors surmounted by a statue of the Virgin Mary, which uses the standard iconography of the Immaculate Conception (it is worth remembering that Mary was reaffirmed as "Mother of the Church" during Vatican II). In England in 2008, a

font designed by sculptor William Pye (see illustration, page 130) was installed in Salisbury Cathedral, its first permanent font for more than 150 years. As well as fulfilling its traditional function, the cross-shaped font is pointed at each end and there is a constant flowing stream of water. Rather than water, Finnish architect Matti Sanaksenaho draws us into St Henry's Ecumenical Art Chapel with that other, most powerful of symbols – light. Designed as a refuge and as a place of prayer for the patients of a hospital specializing in cancer treatment, the structure has quickly gained the nickname "The Fish Chapel". Sanaksenaho consciously used the early Christian symbol of the fish in order to unite the various denominations of patients being treated. Internally the building resembles an upturned boat, reminding us that the word "nave" comes from the Latin *navis*, meaning ship, and that the Church carries the faithful on their journey through life, and for that matter beyond, leading them toward the Light of the World, Jesus.

◖ OUR LADY OF THE ANGELS
Robert Graham, 2002, CATHEDRAL OF OUR LADY OF THE ANGELS, LOS ANGELES, USA

Graham's bronze sculpture stands in what is effectively a tympanum above the doorway to the new cathedral in Los Angeles, and it draws on the imagery of the Immaculate Conception – the iconography is identical to that on Verbruggen's pulpit in Brussels (see page 43). Mary stands on a crescent moon, and is literally clothed by the sun: quite apart from the brilliant yellow background against which the sculpture is placed, the halo is a hole in the building through which direct sunlight can shine – an idea used in Baroque design (notably Bernini's *Cathedra Petri* and *St Theresa*, see pages 66 and 93). However, Mary's appearance is modern, an amalgam of the city's many racial types.

◗ ST HENRY'S ECUMENICAL ART CHAPEL
Matti Sanaksenaho, 2005, TURKU, FINLAND

The idea for this chapel came to Finnish architect Matti Sanaksenaho after he caught a trout on a fishing expedition. On the outside the building is covered in copper plates, like scales, while the inside might remind us of Jonah inside the whale. The only window is in an arch around the end wall: it cannot be seen from the entrance, so the source of the light is mysterious, drawing us in as Christians have always been drawn to Jesus, the Light of the World.

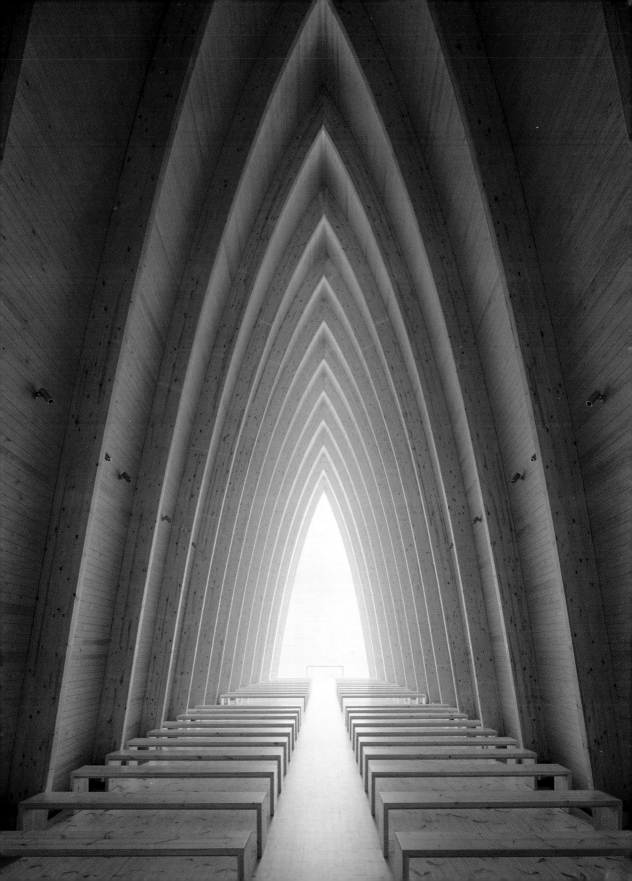

GLOSSARY

aisle Distinct spaces to the north and south of the **nave**, which are separated from it by the **arcade**. As well as providing additional space for the congregation, the aisles allow access to side chapels, space for burial, or for processions around the nave. The ceiling of the aisles is usually lower. Although the tripartite structure contains an allusion to the Holy Trinity, in some churches there are double aisles on each side.

altarpiece A painting or sculpture behind an altar.

ambo An early form of **pulpit**.

ambulatory A route designed to be walked through, often around the **apse** – ideal for processions.

Anglican Relating to the Church of England.

antitype see **type**.

Apocrypha Writings which are considered "secret" or "hidden", and not universally regarded as part of the Christian canon of scripture.

apostle One of the twelve disciples chosen by Jesus as his closest followers in order to preach his message. After Jesus' resurrection, Matthias, Paul and Barnabas are also described as apostles.

apse A semicircular termination to a church, or to the radiating chapels in a larger church, separated from the main space by an **ambulatory**.

arcade The row of columns or piers (solid blocks of masonry) which divides the nave from the side aisle.

archivolt A band or moulding which forms part of an arch, like one in a series of concentric arches.

aumbry A cupboard to store the **paten** and chalice used during the mass.

bema The Orthodox term for the **presbytery**.

boss A stone block securing the joins between ribs in a vault, which is frequently carved and painted.

buttress A masonry support strengthening walls.

campanile An Italian bell tower, sometimes freestanding.

catacomb A place of burial excavated underground.

cathedra The bishop's throne, which gives its name to a cathedral.

chancel *see* **presbytery**.

chantry A small chapel built within the body of the church, usually around the chancel, used for burial, in which masses are said (or "chanted") in memory of the deceased.

chapter house Used for administrative meetings, the name derives from the daily practice of reading a chapter from the Rule of St Benedict so that monks had a regular reminder of the way in which they should live and behave. Chapter houses were included in cathedrals even when those cathedrals were not monastic churches, and give their name to the chapter, the administrative body which runs many cathedrals.

choir (or quire) As the name suggests, this is where the choir and clergy would sit for the most important church services (the archaic spelling is favoured in some English churches).

ciborium A canopy, usually supported by four columns, over the High Altar, or a small container for the consecrated host.

clapboard The exterior cladding of a building consisting of painted planks of wood arranged horizontally.

clerestory (pronounced "clear-story") Windows at the top of the nave that allow light to flood in from above, which would be interpreted as the Light of God: a reminder, during the day at least, that heaven is truly above us.

cloister Originally intended to facilitate communication between the various living spaces associated with a monastery, including the dormitories, **refectory** and **chapter house**, cloisters could also be used for processions, and were sometimes included in cathedrals that were not also monastic institutions.

cosmati Mosaic decoration made up of geometrically shaped pieces of stone.

crossing The point at which the arms of a cruciform church meet.

crypt A chapel underneath the chancel, originally intended to contain the relics of a saint.

deisis A type of image, Byzantine in origin, showing Christ enthroned, flanked by the Virgin Mary and St John the Baptist interceding on behalf of mankind.

disciple A follower of Jesus.

episcopal Relating to bishops (Episcopalian is the name given to the Anglican community outside England, especially in the United States).

evangelist Someone who spreads the word of Christ, and more specifically the authors of the four gospels.

fan vault A type of vault featuring radiating equally spaced ribs.

flying buttress A type of buttress where the base is some distance from the wall, so that there is a space underneath it.

font The vessel containing water used for baptism.

Galilee chapel A chapel at the entrance to a church, once used as the starting point for some processions.

gargoyle A waterspout often carved in the form of a grotesque (note: not all grotesques are gargoyles, this is a common misnomer).

gisant A tomb effigy in which the subject is shown lying down.

hatchment A type of funeral monument, usually diamond-shaped, depicting the coat of arms of the deceased.

High Altar The main altar in a church.

host The word given to the bread, usually in wafer form, used during the mass.

iconoclasm The destruction of religious images.

iconostasis The screen in an Orthodox church dividing the **naos** from the **bema**, which is decorated with icons.

lady chapel A chapel dedicated to the Virgin Mary: in English cathedrals this was often positioned to the east of the High Altar.

lancet A window formed of a tall, thin single opening in the wall.

lavatorium A place for washing – often found in the **cloister**.

lectern A reading desk on which the Bible is placed.

lierne vault A type of vault in which decorative ribs are added between the structurally necessary ones.

lintel A stone beam resting on two posts or columns.

matroneum A gallery in a church set aside for women. This name is given to some galleries even if they have never had this function.

mausoleum A building set aside for burial, named after Mausolus the classical ruler of Anatolia.

misericord A ledge on the bottom of a seat, on which worshippers can perch when the seat is tipped up – it is often carved.

naos The Orthodox term for the **nave**.

narthex A vestibule or porch which forms an introductory space just outside the body of the church proper.

nave The main body of the church. The word comes from the Latin *navis*, meaning "ship", and reflects the idea that the congregation is on a journey through life protected by the Church and directed toward God.

Orthodox "Right thinking", referring to a belief which is considered to be "correct" – or to the various branches of the Eastern Church.

Pantokrator (or Pantocrator) "All powerful", "All Ruling", a Byzantine title that appeared in representations of Christ as ruler and judge of the world.

paten Dish on which the **host** is placed for the Eucharistic prayer.

pews Bench seating in churches. If these benches are closed by doors, they are called box pews.

piscina A basin, often carved in stone, in which to wash the vessels used during the mass.

portico A covered entrance to a building, or corridor in front of the entrance, which is supported by columns.

presbytery The area in a church reserved for the clergy (that is, around the altar) – it can also be referred to as the **chancel**.

pulpit The sermon is preached from the pulpit, which is raised to allow greater visibility for the congregation.

pulpitum The screen in front of the choir, from which preaching would once have taken place. This is sometimes called the choir screen.

quadripartite Divided into four – specifically used for a type of vault.

refectory The monks' dining hall.

reredos A painting or relief behind the altar, and another word for **altarpiece**.

rood screen A screen on which a rood, or cross, was placed. In cathedrals these would usually have been one or two bays west of the *pulpitum*, whereas in churches they are the division between the **nave** and the **chancel**.

sacristy The room (named from the Latin *sacristia* for "sacred") in which the priest robes and prepares for mass – an equivalent of the **vestry**.

sedilia Seating in the south wall of the **chancel** used by the priest and assisting deacons during the mass.

sgraffito A decoration formed by scratching lines into stone, or by scratching off a layer of paint or plaster to reveal a different coloured layer beneath.

spire A tall, conical structure, pointing up to heaven, which can be square, octagonal or circular at its base, often built as a marker for the church.

steeple The combination of a tower and a spire.

tessera A small square of stone or glass used as an element of a mosaic.

tetragrammaton The four Hebrew symbols making up the name of God.

Theotokos "Mother of God".

titulus The board nailed to the top of the Cross that included the words "Jesus of Nazareth King of the Jews", often abbreviated in Latin to *INRI*.

tower Although many churches have a tower above the **crossing**, this would also be the most common place for a dome. Towers are also commonly located at the west end, and less commonly also at the east end and on the transepts. They frequently have either clocks, or bells, or both.

tracery The thin stone ribs in a window that divide the opening and hold the glass.

transept A projection at right angles to the **nave**. The first church to include a transept was Constantine's basilica of St Peter's in Rome. Transepts were constructed there to allow pilgrims greater access to the tomb of St Peter at the **crossing**. As well as making a church into a symbolic cross, transepts were favoured because more altars could be built facing east.

triforium The level above the arcade. It sometimes contains a passage which can go all around the church, in which case it should more accurately be called a "tribune", but sometimes is just a transitional area of wall between the arcade and the **clerestory**.

trumeau A central column in a doorway. Often this would include a sculpture of the Virgin Mary, or of the patron saint of the church.

tympanum The semicircular area in between a doorway and the arch above it, or the triangular area in a pediment.

type A character or episode in the Old Testament whom or which is seen as paralleling or prefiguring another character or episode in the New Testament. The New Testament equivalent is known as the antitype.

vault Either a space underneath the floor in which people are buried, or a stone ceiling, which can take a variety of forms.

vestry *see* **sacristy**.

volute A curving form, or scroll, often carved in stone, which can be part of the decoration of a functional part of the building.

west front The main façade of a church or cathedral is used as the entrance for major celebrations, and is frequently decorated with sculpture which may be generic, or can be specific to each church. The architecture is often designed to create a sense of grandeur.

CHRONOLOGY

63BC	Roman Empire takes control of Palestine.
0	Supposed year of birth of Jesus, although some scholars think that Jesus may actually have been born in 4BC.
AD33	Presumed date of the crucifixion of Jesus.
60s–90s	Period when the gospels of Matthew, Mark, Luke and John are most likely to have been written.
64	Much of Rome is destroyed by fire. The Christians are blamed, leading to major persecutions, including the martyrdom of St Peter.
70	The sack of Jerusalem and destruction of the Temple by the Romans causes a diaspora of the Jews and the early Christians.
285	Possible date when St Anthony retires to the desert, marking the beginnings of monasticism.
303–311	The tenth, and last, persecution of the Christians, under the emperor Diocletian, is the most severe.
313	Constantine legalizes Christianity in the Roman Empire with the Edict of Milan.
325	The Council of Nicaea asserts that Jesus, the Son, was co-eternal with the Father, and promotes the Nicene Creed.
330	Foundation of Constantinople.
337	Constantine, the first Christian Roman emperor, is baptized on his deathbed.
360	Approximate date that Athanasius of Alexandria writes the life of St Anthony of Egypt (St Anthony Abbot).
380	Christianity becomes the official religion of the Roman Empire.
431	The Council of Ephesus recognizes Mary as *Theotokos*, "Mother of God".
451	The Council of Chalcedon establishes the "two natures of Christ".
537	Completion of Hagia Sophia in Constantinople.
632	The death of Muhammad.
726	Byzantine emperor Leo III declares that all images should be destroyed, signalling the start of the Iconoclast Controversy.
800	Pope Leo III crowns Charlemagne "Emperor of the Romans".
843	The Triumph of Orthodoxy ends the Iconoclast Controversy.
962	Otto crowned Holy Roman Emperor.
1014	The Western Church introduces the *filioque* clause into the Nicene Creed to the consternation of the Orthodox Church.
1054	The Great Schism between the Orthodox and Western Churches.
1095	The First Crusade to recapture the Holy Land for Christianity.
1125	Bernard of Clairvaux writes his *Apologia*, including a criticism of Cluniac monks and a defence of Cistercian values.
1137–1144	Abbé Suger rebuilds the Abbey of St Denis, now recognized as the first Gothic church.
1170	Thomas Becket is murdered in Canterbury Cathedral.
1204	The sacking of Constantinople by the Venetians – the Fourth Crusade which never reached the Holy Land.
1221	Death of St Dominic, founder of the Order of Preachers ("The Dominicans").
1226	Death of St Francis, founder of the Friars Minor ("The Franciscans").

1300	Pope Boniface VIII institutes the first Jubilee, or Holy Year, encouraging pilgrimage to Rome.
1342	The Franciscans are given the responsibility to care for sites in the Holy Land.
1440	Lorenzo Valla demonstrates that the "Donation of Constantine" is a forgery.
1453	The Ottoman Empire captures Constantinople, which is renamed Istanbul: this marks the definitive end of the Roman Empire.
1492	Christopher Columbus discovers the "New World". On his second expedition, in 1493, he is accompanied by Franciscan missionaries.
1506	Bramante starts the rebuilding of St Peter's in Rome.
1517	Martin Luther nails the "Ninety-five Theses" to the door of Wittenberg Cathedral, marking the start of the Reformation.
1521	Luther denounces the sacraments as corrupt. King Henry VIII of England writes *Defence of the Seven Sacraments* and is declared Defender of the Faith by Pope Leo X.
1534	The Act of Supremacy makes King Henry VIII the head of the Church of England. Ignatius of Loyola founds the Society of Jesus (better known as "The Jesuits").
1535	King Henry VIII orders the dissolution of England's monasteries.
1545	The first session of the Council of Trent: the start of the Counter Reformation.
1547	Accession of King Edward VI of England.
1549	Book of Common Prayer introduced by the Church of England
1563	The twenty-fifth and last session of the Council of Trent.
1611	Publication of the King James Version of the Bible.
1612	The completion of St Peter's basilica façade by Carlo Maderno.
1620	The Pilgrim Fathers set out for America, seeking a life of religious freedom and tolerance.
1622	Ignatius of Loyola and Teresa of Ávila canonized by Pope Gregory XV.
1647	George Fox starts to preach publicly, which leads to the foundation of the Religious Society of Friends ("The Quakers").
1667	Bernini adds the "arms" to the piazza in front of St Peter's.
1728	James Gibbs publishes his *Book of Architecture*, particularly influential for church building in the United States.
1739	In England John Wesley founds the Methodist Church.
1839	Anatole Demidoff and André Durand publish *Voyage pittoresque et archéologique en Russie*, influential for the development of the Russian Revival style.
1845	Augustus Pugin publishes *The True Principles of Pointed or Christian Architecture*, promoting neo-Gothic architecture.
1854	The Immaculate Conception becomes Catholic dogma.
1870	With the unification of Italy the pope retreats to the Vatican and ceases to be a worldly ruler.
1962	The opening of "Vatican II", the reforming Second Vatican Council, which lasted until 1965.
2000	All denominations celebrate the "millennium" as marking 2,000 years of Christianity: for the Roman Catholic Church this is a Great Jubilee, 700 years after Pope Boniface VIII instituted the first Christian jubilee.

FURTHER READING

Christianity can only be understood well if you have a thorough knowledge of the Bible, which is therefore the most important book you can read to get a better understanding of churches and cathedrals. All of the quotations in this book are from the Authorized (King James) Version of the Bible, first published in 1611. However, only the earliest saints are mentioned in the Bible. For medieval and later artists, the main source for stories about the lives of the saints was *The Golden Legend*, an anthology gathered together and written down by the Bishop of Genoa in the 1260s. In a similar way Dante's *Divine Comedy* was hugely influential, as some authorities gave it a status second only to the Bible itself. An understanding of the history of the Church itself is also useful, to which end the following books are invaluable:

Chadwick, Owen. *A History of Christianity*. Weidenfeld & Nicholson: London, 1995.

Dante (Dante Alighieri). (Translation and comment by John D. Sinclair.) *The Divine Comedy* (three volumes: *Inferno, Purgatorio, Paradiso*). Oxford University Press (OUP): London and New York, 1961.

Hillerbrand, Hans J. *Christianity: The Illustrated History*. Duncan Baird Publishers: London, 2008.

Livingstone, E.A. *The Concise Oxford Dictionary of the Christian Church*. OUP: Oxford, 2006.

MacCulloch, Diarmaid. *A History of Christianity*. Allen Lane: London, 2009.

Porter, J.R. *Jesus Christ*. OUP: New York; Duncan Baird Publishers: London, 1999.

Porter, J.R. *The Lost Bible: Forgotten Scriptures Revealed*. University of Chicago Press: Chicago; Duncan Baird Publishers: London, 2001.

Porter, J.R. *The Illustrated Guide to the Bible*. OUP: New York; Duncan Baird Publishers: London, 2007.

Voragine, Jacobus de. (Translated by Christopher Stace.) *The Golden Legend*. Penguin Books: London, 1998.

There are also many books which cover the history of the buildings and the symbolism of their art and architecture. The following is only a small selection:

Clifton-Taylor, Alec. *The Cathedrals of England*. Thames and Hudson: London, 1967.

Hall, James. *Dictionary of Subjects and Symbols in Art*. John Murray: London, 1994.

Murray, Peter and Murray, Linda. *The Oxford Companion to Christian Art and Architecture*. OUP: Oxford, 1998.

Raguin, Virginia and Higgins, Mary. *The History of Stained Glass: The Art of Light – Medieval to Contemporary*. Thames and Hudson: London, 2008.

Summerson, John. *The Classical Language of Architecture*. Thames and Hudson: London, 1980.

Verdon, Timothy. *Mary in Western Art*. Pope John Paul II Cultural Centre: Washington, D.C., 2006.

For a more thorough study of specific periods, or even individual artists or architects, the following are recommended, and have been useful when writing this book:

Beltramini, Guido and Burns, Howard. *Palladio*. Royal Academy of Arts: London, 2009.

Du Prey, Pierre. *Hawksmoor's London Churches: Architecture and Theology*. University of Chicago Press: Chicago, 2000.

Gordon, Dillian. *The Wilton Diptych: Making and Meaning*. Yale University Press: London, 1994.

Harbison, Craig. *The Mirror of the Artist: The Art of the Northern Renaissance*. Pearson Education: London, 1996.

Lowden, John. *Early Christian and Byzantine Art*. Phaidon: London, 1997.

Snodin, Michael and Llewellyn, Nigel (eds.). *Baroque: Style in the Age of Magnificence*. V&A Publishing: London, 2009.

Stalley, Roger. *Early Medieval Architecture*. Oxford Paperbacks: Oxford, 1999.

Stemp, Richard. *The Secret Language of the Renaissance*. Duncan Baird Publishers: London, 2006.

INDEX

ACKNOWLEDGMENTS & PICTURE CREDITS

The publisher would like to thank the following people, museums, and photographic libraries for permission to reproduce their material. Every care has been taken to trace copyright holders. However, if we have omitted anyone we apologize and will, if informed, make corrections to any future edition.

Key

AA The Art Archive
AH Angelo Hornak Photo Library
AKG akg-images
BAL The Bridgeman Art Library
Scala Scala Archive
SH Sonia Halliday Photographs
l = left, r = right, a = above, b = below

Endpapers Gabinetto dei Disegni e delle Stampe degli Uffizi, Florence, courtesy of the Ministero Beni e Att. Culturali/Scala; **1** St Mark's Cathedral, Venice/Scala; **2** SH; **4** Brother Luck/Alamy; **7** Roger Lacey/fotoLibra; **8** Goodshoot/Corbis; **9** Alinari, Florence; **10** Skyscan/Corbis; **12** CuboImages/Alamy; **14** David Lyons; **15** Richard Stemp; **16** Spectrum/Heritage Images/Scala; **17** AH; **19** SH; **20** Travel Library/ Robert Harding Picture Library; **21** Scala; **23** SH; **24** Scala; **25** AH; **26** Photo Opera Metropolitana Siena/Scala; **27** SH; **28** Sid Frisby/fotoLibra; **29a** Stuart Johnston; **29b** © Crown Copyright Historic Scotland www. historicscotlandimages.gov.uk; **30–31** St Michael Kirchengemeinde/ Deutsches Bergbau-Museum, Hildesheim, 1999; **32** Julia Hedgecoe; **33** © Heritage House Group Ltd; **34** Scala; **35** Robbie Munn/Reproduced by Permission of the Dean & Chapter of Rochester Cathedral; **37–39** SH; **41** © Heritage House Group Ltd; **42** Achim Bednorz; **43** David Gee 1/ Alamy; **44** Photo © Adrian Fletcher, www.paradoxplace.com; **45** Photo © Adrian Fletcher, www.paradoxplace.com; **46** © Heritage House Group Ltd; **47** Bildarchiv-Monheim/Alamy; **48–49** Westminster Cathedral, London/ The Courtauld Institute of Art; **49a** Shutterstock; **51** © Heritage House Group Ltd; **52** Scala; **53** Doug McKinlay/Photolibrary; **54** De Agostini/ Getty Images; **55** Victoria & Albert Museum, London; **56** E & E Image Library/Photolibrary; **57a** Bildarchiv-Monheim/Alamy; **57bl** Bildarchiv-Monheim/Arcaid; **57br** Musée National du Moyen Age et des Thermes de Cluny, Paris/BAL; **58** Museo Arcivescovile, Ravenna/Erich Lessing/AKG; **59** mediacolor's/Alamy; **60** © Dumbarton Oaks, Byzantine Collection, Washington DC; **61** Angelo Hornak/Alamy; **62–63** Bildarchiv-Monheim/ AKG; **65** AH; **66** Scala; **69** Craft Alan King/Alamy; **70–73** Cameraphoto Arte Venezia/BAL; **75–76** Alinari/BAL; **78** SH; **79** © Art and History Museum Fribourg/Primula Bosshard; **81** National Gallery, London/Scala; **82–83** Museo Civico Medievale, Bologna/Scala; **84** Erich Lessing/AKG; **86** imagebroker/Alamy; **87** Erich Lessing/AKG; **89** Church of St. Foy, Conques/ BAL; **90** Scala; **91** SH; **92** BAL; **93** BAL; **94–95** National Gallery, London/ Scala; **96–97** Achim Bednorz; **98** Fine Art Museum, Bilbao/Alfredo Dagli Orti/AA; **99** Bernisches Historisches Museum, Bern; **100–101** Scala; **102** Bildarchiv Steffens/BAL; **103** Museo del Prado, Madrid/AA; **104** Gavin Hellier/Robert Harding Images/Corbis; **105** John Heseltine/Corbis; **106** BAL; **108** Look Die Bildagentur der Fotografen/Alamy; **109** Walter Bibikow/ awl-images; **111** Chester Brummel/AA; **112** Manuel Cohen/AA; **113** Museo Pio-Clementino, Vatican City/Scala; **114–115** National Gallery, London/ Scala; **117** SH; **116–117b** BAL; **118** AH; **119** Kairos Turismo Cultura Eventi; **120–123** Musée d'Unterlinden, Colmar/Scala; **124** © Heritage House Group Ltd; **125** © Heritage House Group Ltd; **126** Cairney Down/ Alamy; **127** Scala; **128** Scala; **129** AH; **130** awl-images; **132l** Araldo de Luca/Corbis; **132r** SH; **133** AA; **134** Treasury of St Peter's, Vatican City, Rome/Scala; **135** Scala; **136** Erich Lessing/AKG; **137** Gianni Dagli Orti/AA; **138** Scala; **139a** British Library, London (Add. ms.19352 f.27v.)/© British Library Board. All Rights Reserved/BAL; **139b** British Museum, London; **141** Courtesy of the Ministero Beni e Att. Culturali/Scala; **142** Louvre, Paris/ Daniel Arnaudet/Photo RMN; **143** Dagli Orti/AA; **144** Andrea Jemolo/ AKG; **145** Dagli Orti/AA; **146** Bildarchiv-Monheim/Arcaid; **147** A.F. Kersting/AKG; **148** Bildarchiv Steffens/AKG; **149** Jürgen Sorges/AKG; **150l** Hervé Champollion/AKG; **150r** AH; **151** Peter Willi/BAL; **152–1533** Scala; **154** Scala; **155** Alan Copson/awl-images; **156** Hervé Champollion/ AKG; **157** AH; **158** Fondo Edifici di Culto – Min. dell'Interno/Scala; **160** Stefan Drechsel/AKG; **161** De Agostini Picture Library/AKG; **162** Achim Bednorz; **164–167** National Gallery, London/Scala; **168** Scala; **169** Scala; **170–173** St Bavo Cathedral, Ghent/Giraudon/BAL; **174** Uwe Dettmar/ Bildarchiv-Monheim/Arcaid; **175** AKG; **176** Scala; **177** James Morris/AKG; **178** Zentralbibliothek, Zurich (ms.B 316 f.321v.); **179** Mark Hannaford/ awl-images; **180–181** Koninklijk Museum voor Schone Kunsten, Antwerp/ AA; **182** Scala; **184** Bard Johannessen/Getty; **185** Hervé Champollion/AKG; **186–187** Victoria & Albert Museum, London; **188–191** Fondo Edifici di Culto – Min. dell'Interno/Scala; **192** Tolo Balaguer/Photolibrary; **193** Victoria & Albert Museum, London; **194** Paul Maeyaert/BAL; **195** Chris Rennie/Robert Harding Picture Library; **196** © English Heritage Images. All Rights Reserved; **197** AH; **198** Bildarchiv-Monheim/AKG; **199** Richard Stemp; **200** AH; **201** Richard Stemp; **202** Paul Thompson Images/Alamy; **203** Leuku, Finland; **204** Photolibrary; **205** Photolibrary; **206** Philip Sayer/ The Royal Commission on the Ancient and Historical Monuments of Scotland, Edinburgh; **207** AKG; **208** BAL; **209** Photolibrary; **210** Richard Cummins/Corbis; **211** Marc Mulders/Reuters; **212** Larry Brownstein/ Ambient Images Inc./Alamy; **213** Photograph Jussi Tiainen, by courtesy of Matti Sanaksenaho, Helsinki.